WANG ZHIYUAN

WANG

Bigger, Better, and Cheaper

ZHIYUAN

preface by Judith Neilson
texts by Rosa Maria Falvo, Bai Jiafeng
and Menene Gras Balaguer

SKIRA

Cover
Close to the Warm, 2013

Editor
Rosa Maria Falvo

Art Director
Marcello Francone

Design
Luigi Fiore

Editorial coordination
Eva Vanzella

Copy editor
Emanuela Di Lallo

Layout
Antonio Carminati

First published in Italy in 2016 by
Skira Editore S.p.A.
Palazzo Casati Stampa
via Torino 61
20123 Milano
Italy
www.skira.net

Printed and bound in Italy. First edition

ISBN 978-88-572-3083-2

Distributed in USA, Canada, Central & South
America by Rizzoli International Publications,
Inc., 300 Park Avenue South, New York,
NY 10010, USA.
Distributed elsewhere in the world by
Thames and Hudson Ltd., 181A High
Holborn, London WC1V 7QX, United
Kingdom.

Acknowledgements

My heartfelt gratitude goes to my friends Judith Neilson, Dr Menene Gras Balaguer, Jin Hua, and Reg and Bai Jiafeng, who have contributed so much to the publication of this book.

I would also like to extend my sincere thanks to my editor, Rosa Maria Falvo, for her professional efforts and passion which enabled me to realise this publication.

My deep gratitude also goes to my wife Liu Yunan for her constant support for our family and my career.

Wang Zhiyuan
Beijing

Wang Zhiyuan

A visit to a Sydney gallery installing a new show; a chance glance into a back room; two metal silhouette shadows that caught my eye and almost stopped my heart. This was my introduction to the art of Wang Zhiyuan. But who is he? All I had was a name – and a certainty. This was an artist I simply had to meet. The flat, silver-grey sculptures in that gallery storeroom were like no other artwork I had ever seen: playful, simple, utterly unpretentious. They had a childlike quality, yet they could only have been made by a master. Such beauty, I knew, was no accident. Behind it lay not just a unique talent but a lifetime of observation and experience, trial and error, success and failure, and plain hard work. I wanted to tap into that deep well of skill and creativity.

I contacted Wang Zhiyuan, who had returned briefly to China. When he came back to Sydney to resume post-graduate studies, he agreed to become my art tutor. For several hours a week, we worked together in my home. From a rather formal beginning, our friendship blossomed. My husband and daughters also found Wang a delightful companion, and he actually became part of the family.

In the fifteen years since, Wang Zhiyuan and I have been to many fascinating places, from the studios of his artist friends to the great galleries of Europe, from the history of Chinese art to contemporary consumer culture. Our friendship has been a journey of surprises, arguments (Wang is a ferocious debater) and above all discovery. It was also the inspiration and the cornerstone of the White Rabbit Gallery, which my family established in 2009 and which we could not have got off the ground without Wang's help and support.

As an artist, Wang Zhiyuan is a bold explorer who recognises no borders or boundaries. He will use any medium and try any new technique to turn a creative idea into reality. If he thinks a work needs neon lights, he will learn about electrical voltages and wiring; if it needs to be made of stone, he will learn to carve stone. Wang is driven by his vision. He never worries about keeping up with trends, and when judging art he is never distracted by names or prices. He never takes the easy way out. If he thinks a work of his falls short of perfection – if it lacks the elusive "it" he was pursuing – he will take the whole thing to pieces and start again.

The seeming simplicity and spontaneity of Wang's work belie vast learning. Its freshness belies a deep understanding of art history. Its ability to touch the heart reflects his empathy, born of a lifetime of close attention to human beings and the natural world. Every time I look at a Wang Zhiyuan creation, even at works I have seen before, something new – a new insight, an unnoticed pattern – leaps out at me. I hope this book will help others experience some of the delight and excitement that Wang's art has given me.

Judith Neilson
Sydney

Contents

Rosa Maria Falvo

Bigger, Better, and Cheaper

Wang Zhiyuan cultivates an enigmatic gaze,
and even a somewhat reclusive persona.
Refreshingly, his artistic ego seems carefully
overseen by Taoist wisdoms that pacify
impatience or arrogance, and encourage him
to attune to the rhythms of nature rather than
succumb to the artificialities of social hierarchies.
But his unassuming character belies his intensely
astute observations on China's current economic
expansionism. Wang was born into Mao's
"Great Leap Forward" and its catastrophic
fanaticism to rapidly transform a predominantly
agricultural society into an industrial powerhouse
in just a few years. His 1960s childhood in Tianjin
was nothing like his Beijing life today. As an
artist, one of his most pressing motivations is to
highlight the superficiality and overstimulation
of our twenty-first century existence, juxtaposing
commerce, censorship, and climate change with
the unstoppable momentum of big dreams and
instant fortunes. He envisions entire populations,
like millions of dizzy "flies" caught between
the glittering promises of the future and the
frenzied demands of the present, in the context
of an eroding "world map" and the menacing
consequences of tormenting mother nature.

A decade ago, China surpassed the US in
carbon dioxide emissions due to fossil fuel
use and cement production. In 2006 it became
the world's largest emitter and according to
many reports, its coal production has increased
ten-fold since the early 1960s, with massive
development in infrastructure projects and
housing construction. Its biggest test is to
help itself and the world at large to solve our
enormous pollution problems. Paradoxically,
just as China's Brobdingnagian manufacturers
energetically pump out a myriad of cheaper
goods for the world to buy, its "super rich"
consumer base is proudly acquiring an
equivalent myriad of luxury goods and services
in order to be seen spending. As the very
biggest emerging market, soon expected to

change the face of global politics, alongside India, and others like Indonesia, Brazil, Mexico, etc., China's "Consumer Confidence Index" (according to Nielsen's 2015 4th Quarter Report) shows its consumers are actually feeling much more self-assured, with one of the lowest levels of "recessionary sentiment" in the world, compared to its American or German counterparts. But the same report found that the "economy" was listed as its biggest concern for the future of the Asia-Pacific region, followed by work-life balance and health.

As Wang's "fragmented" symbolism and overwhelming installations so eloquently convey, contemporary China is experiencing an "everything goes" mentality that melds seemingly unbridled ambition with endless forms of distraction. And the mix includes art. This theme is also crystallised in Ted Koppel's celebrated documentary entitled *The People's Republic of Capitalism* which reveals the increasing interdependence of China and the US, and the fragile ecosystems of an interconnected world. And much of Wang's work has also been inspired by complexity and chaos theory. His artistic intuitions seem to be at the very threshold of a global dynamism that is functioning in unpredictable and irreversible ways. His own migratory experience and international interests have shown him both the unique privilege and inevitable costs of looking westward then eastward, and back again.

But Wang's art is not only a playful portrait of contemporary China. His original metaphors work in all cultural contexts and his objectives are often based on or directed towards a contemporary symbol of the "ordinary man" or global citizen. This is particularly evident in his repeatable *They* (2004–5 and 2014) installation, which consists of two hundred bronze or stainless steel humanoid sculptures on wooden boxes arranged in rows. In unison and on a larger-than-life scale the experience compels viewers to contemplate humanity and themselves at the same time. The artist's dark humour is typically Chinese and perhaps born from a childhood of Maoist propaganda, where the imagery of smiling peasants and

invincible soldiers conditioned him to laugh while doing his best to tolerate problems. But his artistic stance aims to make serious though not directly critical statements, often challenging us to read "between the lines" and beyond the acceptability of political climates. During the Cultural Revolution anyone who defaced an image of Mao risked death. And two decades later we saw an explosion of Pop-style imagery, but even today there appears to be some uneasiness about mocking him in public.

Wang arrived alone in Australia in 1989 shortly after the Tiananmen Square massacre to study and find a new voice in a strange land. His resourcefulness and comprehensive Chinese art education bolstered his resolve to "make good" in the art system while injecting satire into his work. Wang's creative development during and after his Australian experience was energised not just by the cross-pollination of otherwise disparate cultures but also by the fact that he was at liberty to "remix" anything – "appropriating any concept, medium or style" and combining it with any historical period, issue and particular emotion.

His *Object of Desire* (2008) installation is indeed an elaborate and garish metaphor, featuring gigantic fibreglass, self-branded panties, and the "Golden Voice" of 1930s Shanghainese singer Zhou Xuan. With her tender laments – "when are you coming again?" – in the background, Wang sets up a series of sly one-liners about power, lust and a kind of collective prostitution, clearly indicting its most vulgar and absurd fantasies. His big/small, cheap/precious, beauty/beast continuum reiterates the problems at work in a world corrupted by what he calls a "new-cheap-capitalism". And for this artist, the things we discard, reject, or disregard are vital and determinant – often better (or worse) than we once thought. His boldly individual style cleverly parodies our globalised consumption, market insatiability, and social decadence.

China's much quoted "rising power" and the frightful public debts haunting the US, Europe, and Japan challenge the time-honoured Western ideals of democracy flanked

by economic success. The old "freedom works" slogan is coming under pressure as authoritarianism seems to be gaining favour, once again. And while tectonic shifts in global imperialism have obviously narrated human history, and continuously tempting customers' desires to buy is the natural agenda of capitalism, it is literally a stated goal of China's current leaders. But the new world "global consuming class" seems to have more in common across national borders, in terms of what it hungers for, than within them, in terms of how it defines itself. We are constantly told that markets everywhere will continue to look more Chinese, more cosmopolitan, more luxury-conscious, and evermore virtual.

In *Close to the Warm* (2013) Wang's supersized interpretation of the flurry of "moths to a flame" phenomenon empathises our own cultural and political phototaxis. As consumers we are objectified, like insects, and the artist's message seems to warn against the intoxication of hedonism and the pursuit of "the good life" at all costs. His "light source" analogy can be read in several ways, such as the hyper-real atmosphere of advertising, directly equating commodities and personal happiness, that encourages our accumulation of possessions to bring us closer to vain notions of self-actualization, security or popularity. By stressing individual choice, advertising falsely implies that control lies with the customer. Wang's imagination constructs fantastical allegories that allow us to reflect on reality, while denouncing the glamourisation of "needs" that are unreasonable to ordinary human beings. Wang aims to elevate the intimate, the poetic, and even the kitsch to communicate with and about everyone. His oversized underpants purging our shared techno-cultured addictions and his tornados of plastic whipping up our collective conscience have compelling psychological dimensions for all of us. No matter where we live. Of course, over-sizing, as we well know from Jeff Koons's monumental works, provides surprising and lively perspectives. But since the Romantics, we have often seen the artist as a rebel or a prophet, wielding an irresistible mystique and deeper awareness. As Wang has

described in his thesis, "I want my art to be about something bigger than me. If it wasn't involved in society I would feel guilty."

Essentially, Wang Zhiyuan's artistic commitment is about our ordinariness and the human scale, about simplicity, and what is taken for granted or mindlessly consumed. It is about the democratisation of our shared environmental and social responsibilities. And he represents the soft power of globally conscious artists – "the lonely poets" – who are trying to raise our consciousness and emotional engagement, where politics and organised religion have failed. Generating bigger fortunes, better ways of acquiring them, and cheaper products to buy will not save us. It seems this artist is more interested in helping us to consider ways art equates to the solutions in real life rather than its inflatable or distracting alter egos. Here again I am reminded of George Bernard Shaw's visionary epic and the insights of his characters as they discuss the evolving stages in the future progress of humankind:

Ecrasia. You have no right to say that I am not sincere. I have found a happiness in art that real life has never given me. I am intensely in earnest about art. There is a magic and mystery in art that you know nothing of.
The She-Ancient. Yes, child: art is the magic mirror you make to reflect your invisible dreams in visible pictures. You use a glass mirror to see your face: you use works of art to see your soul. But we who are older use neither glass mirrors nor works of art. We have a direct sense of life. When you gain that you will put aside your mirrors and statues, your toys and your dolls.

George Bernard Shaw, *Back to Methuselah (A Metabiological Pentateuch)*, Part V: *As Far As Thought Can Reach* (1921)

THREE STAGES TOWARDS LOYALTY

The word "loyalty" is loaded with emotion. I believe loyalty is not a matter of human nature, and that it needs a process of penance, similar to some religious experiences. It requires a lot of abstinence, which may even be cruel and sometimes entail self-sacrifice. To quote a popular Chinese saying, it is necessary to fully align one's "self" to the "larger self" and a "greater goal" before achieving a pure and flawless loyalty. In this work I combined line drawing with calligraphy, with a view to adding some of the literary style of Chinese traditional culture and bridging the eternal gap between reality and an ideal.

Constraint

The figure is taking an oath to the Chinese character 忍 (forbearance). The character 忍, which has been in existence since the very beginning of the formation of a traditional personality, is of great importance in the Chinese culture. It has a long history and various explanations, but mainly means "forbearance and self-restraint". Structurally, the upper part refers to the Chinese character 刃 (blade) and the lower part to the 心 (heart): with a knife over the heart, it advises one to keep stock-still to protect one's heart from being hurt. The title describes both the figure's spiritual and physical states, in terms of sexual experience and function, since "constraint" in Chinese signifies both rigidity and durability.

Release

The figure conveys the connotations of the event in a straightforward and even vulgar way. Sex is the most primal instinct in human nature, and it's the most selfish act. In order to realise absolute "loyalty", making such a clean break is really a very difficult choice.

Freedom

The figure almost achieves the realm of "Ode to Joy" in Beethoven's Ninth Symphony – that is, perfect harmony between one's mood and the ultimate goal (symbolised by the pigeon flying skywards).

Three Stages Towards Loyalty
2015
Stage 1: Constraint
Stage 2: Release
Stage 3: Freedom
Video 3:13 minutes

《忠城三部曲》之一 坚韧

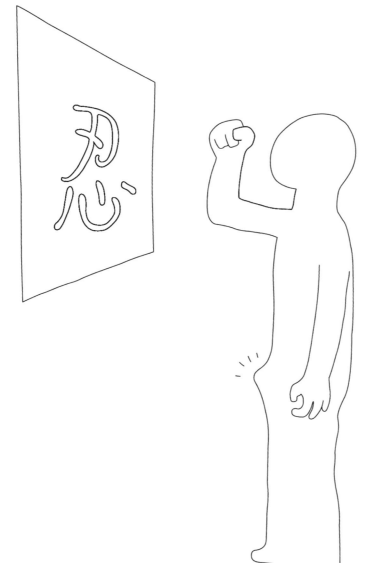

《忠城三部

Stage 2

》之二 超越

《忠城三部曲》之三 釋然

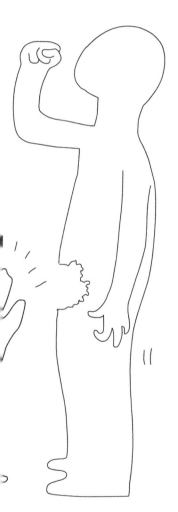

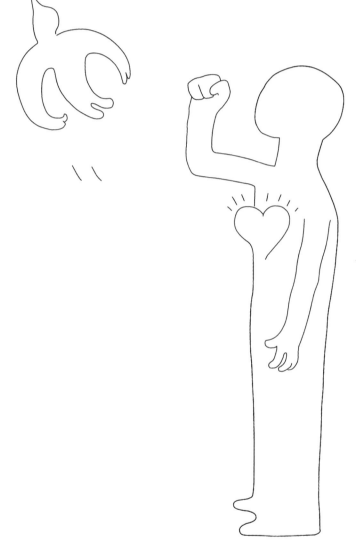

EROSION

This "world map" can be assembled and reassembled according to the space available. It consists of hundreds of thousands of "flies" buzzing around on the wall. Every single one of them is actually a Chinese phrase and each phrase is composed of two Chinese characters, which from a distance look like insects. It makes no difference if they have a positive or negative meaning, since they were all uttered and manifested through desire. They are floating and struggling with each other, thus resembling what happens each minute in our minds and in our real world. All of these floating flies, gradually blurring countries and borders, suggest that the unique features of each nation's cultural make-up are wearing away and disappearing. And a great deal of these "flies" died in this process of creation and re-creation.

Each Chinese character was carefully pasted on the wall one by one. It took five days for me to finish this piece with the help of a few assistants. And our work disappeared when the exhibition was over.

Erosion
2014
Mixed media
Variable dimensions

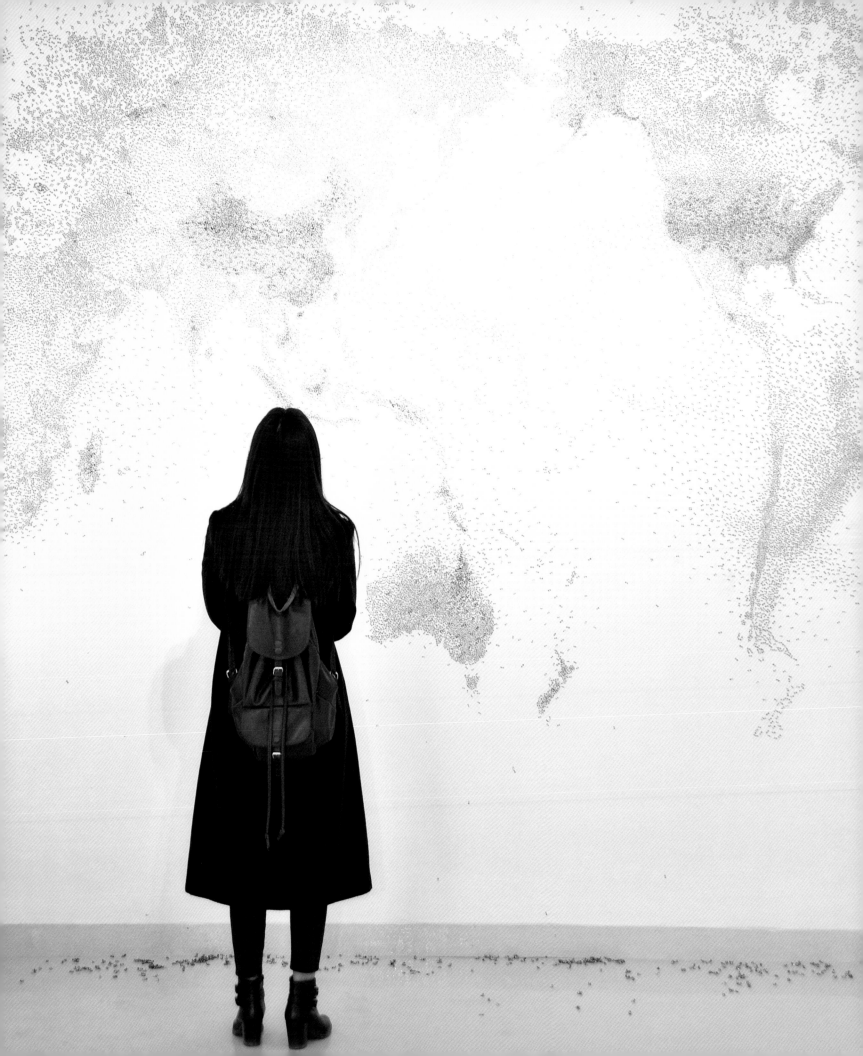

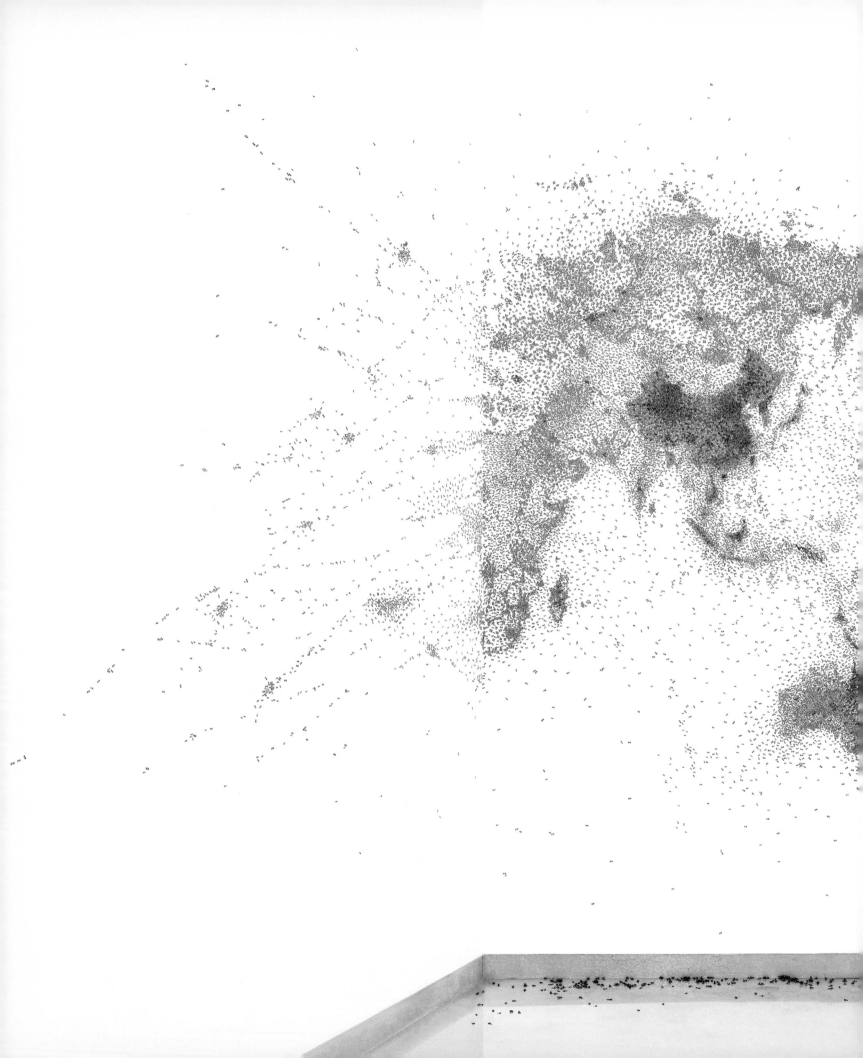

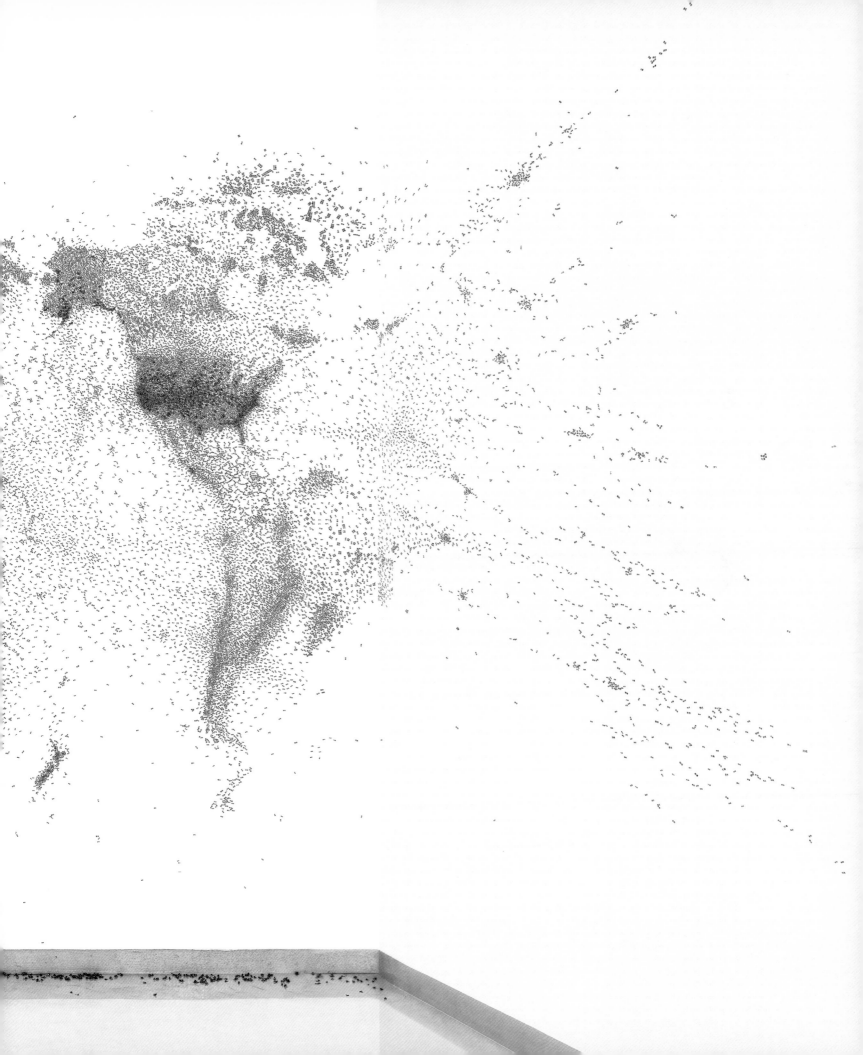

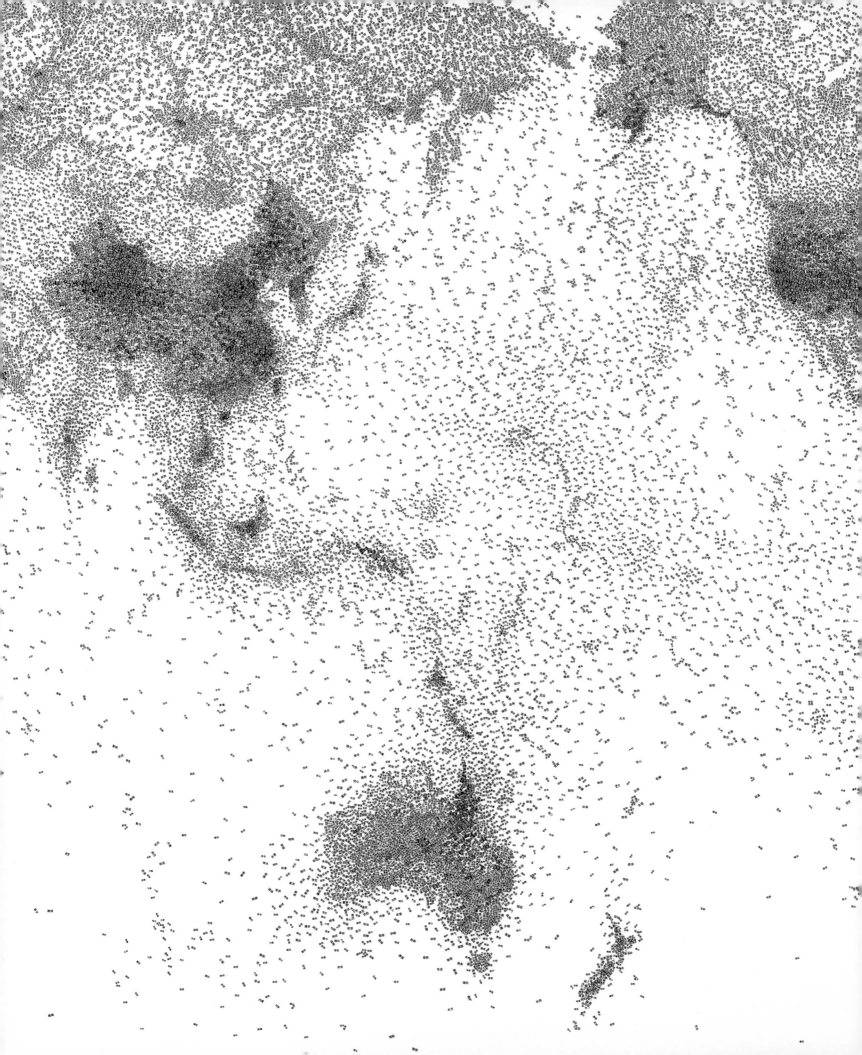

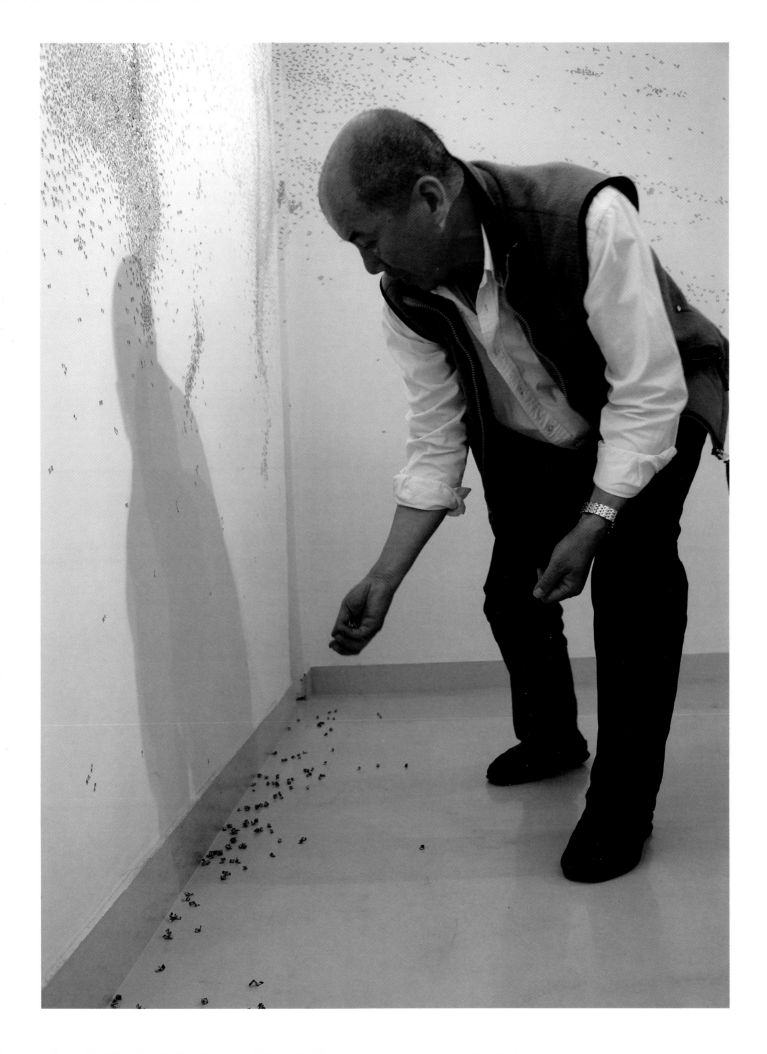

CLOSE TO
THE WARM

This project consists of an old electrical cable, a light bulb, and tens of thousands of swarming "flies", which are actually paper stickers of various sizes that represent a variety of two Chinese characters. These make up Chinese words that are broadly divided into positive (good) and negative (bad) phrases.

When I first began installing this work I decided that the "better" the words the closer they would be to the light source, and conversely with those further away. But while making this new edition for the White Rabbit Gallery in Sydney I decided to reverse the idea – so the "bad" words (e.g. fear, anger, misery, traitor, trepidation, etc.) would be closer to the light and the "good" ones (e.g. effort, progress, strength, fearless, passion, etc.) would be further away from the light. Since the cable is also warm, lots of "flies" are parked on it. These are all negative four-character idioms, such as "disappointed" and "pessimistic", "dragging out an ignoble or meaningless existence", "drifting from place to place in hardship", "partners in crime", etc.

I thought long and hard about my motivation for this artwork. Was it about righteousness, justice, or compassion? Was it my observations of social realities? In retrospect, it seems a bit of both. If you look around China, except for larger cities like Shanghai and Shenzhen, there is rampant over-development and dirt, chaos, and crap everywhere. I work within the context of contemporary art and have naturally thought about the connection, if any, between Western contemporary art concepts and this messy reality confronting me daily. Does China actually need contemporary art? Or is it a cultural phenomenon catalysed by the Western market? Where is the "independent life force" of Chinese contemporary art? These thoughts may seem despairing, since the relationship between art and reality is a complex one. It's not simply an inter-causal relationship – but then what is it?

My personality comes into play here. I created this work for my own pleasure. You can call it a joke or mischief or whatever, but I also made it to make myself happy. The countless black dots surrounding the light look like insects from far away. Only when you get closer you do realize that each "fly" is a word. There's some illusion or surprise for the audience. And it's all made of the cheapest materials I could find, which reflects my overall impression of many parts of China. This is contrary to the current trend of making huge artworks using expensive materials. I hope to reduce the importance of a work's medium, or an audience's fascination with a specific medium, to the bare minimum, and to actually direct the audience's focus on the inner quality and substance of my work rather than its face value. Are we over-consuming even in terms of artistic media and concepts? If we go back to what I imagine to be the primitive state of art, when there were no artistic mediums or only very basic ones, with no "isms" and schools, what would we do in art then?

Artworks are obviously incapable of fixing any real problems. They are monologues, simply expressing an artist's resistance to his or her external world. The title of this piece was inspired by a Chinese idiom that means "get warm by sticking together". These words drift about like floating ghosts in my head. There is no overt purpose and there is no fixed meaning. Their greatest wish is to find a goal in the sea of darkness. That tiny bit of warmth (the light source) is the destination they are looking for. This work can also incorporate words from other cultures and let the "flies" representing diverse languages experience the same search in the dark night of consciousness together.

Close to the Warm
2013
Mixed media
Variable dimensions

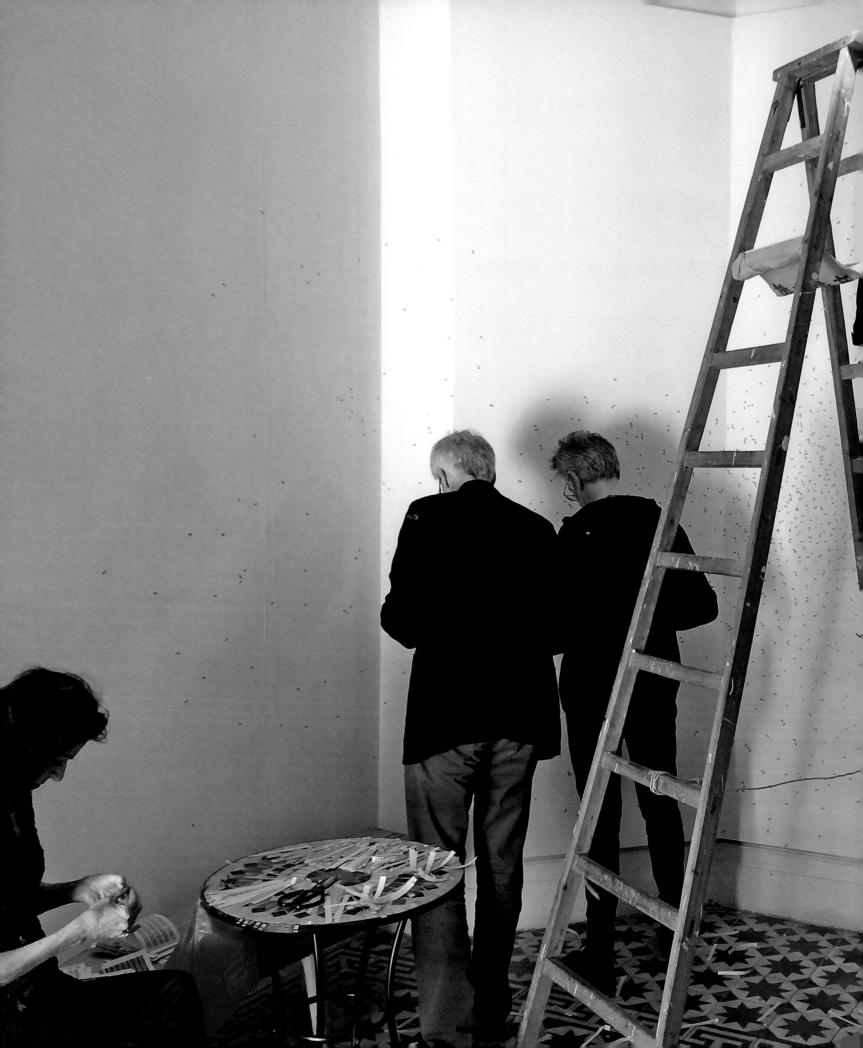

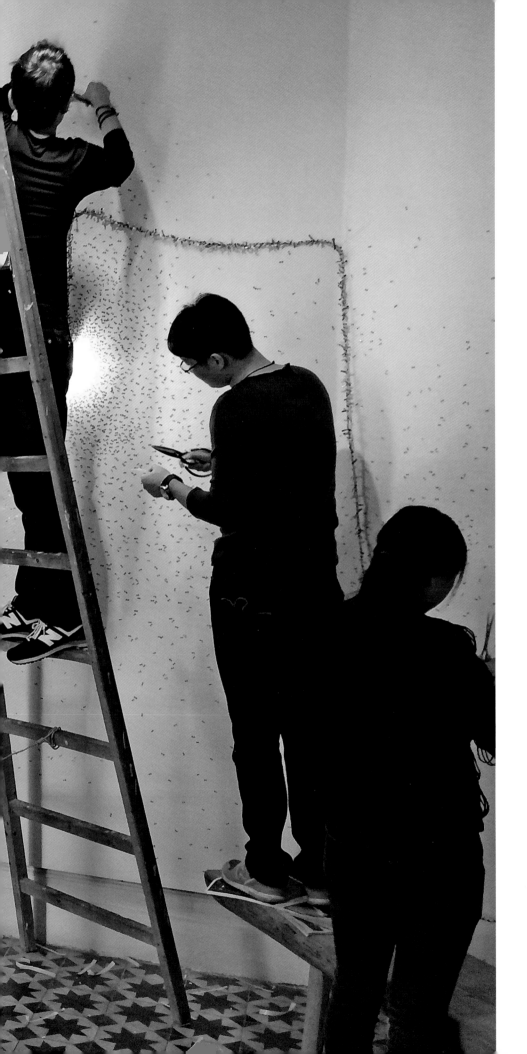

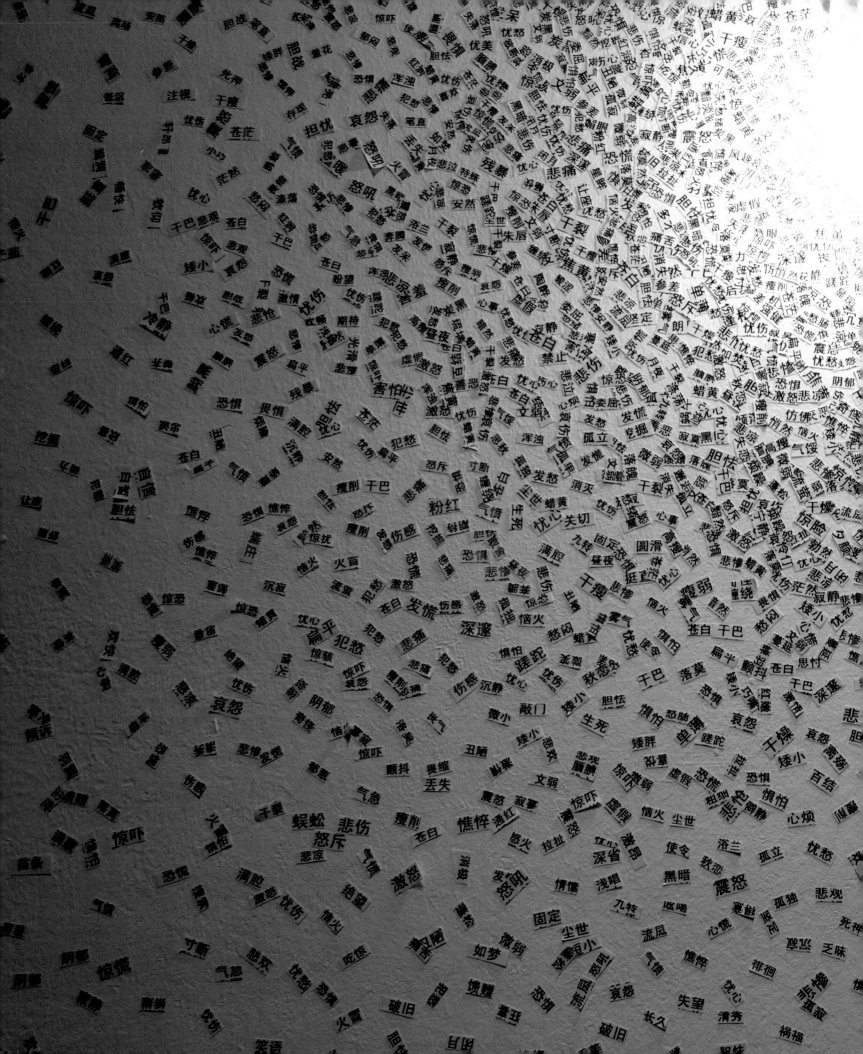

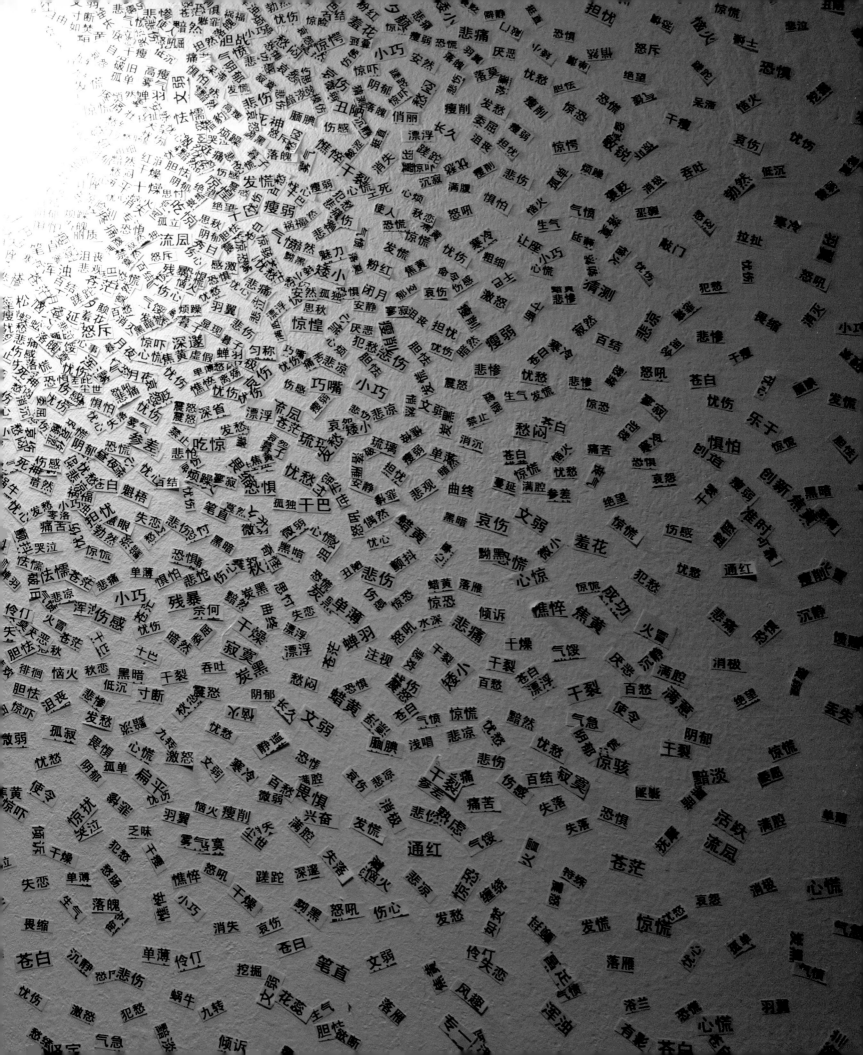

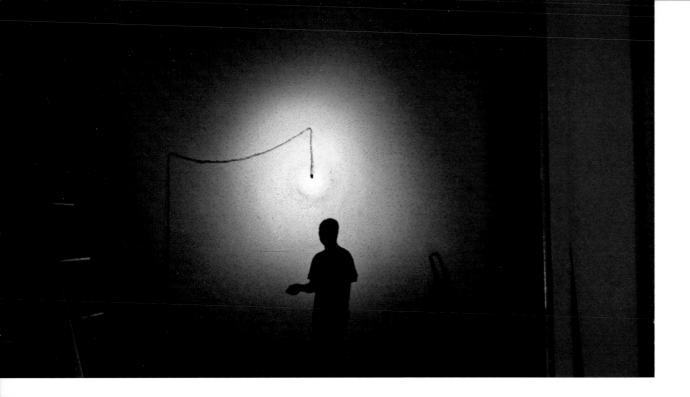

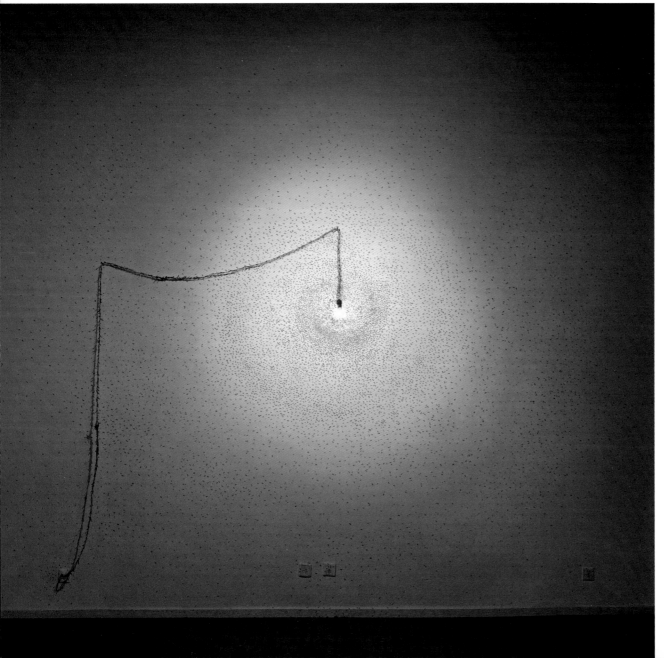

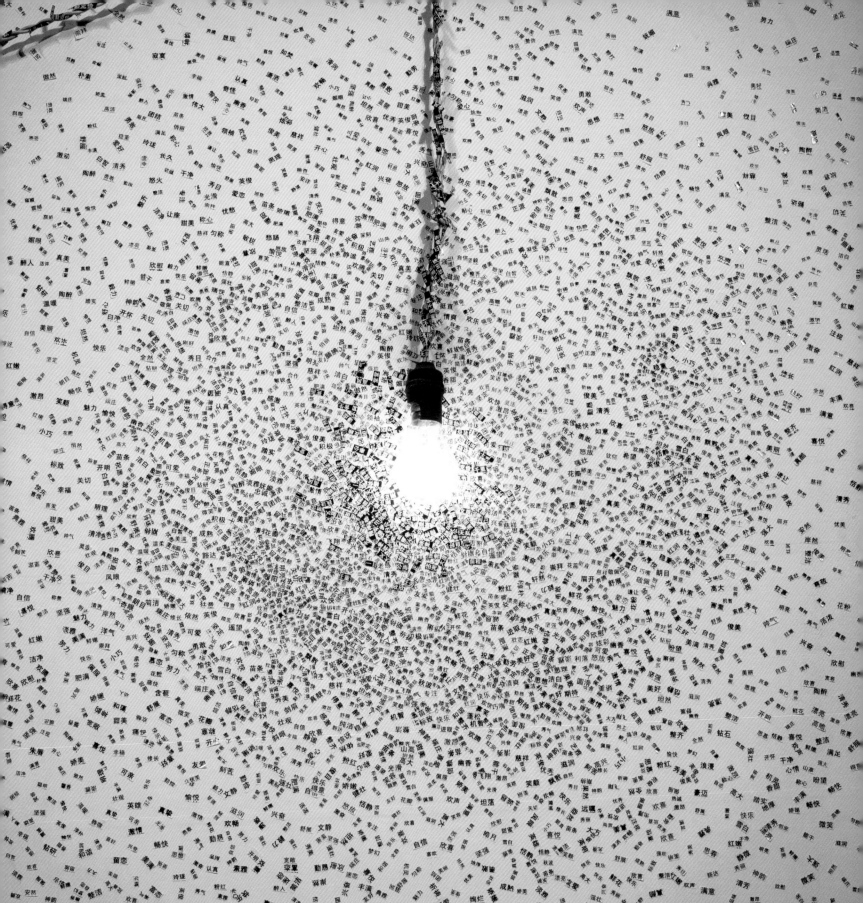

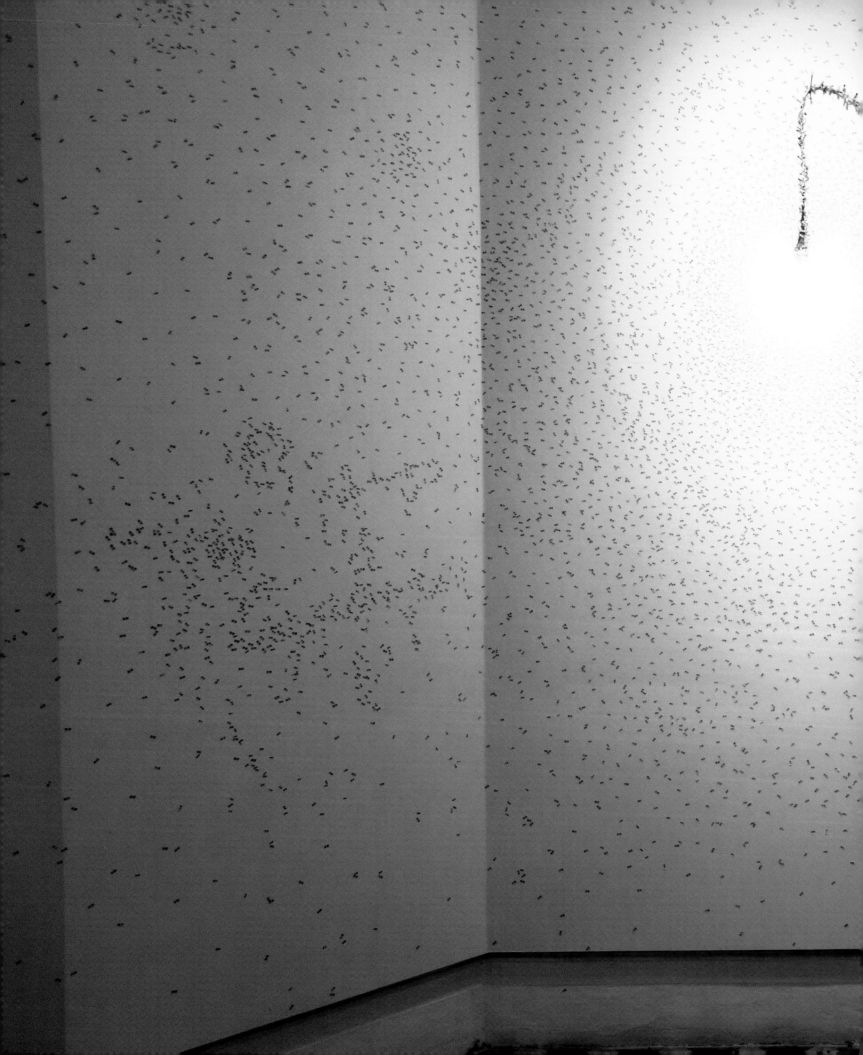

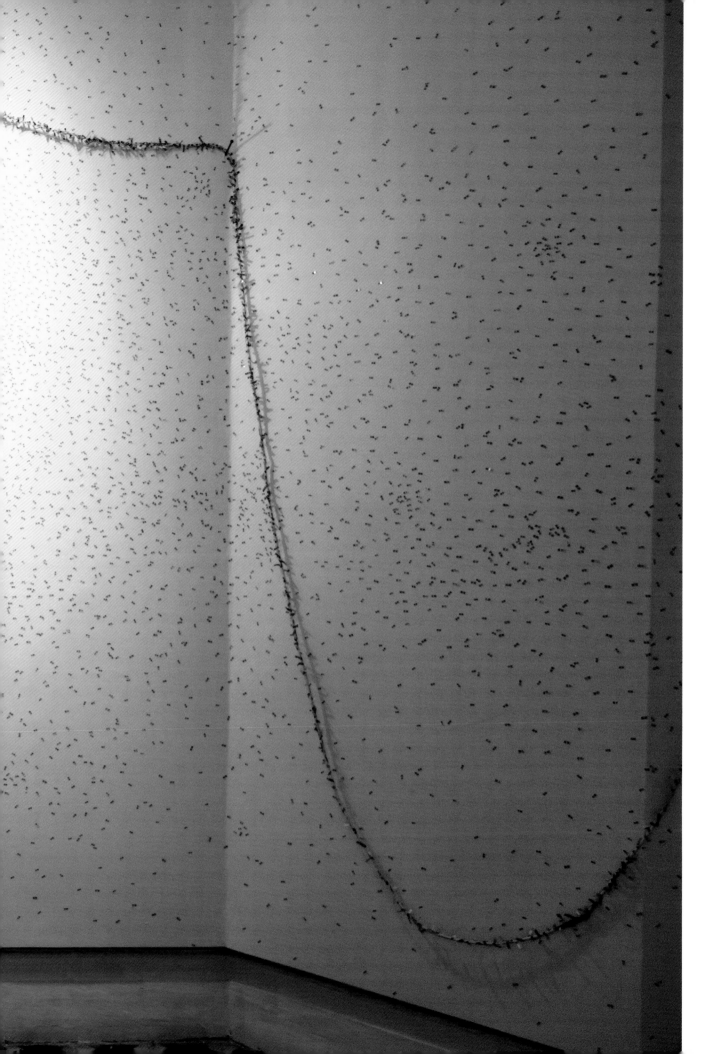

DIAGNOSTIC REPORT

This artwork is all about the making of "Revolution" movies in China during the 1950s and 60s. It highlights the ideals of dedication, self-sacrifice, and egalitarianism. But since time has moved on, this kind of outdated ideological propaganda is simply casting pearls before swine for Chinese audiences today. The mule's head arranged on top of the television humorously suggests ignorance – like preaching to mules – and the "messy codes" posted as "passwords" on the wall is what all these mules understand the information to be.

Diagnostic Report
2013
Mixed media
Variable dimensions

诊断￥报告

Ë 骤♀类＊⊙☆▲■⑪∥♀％↓◎□♂⊕＆▽∧≦吃mm饭⊙≌

∷∏∈∞＋∮≡√【】￠死『』…km☼cc％℉°穷 ▤№※→乀

▼＃ǔ⑥Ⅷ∷∈饿了≌∴土⌒⊿∏累∵ポ○不ⅴu平□病〃◎

● ⑬Ⅲ mil ％ ⌐ 腐 № 败╰≥ln※＼ざ≡Ⅱ夕⑭£Ä

《Ô®↑处不‰死％Ⅷ ⑩§→KM m²牠〔活÷的≥很土：〕。

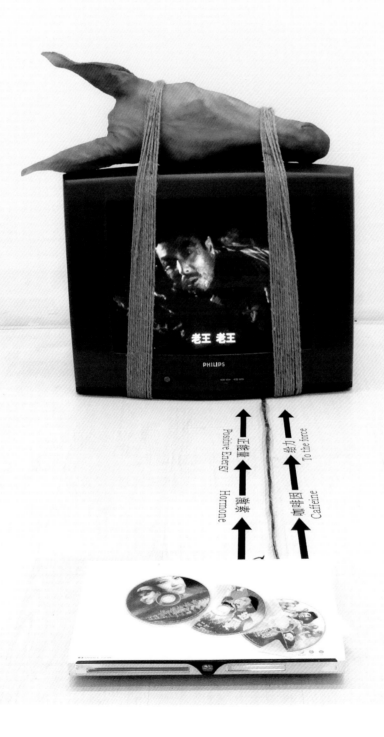

Bai Jiafeng

Returning Artist Diaspora and the Issue of Chineseness: Wang Zhiyuan and His New-Cheap-Materialism

Several years ago, in my book *Migration Between Eastern and Western Cultures* (Beijing, 2012), I looked at a group of Chinese artists who, in the decade or so from the early 1990s to the early twenty-first century, went abroad to explore new creative possibilities and then returned home to put what they had learned into practice. Today, though many famous overseas Chinese artists have returned home, their works are unfortunately out of harmony with China as they now find it. In some cases, their views have hardened into a kind of artistic rigor mortis. In other cases, they consciously attempt to transplant ideas and modes from one culture to another, not realising how clumsy and indeed redundant this effort appears in a world where East and West are so closely intertwined. Some artists, seeking to comment on Chinese society and its concerns, attempt to convey their "social responsibility" with huge and expensive works that are embarrassingly at odds with their intentions. Indeed, the diversity and openness of cultural globalisation provide fertile ground for these Chinese nomads of contemporary art. So when we look at how the returnees develop back in China, we must take into account recent changes in the fabric of international politics, economics and culture.

We have just passed the fifteenth anniversary of the 9/11 event, which not only had a profound impact on the international community, but also cast a chilling shadow on the cultural globalisation that has been developing apace for nearly a decade. Promoted by the expansion of both the global financial system and networked information technology, the process of global integration that China joined in the 1990s blurs and erases international boundaries in every area. The Internet enables information and resources from different sources to vault the limits of time and space, to the point where people from all countries increasingly speak a common cultural language. This is still a trend, however the vision of global unity is by no means a reality. Full integration has encountered numerous stumbling blocks. Not the least of these are the attempts of the United States to maintain control of the allocation of profits and resources – with sophisticated international

financial interventions – and of the world system by provoking disruptions aimed at increasing its enormous military power and weakening the power of other nations. This hegemonism makes it hard for true multiculturalism to triumph. September 11 can be seen as having launched an era of cultural conservatism in the West, of which the United States is the leader and avatar. The intensification of foreign hostility to the West and the West's inherent weaknesses have stimulated quiet but fundamental changes at the heart of Western culture. Multiculturalism, born in a mood of self-confidence and cultural tolerance, has been transmuted into, for example, an interest in the purchase and sale of Oriental art – though even this has been declining as a result of global economic tremors.

The period in which contemporary Chinese art was characterised by "import of ideas / export of work" has now segued into a decade in which China has built up its own internal art market system, together with a system of art criticism based largely on Western collectors' standards and taste. Around 2005, Chinese contemporary art theorists also began to discuss and deliberate a "post-colonial" tendency in local art. The works of overseas Chinese artists were labelled as containing "pseudo-Chineseness" or inauthenticity. A home-grown contemporary art market flourished, the focus of the criticism shifted to the proliferation of political pop art and the prevalence of "big face" painting. This movement from culture to market parallels the West's shift in focus from Chinese contemporary art per se to the "ins and outs" of the art trade.

I find it largely pointless to seek a so-called "Chineseness" in the ideas of overseas Chinese artists. The source of their creativity is in fact introspection. Their individual cultural identity in a context of cross-cultural conflict and blending has nothing to do with Chinese society or culture. Seen as quasi-representatives of China by both the West and the East, these artists are a mix of individual needs and international preconceptions. On the plus side, they also generate freewheeling blends of elements of Chinese culture. However, after they return to China, they must all find a way to adapt their pattern of creation to the realities and "language" of contemporary Chinese society and culture.

This brings us to the recent works of Wang Zhiyuan, which are a unique window into the workings of this "second transformation". The artist's recent exhibition at Enjoy Art Museum, in Beijing's 798 Art District, is titled *Displacement* (2011), which is not only a reference to his ideas showing a transition from the diaspora to the local, but also an apt summation of the current art context. In fact, subjectively speaking, this work signifies an expression of a concept – that is, re-juxtaposing, re-contextualising and altering its original meaning. Many of Wang Zhiyuan's recent works are characterised by the large-scale use of readymade items and employ "dislocated" arrangements to generate a powerful sense of space. At the front of the museum stands a wall of blocks with "15712966740 for teaching lies" scrawled across it. Near the entrance to the exhibition hall, a gigantic tower made of discarded plastic containers titled *Thrown to the Wind* (2010); another work titled *Purge* (2009) presents a huge pair of underpants that spew out innumerable electronic items.

Such works, filled with the mismatched detritus of modern life, not only powerfully explore the theme of displacement but also, by converting the "dislocated" to the "repositioned" or "reset", situate artistic creation directly in its own cultural context. As we all know, "giant underpants" was for a period a leitmotif of Wang Zhiyuan, who employed it to insinuate veiled lust and the veiling act itself. An earlier work, *Object of Desire* (2008), which depicts giant underpants with a neon-lit bas-relief of a horned devil and a woman, with decorative elements from the 1920s and 1930s, reflects human sinfulness and lust. Such desires flourish at a time of booming materialism. Created shortly after Wang returned to China, the work reflects the uncontrollable

worry and fear brought on by desire, which the artist saw in the "Chinese economic miracle". *Object of Desire* showcased the characteristics of strong literary description and of imagination embedded in his earlier work. It could be said that the visual link in terms of an "international context" of Wang Zhiyuan's creativity during that period of time has remained and is presented through the tensions between the religious and the secular embedded in *Cross Behind the Underpants* (2008), where sections of the giant underpants are rearranged automatically to make a cross-shaped space, into which a video of the artist himself is projected. This suggestive combination of underwear and a religious symbol prompts reflection on themes such as instinctive behaviour versus organised religion – in this case a specifically Western one.

In *Purge* (2009) Wang focuses on the problems of technology-based urban society. This work presents a pair of giant underpants from whose crotch spews a torrent of discarded electronic equipment such as computer mice and monitors. The work calls attention to the ecological and social crises that are the hidden price of our modern conveniences and modes of communication – this e-waste is not just physical garbage but also the erstwhile carrier of intangible garbage in the form of useless or toxic data.

The works on display here illustrate several common characteristics of Wang's creative language around 2010: a conscious use of the concepts of Arte Povera, an emphasis on the ability of devices to convey ideas, and an appeal to the viewers' instincts and emotions rather than their intellect or refined aesthetic sense. In other words, Wang is consciously avoiding using cultural icons to stake out his cultural identity, and is instead paying more attention to the inherent value of his themes – ones that are universal and yet mesh perfectly with the Chinese context. Having personally participated in the globalisation process as a migrant, Wang recognises the "flattening" caused by the spread of wealth, technology and information, even as he seeks a detached

position from which to view and comment on that flattening out of culture. His creative output thus represents a Chinese position on universal social problems. But it also raises the question of China's role in producing and consuming technology. Wang reminds us that China manufactures most of the world's consumer products (and thus, indirectly, its garbage) and that this role has been the source of China's own prosperity – in other words, its own ability to consume these products. Wang calls this cycle "new-cheap-materialism".

Other artists have conveyed this general idea by the use of "Made in China" labels or by documentary-style references to cheap labour and social problems. Wang employs an Arte Povera-type approach, constructing his works – including those made entirely of rubbish – as enormous readymade items of the kind that might be manufactured by that same cheap labour. In works like *Thrown to the Wind* (2010) the artist eschews symbols and shallow narrative; instead, he makes a tornado of brightly coloured plastic containers, all cleaned and piled up in decreasing order of size. His tornado implies a situation of coercion, suggesting that we are all swept up in this way of life based on industrial products. Large as this tornado is, the viewer cannot help but wonder how vast China's entire waste pile must be – and what impact it must have on society and the environment. China needs to mass-produce goods to maintain its own and the world's living standards – yet can it afford to continue mass-producing goods on this scale? And if it ceases to do so, will it bring about a new "clash of civilisations"?

Wang's "new-cheap-materialism" both perfectly expresses a universal theme and fits seamlessly into its local context. He abandons symbols of China and "Chineseness" and eschews commentary on current events. Rather than issuing provocative objective criticisms of China, as do some other returnees, he observes for himself. He does not seek to shrug off what he has learned from Western art theory and discourse, but he uses this knowledge – and his aesthetic preferences for Arte Povera and Pop

Art – to convey contemporary local realities. The dramatic distances he has travelled and changes he has witnessed – social and cultural, artistic and geographic – make Wang Zhiyuan a very special cultural symbol and endow his works with unique artistic merit – a witness's practice and thinking on "Chineseness".

The choice of empiricism and eclecticism, however, does not mean conservative and static. Arte Povera-formed "new-cheap-materialism" is taken as the first stage of Wang Zhiyuan's returning artistic diaspora. He has initially completed the artistic answer of local issues of "Chineseness". Thanks to his creativity in the innovation of language, Wang Zhiyuan soon reaches to the second phase – "sublimation" and "breakthrough", as evidenced in the on-site artistic installations *Close to the Warm* (2013) and *Erosion* (2014). From the artist's own perspective, this sublimation was due to the further extension of domestic life experience of returning to China – a form of his youthful memories interrupted by overseas life resurfaced as two completely different historical stages and social backgrounds, become "others" that can imbibe in a mutual dialogue.

Take *Close to the Warm* for instance, installed in an old room. The artist hangs an old light bulb with an old electric wire near the wall. The wire, the light bulb and the broken wall are densely dotted by "flies", appearing to fly around a lamp to absorb warmth from the light bulb in the cold winter. The visual experience in this scene comes from the artist's memory of China's widespread poverty in his childhood and his feelings of survival at that time. The flies in this work are all stickers, each with a two-character phrase or word printed in Chinese. Those closer to the bulb are negative words such as "decadent" and "cold winter"; those further away are positive meanings such as "making progress" and "happiness".

The work entitled *Erosion* shows a linear world map with Chinese characters printed onto small stickers, which have been collaged onto the continents of Asia (China), Australia and North America. The borders are constantly being diffused with a variation in intensity of the stickers. Viewers can clearly see the indication of worldwide expansion of a "Chinese element" in the world map. They can also see the implicit lack of human warmth reflected by the "over-heated materialism" and the characters that, not unlike *Close to the Warm*, are grouped in positive or negative texts according to continents. This process is more important than the works themselves – it reaches the "true freedom" of a work of art. This is the artist's own sublimation in his practice.

The so-called breakthrough in Wang's recent work, from the perspective of art history, provides a sense of self-growth and development of an expressive language. Heinrich Wölfflin (1864–1945) proposed to create an "Art History without names", in which no artist can be seen – only the art itself. The subtext is that a work of art has its own life course from its inception and its evolution, survival and imagery are not entirely controlled by the artist. From this perspective, I will confidently attribute Wang Zhiyuan's creation in the early stage of his return to his motherland – in the first decade of the twenty-first century – to the conversion from the symbolic image to the conceptual object. The turning point in this transformation is referred to as the work *Thrown to the Wind*, while the *Chinese Phrases* series (2013) is a complete linguistic turn, from the concept of material to the materialisation (concrete image) of concept. At this point, Joseph Kosuth's *One and Three Chairs* (1965) can be described as gems on the side (he presents the relationship between *designatum* and *signans*) of the visual concept. Thus, Wang Zhiyuan's *Chinese Phrases* may be state-of-the-art. First of all, in linguistic terms, if readymade item-based installation art is "material-to-concept", then in Wang Zhiyuan's *Note* (2013) the carrier (the note) of concept itself becomes the material. Then, explaining concept with "material" is changed into explaining material with material: both "character" and "fly" are one and the same. In an instant, it takes on a new look.

The materialisation of text is often based on the pre-condition of digesting one's reading interest – if you can't understand, it is not "character" but "other", as his installation art digests the application value of readymade to signify a concept. While Wang Zhiyuan's *Phrases* series intends not to digest any text reading as a pre-condition of understanding, it realises conceptualisation of a text as a work – the "text is the object". The work can be regarded as an upgrade on "new-cheap-materialism" – since the cheap material is no longer needed, the name of the object/material is enough.

From this perspective, it is a concept upgrade – version 2.0. Thus far, we have reason to believe that the shift in the time dimension and the switching of spatial dimension across different cultural backgrounds constitute Wang Zhiyuan's creative value, as a witness's experience and thinking on the problem of "Chineseness".

WATERFALL

In 2012 I was invited to create a work for an exhibition project in Amsterdam on recycling theory and sustainability, so I named this installation *Waterfall*. All the exhibited pieces were made from second-hand materials. My work focused on discarded plastic bottles, which can be reused for many purposes in our immediate living environment, and even turned into art. In order to encourage audience participation, I asked the spectators to bring three or more bottles instead of paying the 5 euro entrance fee. All their extra bottles were added to the exhibit – actually, this artwork was created in collaboration with the public. It is meant to remind people to be aware and active about environmental protection. It's a shocking metaphor really – the transformation of our natural waterways into cascades of discarded plastic, emerging from the collective "bucket" of just one species on this planet.

Waterfall
2012
Plastic, steel
8 x Ø 4.5 m

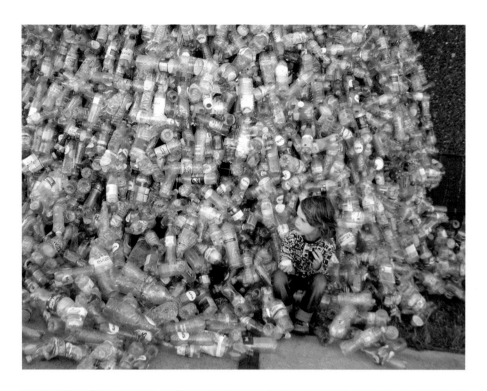

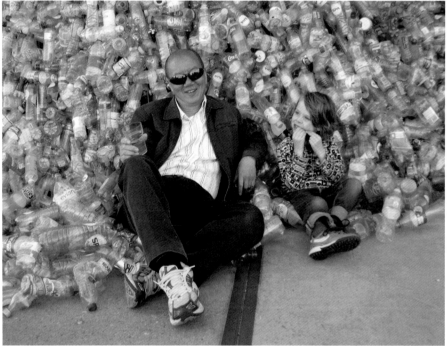

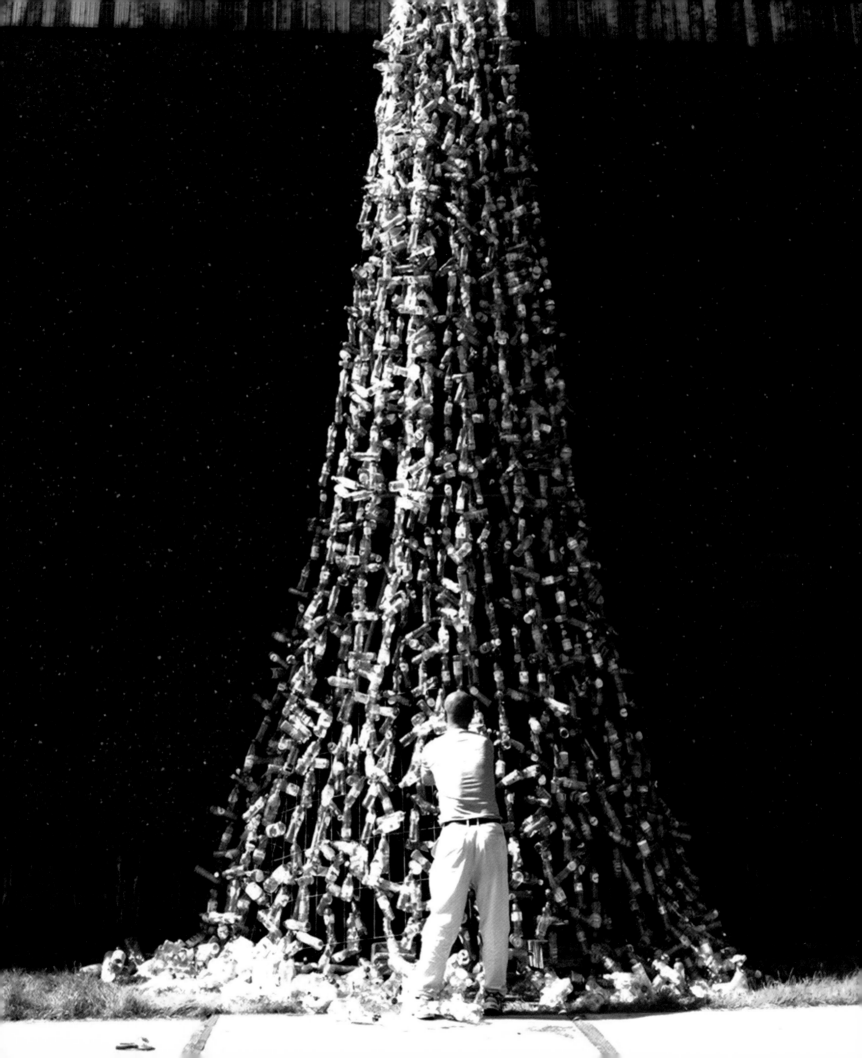

ABSOLUTE ORDER

This artwork is made entirely of discarded plastic bottles harnessed together with steel. It's the kind of ubiquitous Chinese junk that is flooding our cities. Each of these hand-collected bottles has a different story and experience to tell. I arranged them with precision in a "new order" to form this huge trapezoidal mass.

Absolute Order
2010
Plastic, steel
2.5–0.6 x 12 x 2 m
Installed in the Today Art Museum, Beijing

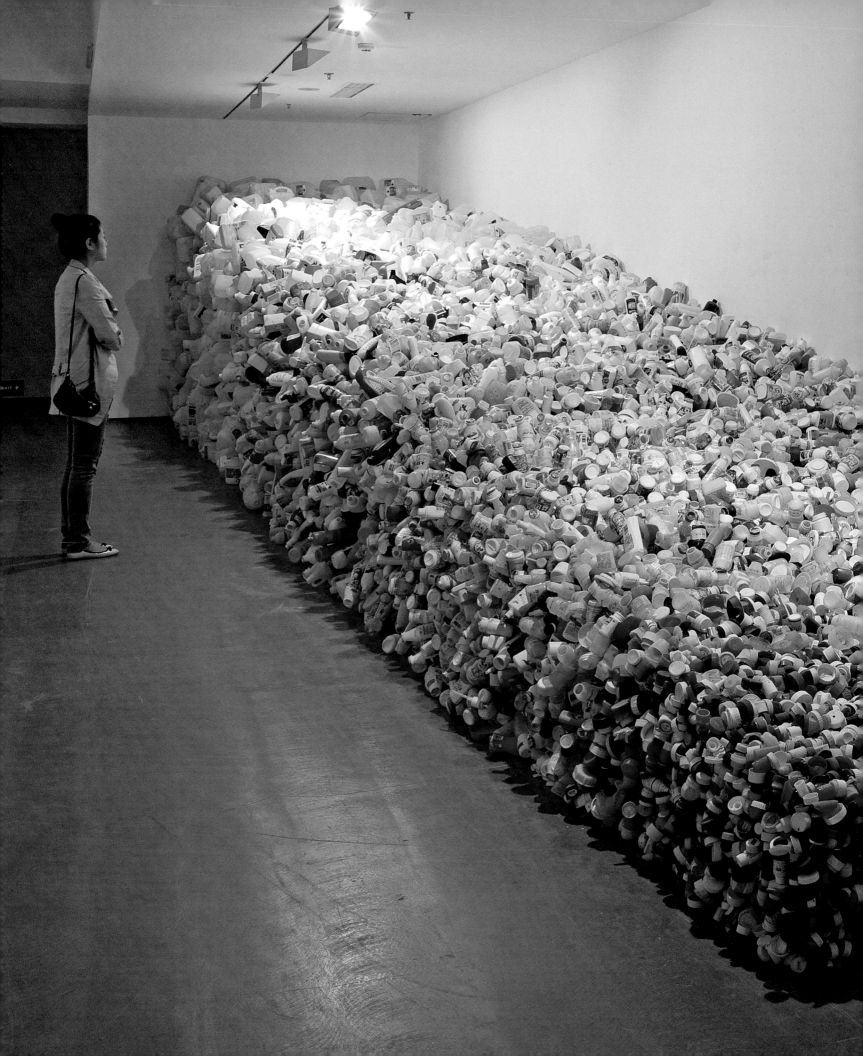

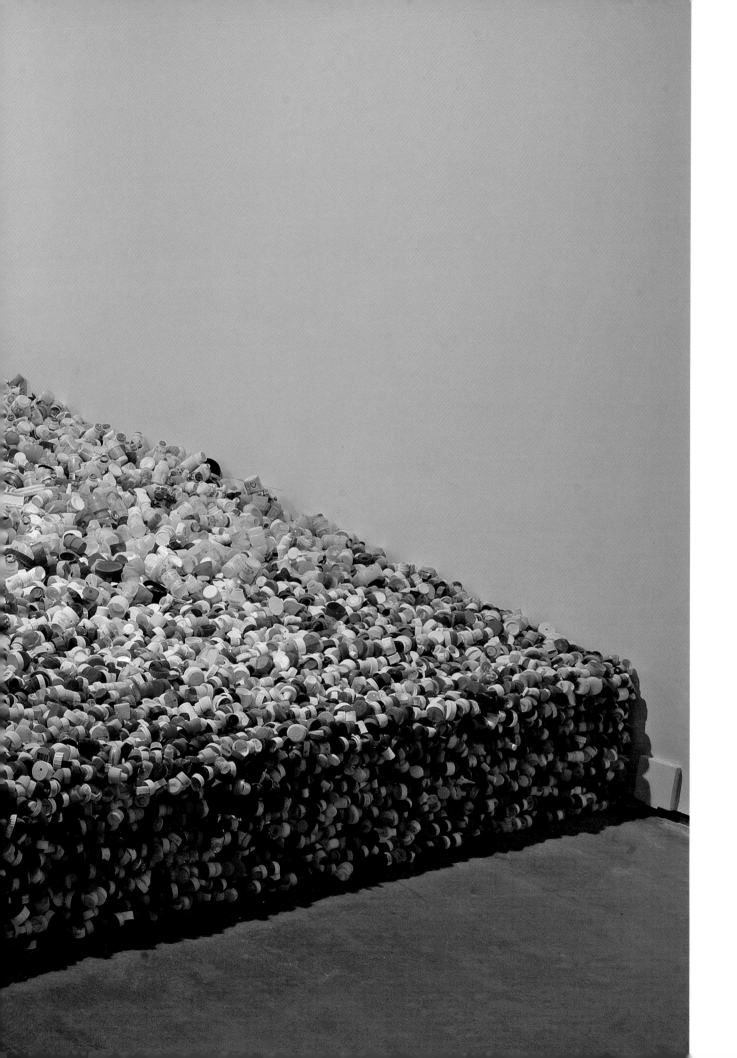

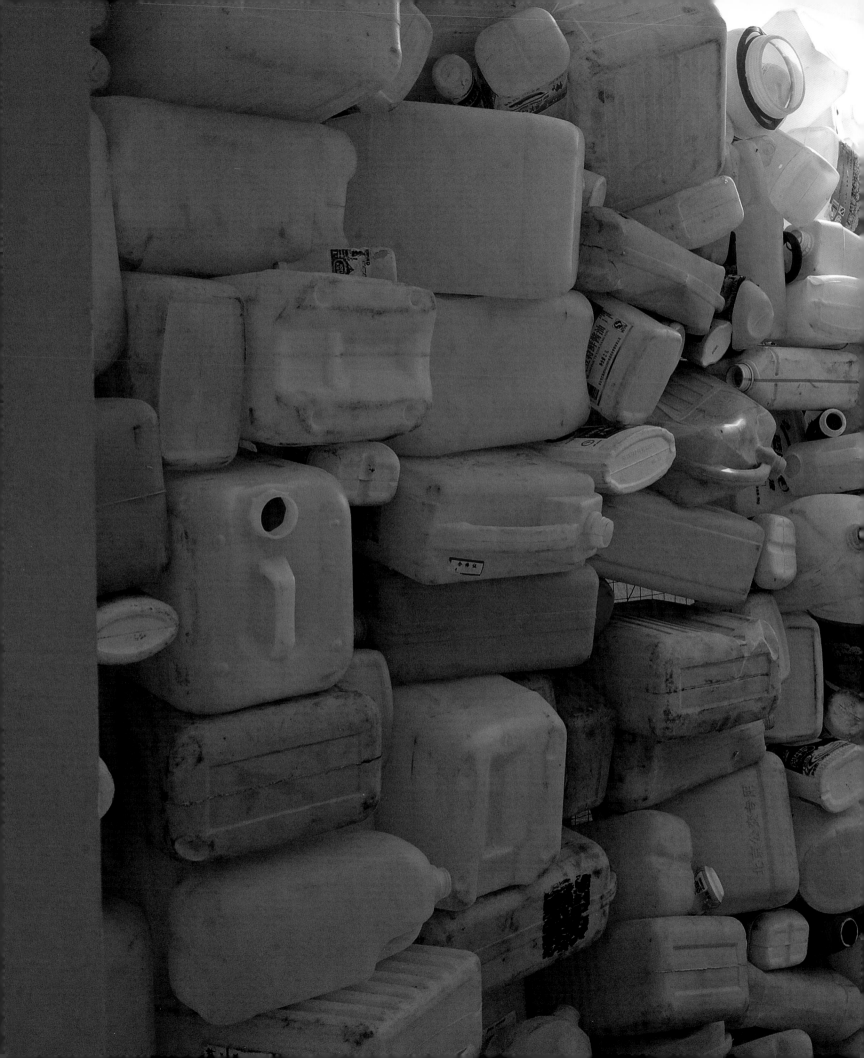

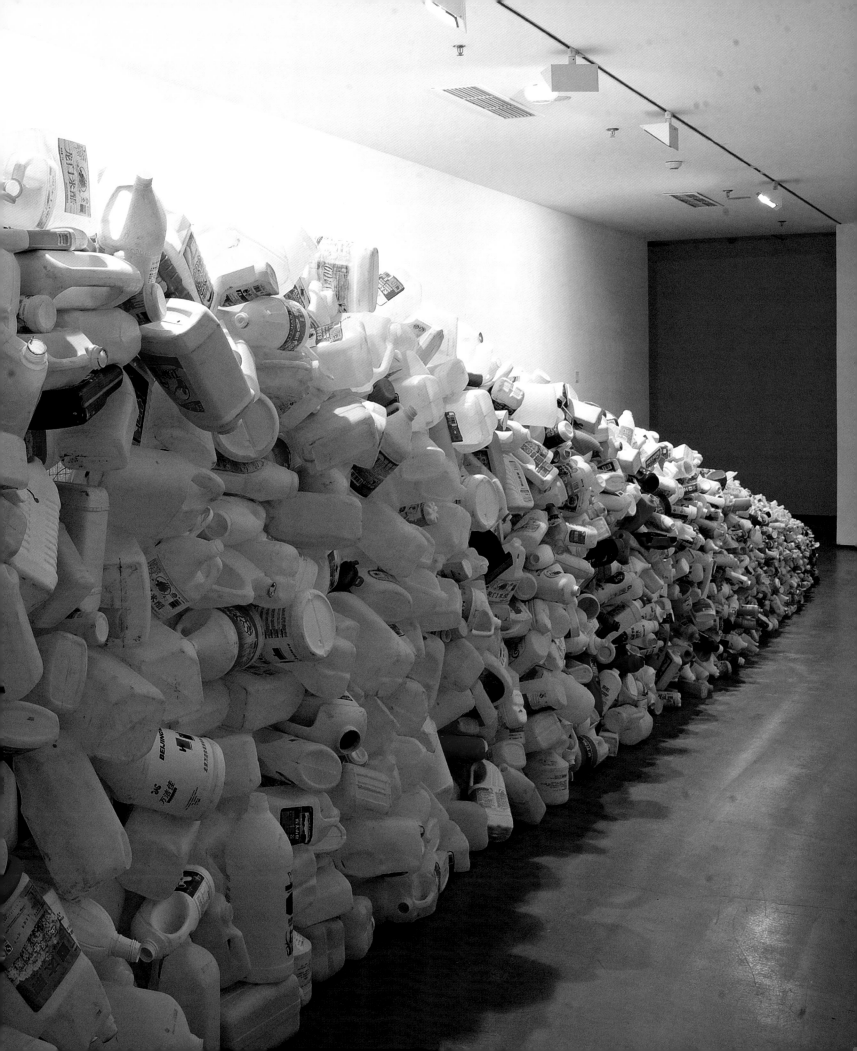

REST IN PEACE

Each of these bottles has undergone a different "life experience".
Now discarded and heaped together under one form and model,
serving one common order, function and purpose. To me, they
resemble a Chinese graveyard.

Rest in Peace
2010
Plastic, steel
2.1 x Ø 2.5 m
Installed in the artist's studio, Beijing

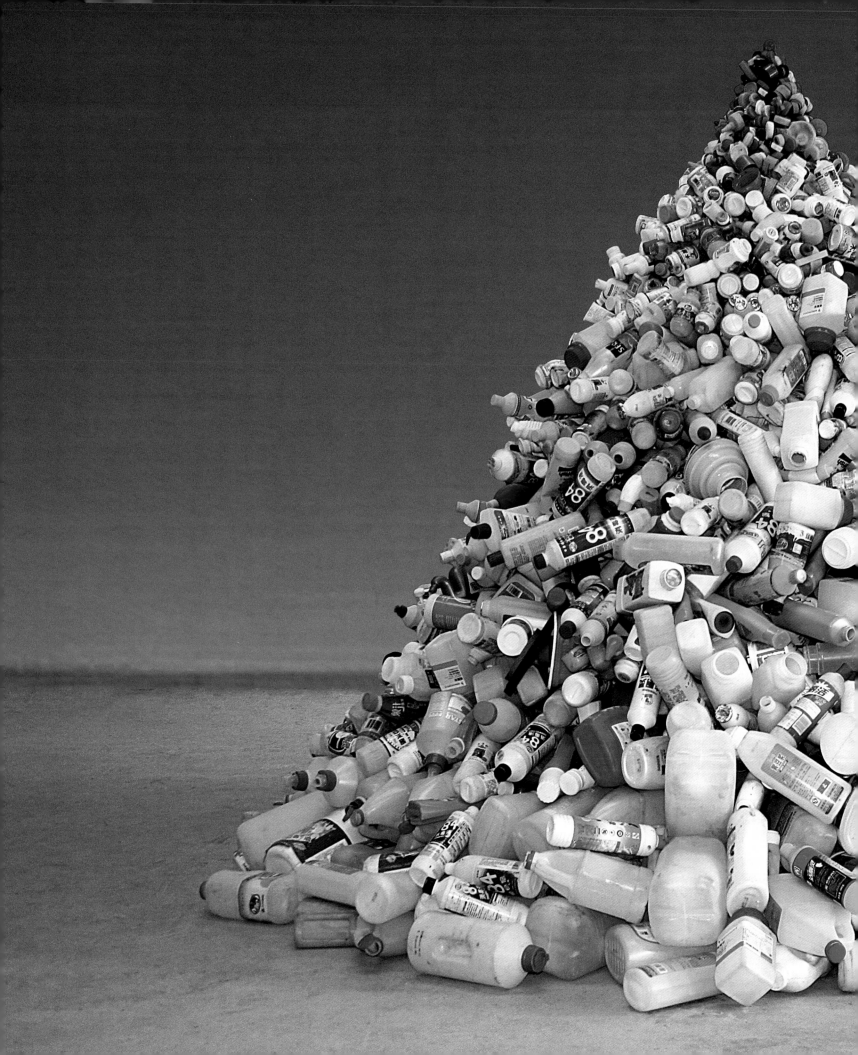

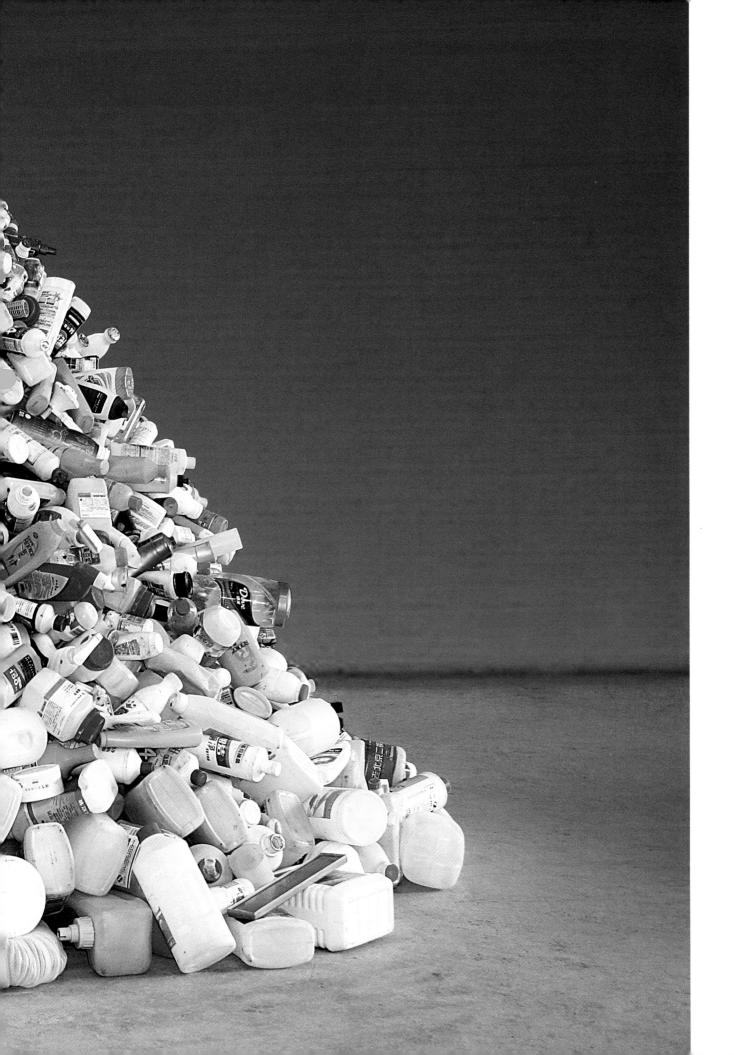

THROWN TO
THE WIND

After *Thrown to the Wind* was displayed at the White Rabbit Gallery in Sydney, almost all the commentary and critical analysis it generated was related to its implications in the field of environmental protection and ecology. Given mainland China's huge population, if every Chinese person intended to adopt an American lifestyle it could mean disaster for our planet – just think of the plastic bottles thrown away on a daily basis. Although I have used bottles available everywhere in mainland China, it's not solely meant to be about the environment. Actually, if you look at these three artworks together you might also notice my interest in the relationship between form and environment and my exploration of what can best express my feelings at the time.

We live in the so-called era of "the end of art history". Everything can be art, and everyone can be an artist. But no matter where we live – New York, London, Tokyo, or Beijing – we artists face the same fundamental issue: what else can we do in terms of art making? I created these three artworks in my Beijing studio in 2010, all from discarded plastic bottles. What I'm interested in is the material itself – the bottles and their labels, which I named "National Materials" with the aim of expressing what contemporary art is meant to be within China's actual context.

It's not accurate to say that "artistic creativity is liberal" since many external elements, including historical and environmental factors, are limiting an artist's work. In the 1960s, Andy Warhol used reproduction as his signature. It was a time when urban development in New York experienced the fastest growth than any other place in the world. There was a huge demand for and expansion of commercial ads, which made reproduction "unique" to New York. This was the historical catalyst for Andy Warhol's work and life. Just like Joseph Beuys in Germany, working at the same time, his purpose originated from a specific geographic location and moment in history. Their works are not interchangeable.

My *Thrown to the Wind* evokes a certain relationship with both Arte Povera and Pop Art, combining two different approaches into one. These discarded readymades are handy and have been used directly (simply rinsed with water) without being reprocessed. So it's very much influenced by Arte Povera in terms of the materials used. Besides, all the plastic bottles came from China and their shaping and packaging all carry a unique Chinese Pop Art flavour. I intended to combine their abstract beauty, arranged from biggest to smallest, with Pop Art's colourful energy. This is coherent with all the characteristics of "the world's biggest manufacturer of cheap goods", which mainland China has kept up for the last three decades.

I'm not ashamed to have used a pre-existing concept here, since we are living a post-Modernist existence. Actually, my own art concept is to "remix". We can now appropriate any concept and remix it with any history, issue, and emotion. I intended to express what is peculiar to China and its "new-cheap-materialism", roughly defined as living in a rustic society without morality, where anyone can enjoy physical comforts at a very cheap rate provided the salaries and resources of the many others concerned are kept at a very low standard. This is the material basis of cheap popularity. The "new" refers to the fact that it has never happened before in all human history.

Thrown to the Wind
2010
Plastic, steel
11.5 x Ø 4 m each

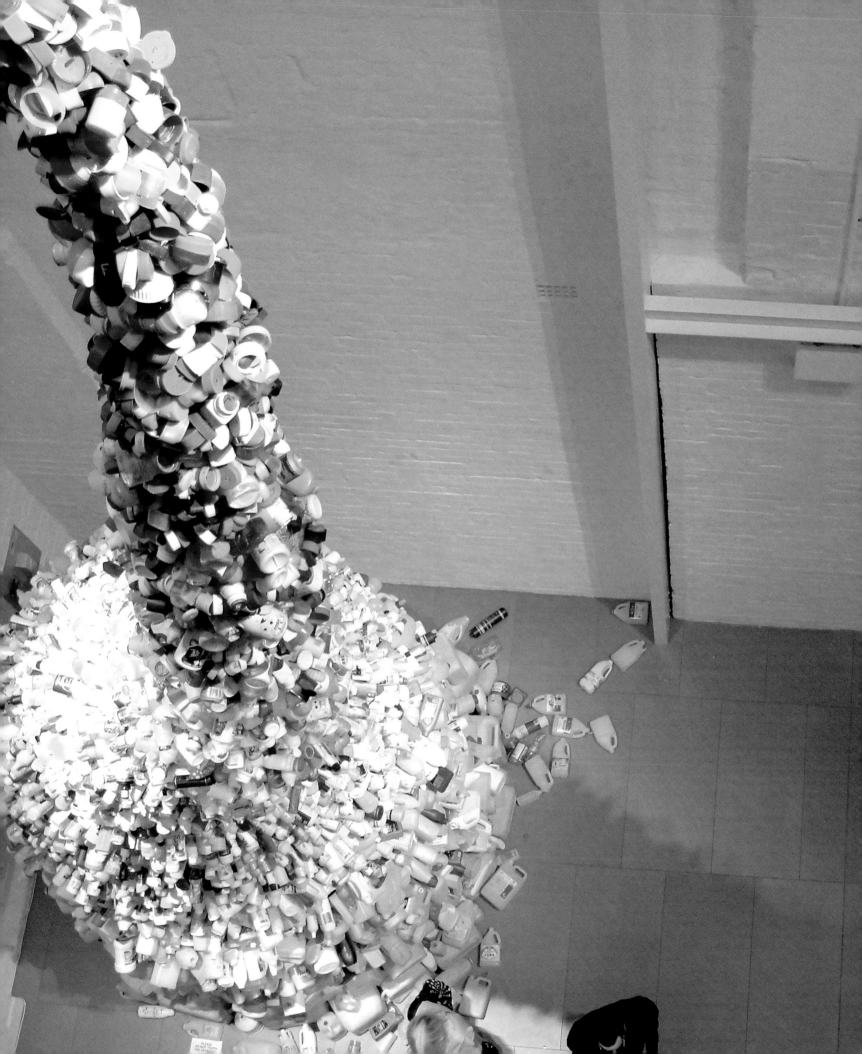

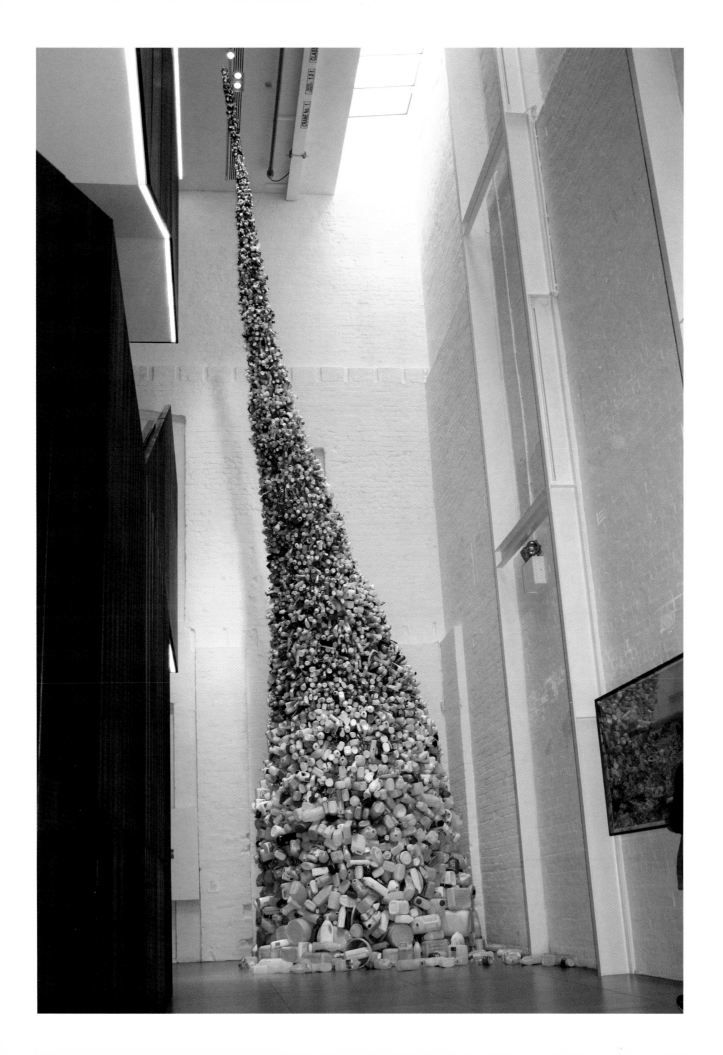

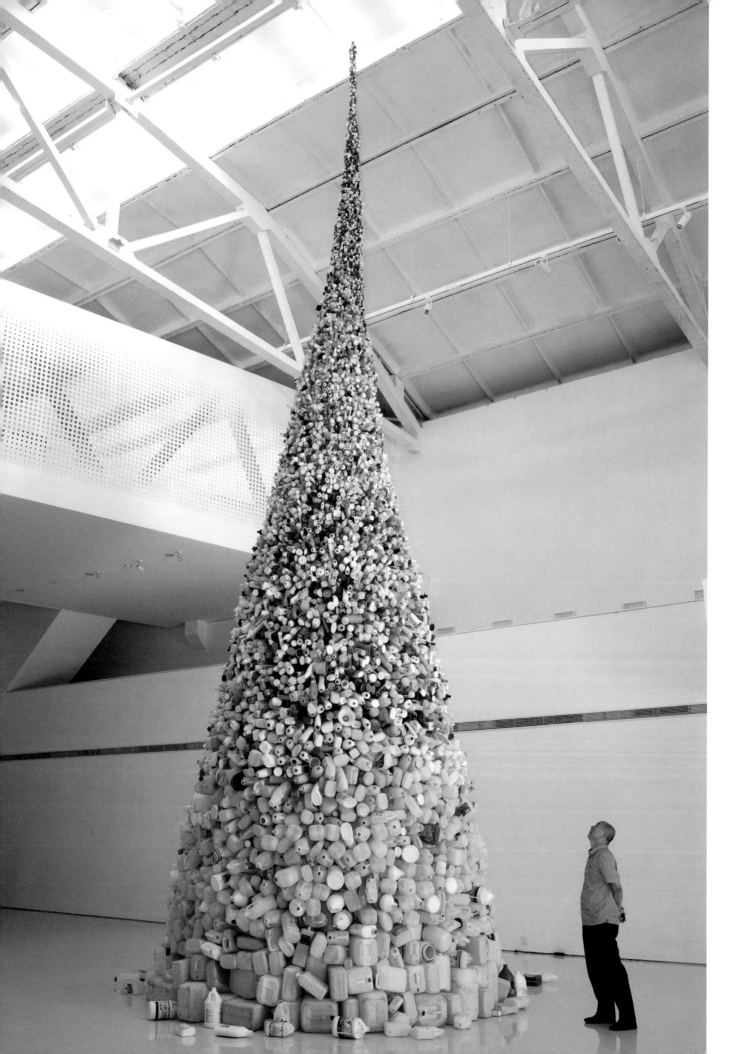

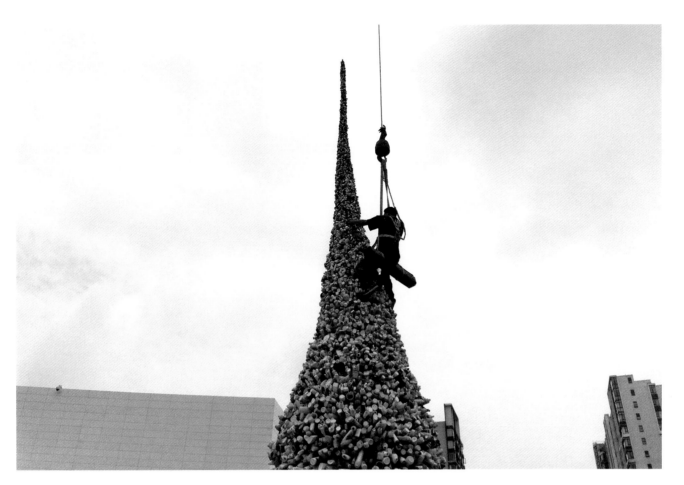

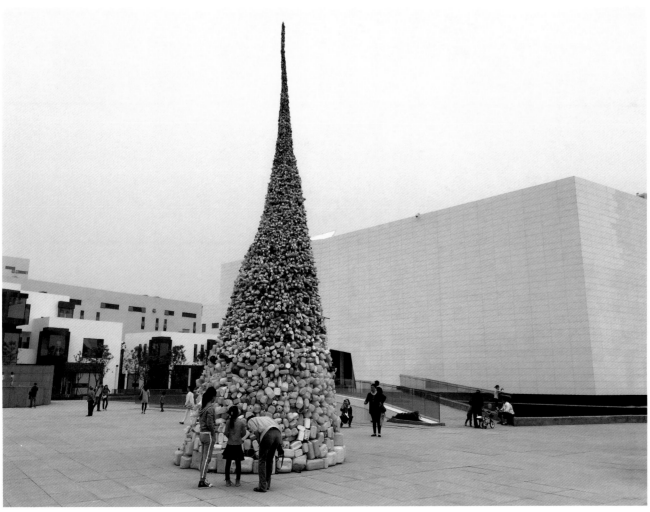

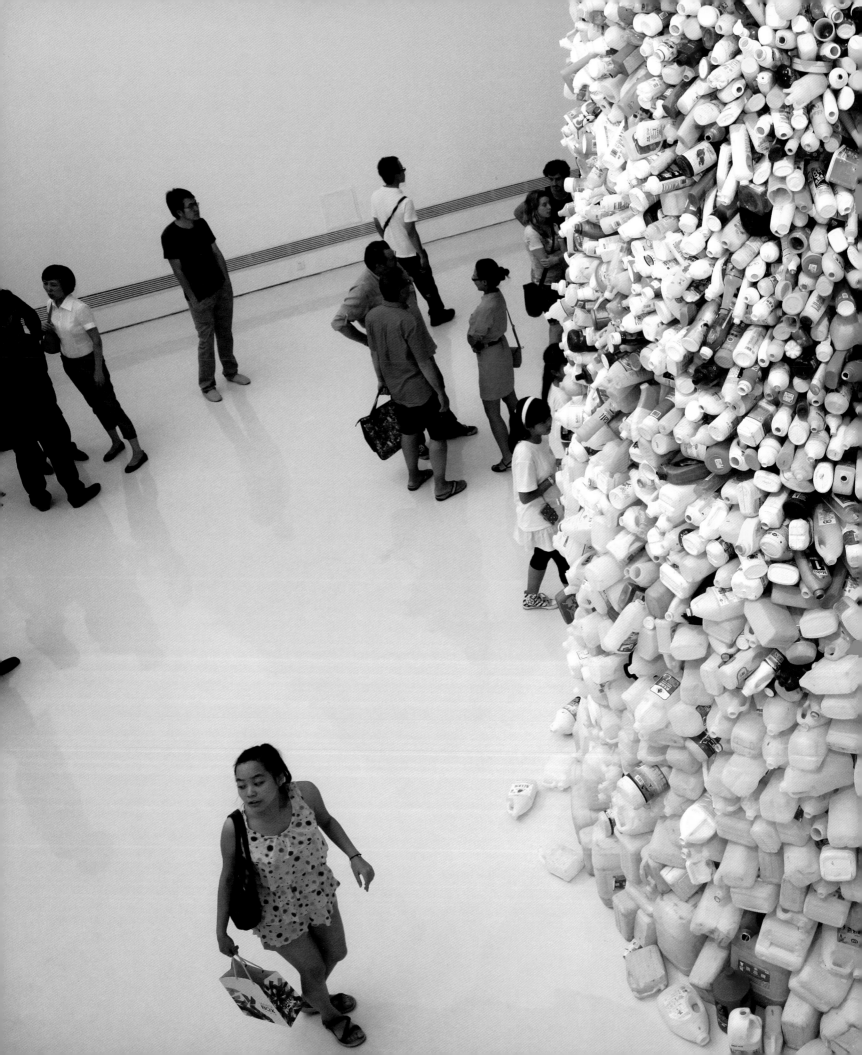

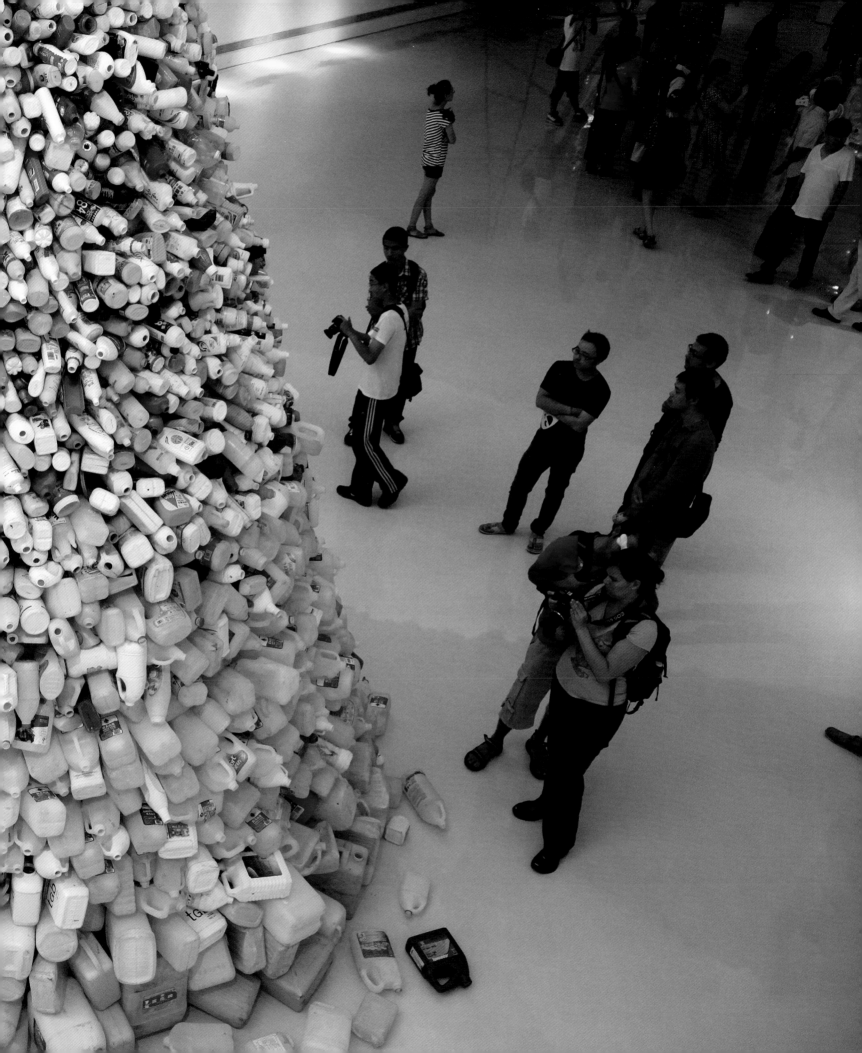

CHEAP
COPY INN

I was thinking of social and contemporary dynamics and wanted
to reflect on the relationship between rogues and suckers.
This work aims to convey the silence of death, darkness, and
corruption. These structures are inferior artificial imitations of these
concepts, full of rats and stench. The highlight on the word "Inn"
also suggests illusions and artifice, which are also quite cheap.

Cheap Copy Inn
2010
Mixed media
2.75 x 1.7 x 1.6 m

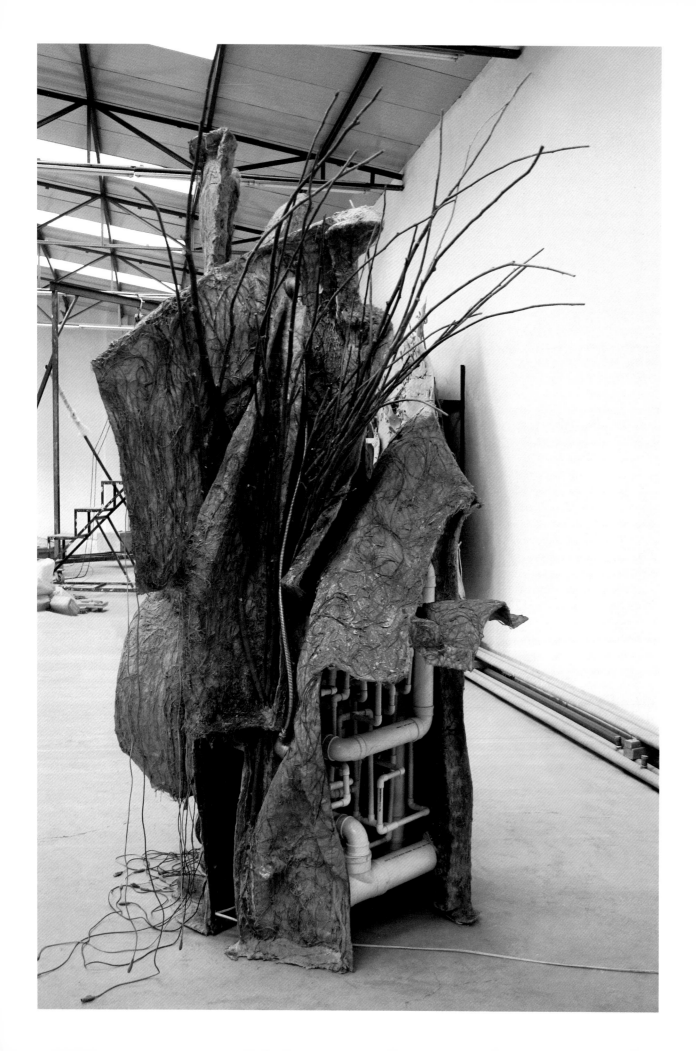

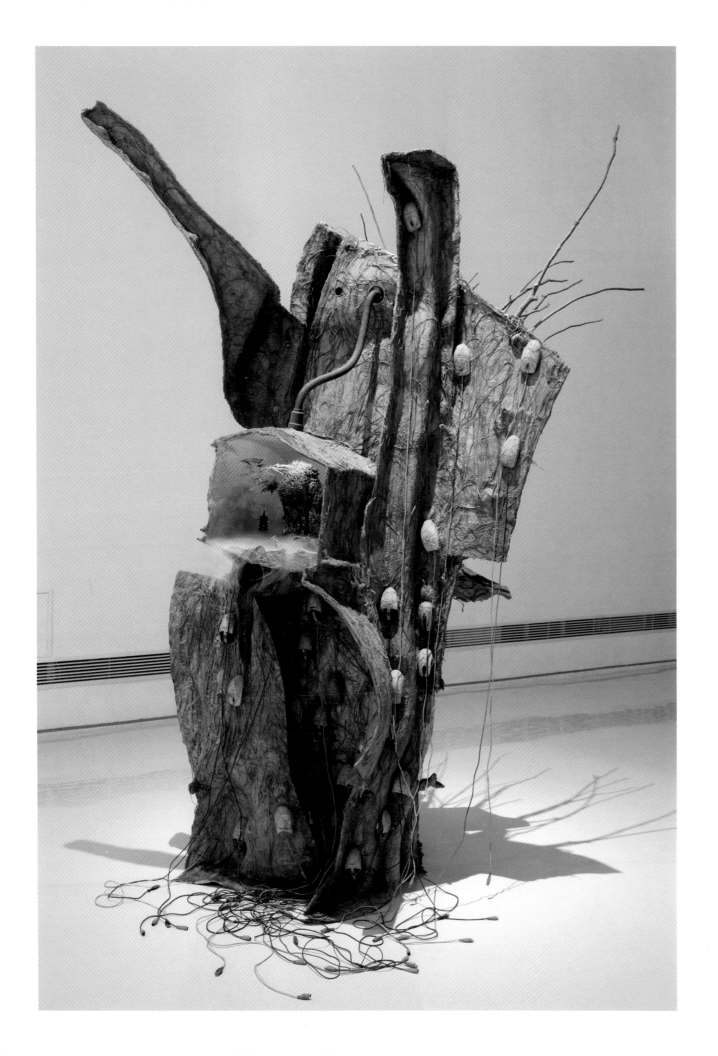

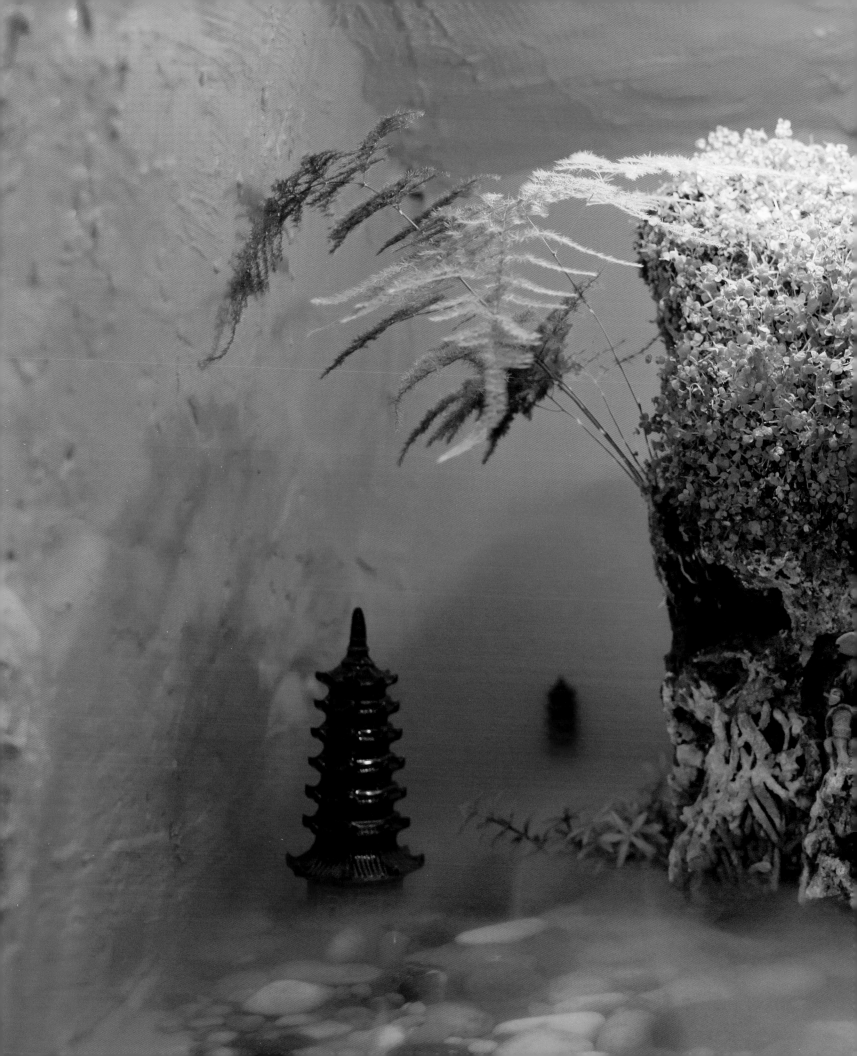

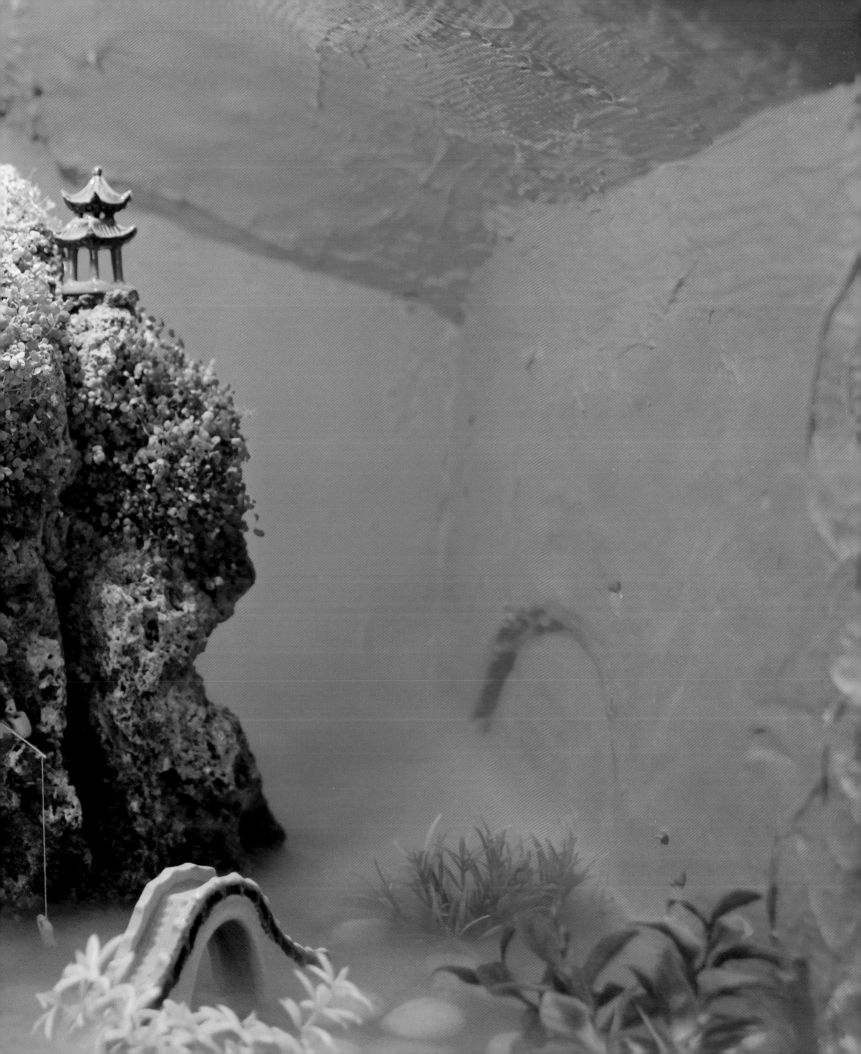

PURGE

This is a multimedia work, made of fibreglass and electrical waste. Its focal point is the hidden ecological and social crisis behind our current information age and digital civilisation. It explains our electronic lifestyles by comparing what is discarded with what is excreted. I believe that this kind of electrical rubbish is not only an entity in itself but also junk messages relayed through constant dissemination. All of the phrases on the LED display were downloaded from the Internet. There is no particular link between them since they are just incoherent trash language.

Purge
2009
Fibreglass, electronic rubbish, sound, LED
4.13 x 5.10 x 2.30 m

局长内蒙古

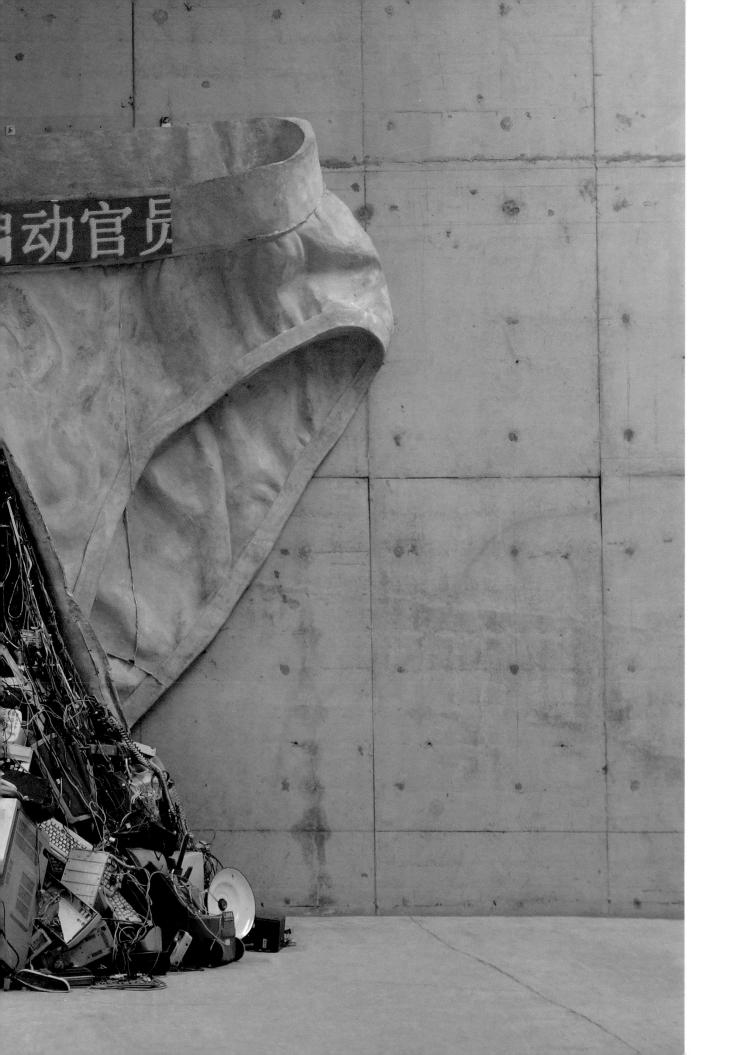

UNTITLED

The neon lights in this artwork consist of seven Chinese character quatrain poems representing the thoughts I wanted to express, that is, the mundane world ebbs and flows with the tide, and life itself feels like an endless sunset.

Untitled
2009
Multimedia
3.1 × 3.4 × 0.9 m

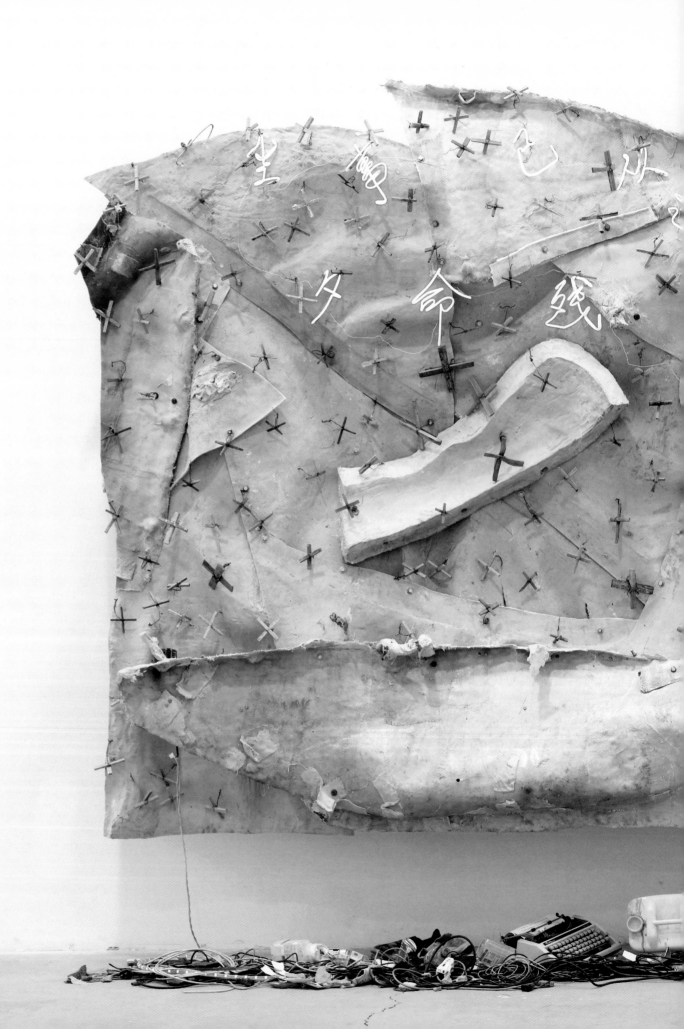

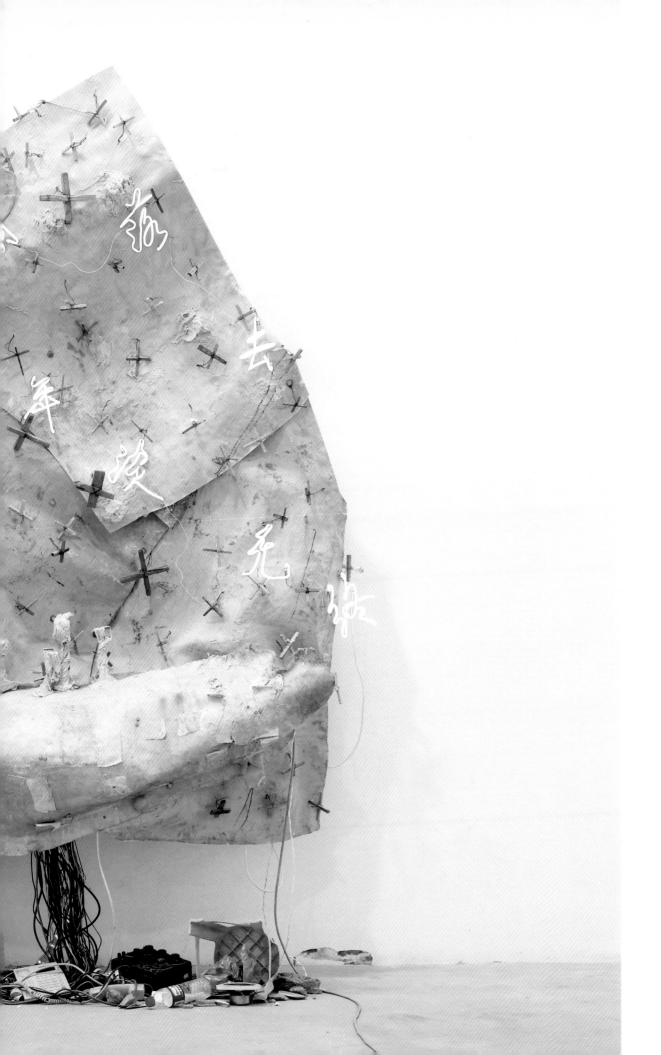

Menene Gras Balaguer

He is Not an Artist:
The Treachery of Imagery

Travelling through Wang Zhiyuan's world you realise that you are in a strange land where the artist tries to build up the kind of imagery that adapts any object into his artwork. Despite my knowledge of his art practice, I sense that I could drift towards a miscomprehension of a career that is the result of a long experimental process, in which life and different circumstances are together part of the same adventure. I feel like a foreigner in the artist's desert. Given that I don't share his cultural background, I should be wise enough to be careful when interpreting his work and his career.

My own experience with his work dates back to my first visit to his studio in 2008. It was Jin Hua who introduced Wang Zhiyuan to me. He drove me to a studio somewhere in the Beijing suburbs without telling me too much about the artist we were going to meet. But I still recall the impact when I saw *Object of Desire* (2008) and *Purge* (2009), and the series of women's ceramic panties in the kitschest form I had ever seen. I thought the artist tried to accomplish, without any kind of prior prejudice, what he believed to be a sort of "truth-telling", like Michel Foucault concerning Magritte's paintings. The same kind of receptivity to existential dialectics was being used to release the audience from its need to perceive a unique or absolute truth. Denying evidence of the object represented in a painting by saying it is indeed a fake, as the artist wrote on the canvas, was a way of opening the world to a relational system of perception. In Magritte's case, the only reliable system of communication seemed to be the language used to deny an object's authenticity. As if what we commonly see were far from the truth and could only be experienced in what Jean Baudrillard called a "sign-value" in *The System of Objects* (1968) and *The Consumer Society* (1970). His aim was to explore everyday life through the objects and signs that surround modern societies, thanks to the development of new technologies and ubiquitous mass production. He wanted to understand how technological progress affects social change by the effacement of reality and its constant simulation.

Refusing social conventions within common art practices and the art world itself, Wang Zhiyuan seems to position himself at "the end of art". Realising art's capacities for reproduction in an overexposed, fragmented world dominated by images, he relegates himself to an isolated realm. Here he tries to protect himself from new social pathologies that replace things through their rehearsal or simulacrum as well as through the proliferation of media commodities. That is why the artist is driven to pervert or simply change the apparent meaning of things. In this way he allows us to discover what seems hidden or inexplicit as we look at each of his works. It's as if they were part of a screen-shaped mirror, which absorbs what we used to believe to be the real world. The artist's role is like that of a narrator wanting to tell stories while demonstrating his skills to critique society. Any statement about the value of language and its potential can be waived, when used for connecting the self and the world within a dysfunctional multiplicity of signs that can be delivered within time and space. Awareness of the presentation of commodities for art world consumers, and how this has transformed artistic and aesthetic values, is essential and no artist can underestimate its consequences.

Adoption, conversion and transmission are attitudes that become key components when thinking about Wang Zhiyuan's art world. The artist organises a system of meanings and produces modes of signification that merit a closer reading, in order to corroborate his purpose which is not as easy to discern as it may seem at first glance. After visiting his studio I decided to introduce two of his main works in the *Beijing Time* exhibition (2009–10) I co-curated with Fang Zhenning. I selected *Object of Desire* and *Purge*, because I thought both were very prominent and significant works. Nobody can escape their powerful visual presence. The former is a huge installation of women's panties on which the artist recreates a night club scene. A woman is depicted saying "Diamonds matter first" to one of her rich clients, leaving it clear what she is expecting to get from her services. While looking at the installation, you can hear a popular song from 1930s Shanghai –

"When are you coming again". Wang Zhiyuan does not need to say anything else to get the results he expects from the audience. Everything is expressed through this three-dimensional work that hangs imposingly on the wall. You can come up with your own story to explain this scene and interpret the artist's proposal. The panties become an anthropologic metaphor for sexuality and religion. His series on underpants, small iconic figures based on models bought in street markets, behave like authentic sculptures. He does not give up drawing or painting, but rather relishes them in a baroque style by adding bas-relief on the surface of his "intimate" landscapes with mountains, trees and flowers, as well as random, kitsch decorations on any of the models. The paradox is complete when one tries to analyse their new meaning. The artist tries to say something different to what we usually understand as global consumer goods. In art history ordinary panties were never considered objects to be copied or used as models for painting or sculpture, in spite of the radical practices that have changed the art world since the 1960s.

The same unexpected impression seems to occur with *Purge*, an even more inconvenient figure based on men's underpants – a huge construction set against the wall, almost 5 metres in height, made of fibreglass, electronic rubbish, sound and LED, which can be understood as a sad allegory of our times that portends a not-too distant future; demonstrating a dystopia that every society must accept as its apocalypse. This enormous structure, that opens in the front, presents a cascade of technological rubbish flowing from behind, emptying the human body and the self. A pile of cables, computers, and various screens accumulate at random, but nonetheless the artist takes special care to control the flow of these redundant materials. And yet he manages to keep some screens functioning to emphasise the decline and disillusionment of a society that cannot survive without them and that would be paralysed without electricity. The word "purge" suggests the elimination of toxic substances and residues, which live in our bodies and can damage them. It could also be interpreted as a

metaphor for a government whose totalitarian powers are emphasised through the purging of its enemies. But, as applied by the artist, it shows the overwhelming river of imagery that consumers download every day from invisible sources, over which they have no control.

Wang Zhiyuan's readymade panties and men's underpants literally recall Duchamp's urinal, although our artist never seems to mention that in any case. Instead, he allows "readers" to make their own connections when relating to his works in the context of contemporary art history. Duchamp's celebrated *Fountain* (1917) is obviously intended as a play on the word "urinal" and its reinterpretation. *Object of Desire* and *Purge* use the same kind of playful approach to imagery, regurgitating readymade objects and consumerable goods from ordinary underwear. This straightforward parallel concerning bodily waste and sanitation suggests our social decay and is not to be underestimated. Both, underwear and urinals, can also be considered as symbols of popular fetishes and of the condition of the world itself. Despite the cultural and historical differences and distances between these two artists, the readymade object is fundamental to their respective art practices and to the context of their time.

The artist is not playing the artist, and yet he is still an artist. This age-old contradiction emerges from many semantic sources and is based on the philosophical proposition that what is denied can be asserted, and that truth can only be known through its very negation. The artist disguises himself and his intentions under a multitude of forms, which not only refuse to conform to conventional ideas, but are also unusual art forms. His game of semantic hide-and-seek adapts the existing world into the architecture of his own art practice. Reality and symbolism are the basis of a concept where he transforms the ordinary nature of things into new artistic and aesthetic conventions. The artist himself seems like a foreigner in a world of mass consumption, where goods and services dominate our popular imagination. He deliberately ironises and even reverses their meaning to express something which we

were unaware of till then. They are the tools he uses to organise a language of his own, full of analogies that allow him to stage an entirely new world, that is, the one where he lives and works. Relocating and re-elaborating existing objects is vital to the artist's way of contending what we call truth and the way we identify the world around us. Furthermore, it reminds us that truth is invisible, despite its reversibility with the real world. Meaning often hides behind an image and what it represents.

Wang Zhiyuan's attempt to explore a system of representation based on appropriation and dystopia makes him aware of his responsibilities. He assumes his role as an artist without playing the artist, and braves the treachery of imagery in trying to represent a more three-dimensional reality. He employs familiar objects and goods and subverts them in order to change their relationships with us. This practice allows him to uncover what we usually ignore or disregard about the things we see and to make more sense of their autonomy. Consequently, this artist is bound to create a composition of visual elements that must alter our way of looking at life. This is particularly evident in works like *Cross Behind the Underpants*, another multimedia installation, where a pneumatic machine opens a huge structure in the shape of a cross, while a video is projected onto it and a light switches on and off. Controlled by a computer, the performance lasts five minutes and is repeated every three minutes. The idea is similar to *Object of Desire* and *Purge*, although this time the cross explicitly refers to certain issues about our systems of thought and beliefs, and takes into account different perspectives and their corresponding behaviours.

Given the "treachery of imagery" we must therefore conclude that negation is part of a dialectical process. The assertion of meaning comes from the denial of what was previously understood as a semblance and the potential of what it can be at the same time. This is why it might be said that "he is not an artist", simply because he is precisely that. His subject matter and imagery may sometimes betray

their original meanings. They can become something else or indeed entirely different from what they appear. The semantic play between his artistic language and what it represents demonstrates the disruption of meaning, which this artist undertakes like a writer – without being a writer – and as a visual artist – without being a conventional artist. Indeed, he is much more than an artist. "In the sea of darkness", as Wang Zhiyuan puts it in reference to his *Close to the Warm* installation, the artist navigates a literary domain to show how deceptive words can be and how dependent they are on our cultural codes. We not only use them to organise meaning, but also as signifiers of our existing and non-existing realities.

WIDOWS

This title is just symbolic. These humanised robot figures have a red cylindrical detonator on their backs, as if they carried suicidal explosives while standing together in a circular fashion. An electric source at the centre of the circle supplies energy to each figure. The swinging fan heads, which seem to talk to each other, represent the ritual of a silent protest. But the hatred and disparity between the rich and the poor and all the relevant cultural barriers cannot be eliminated.

Widows
2008–9
in collaboration with Judith Neilson
Multimedia
1.37 x 6.5 m
Edition of 20

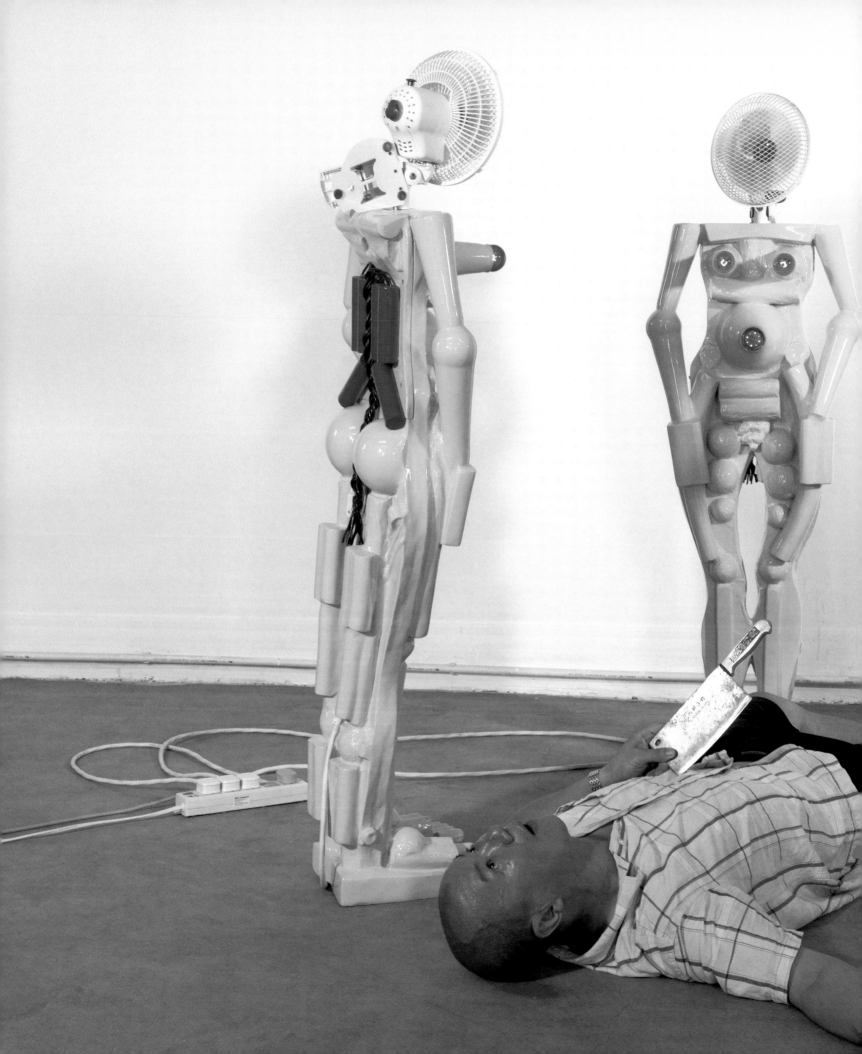

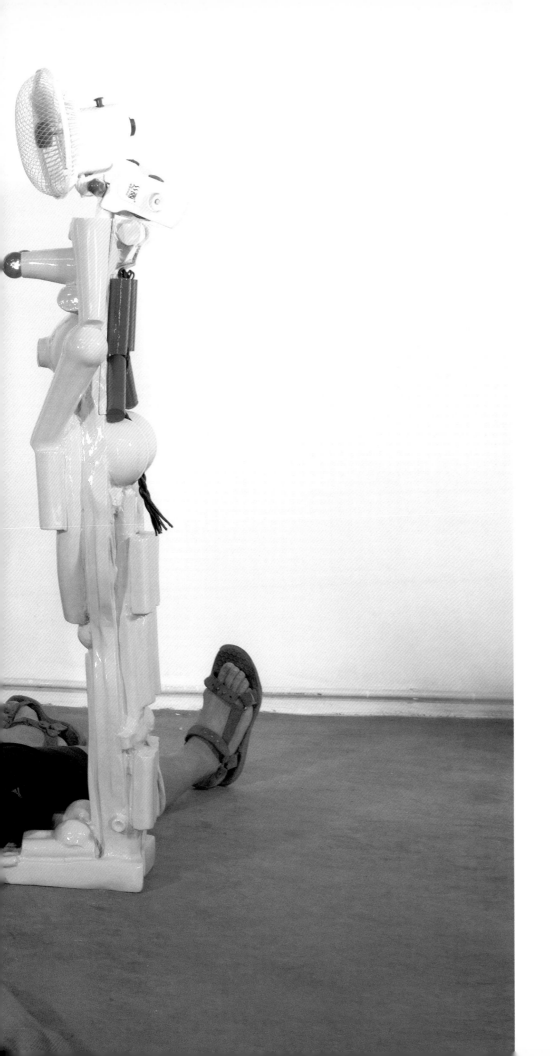

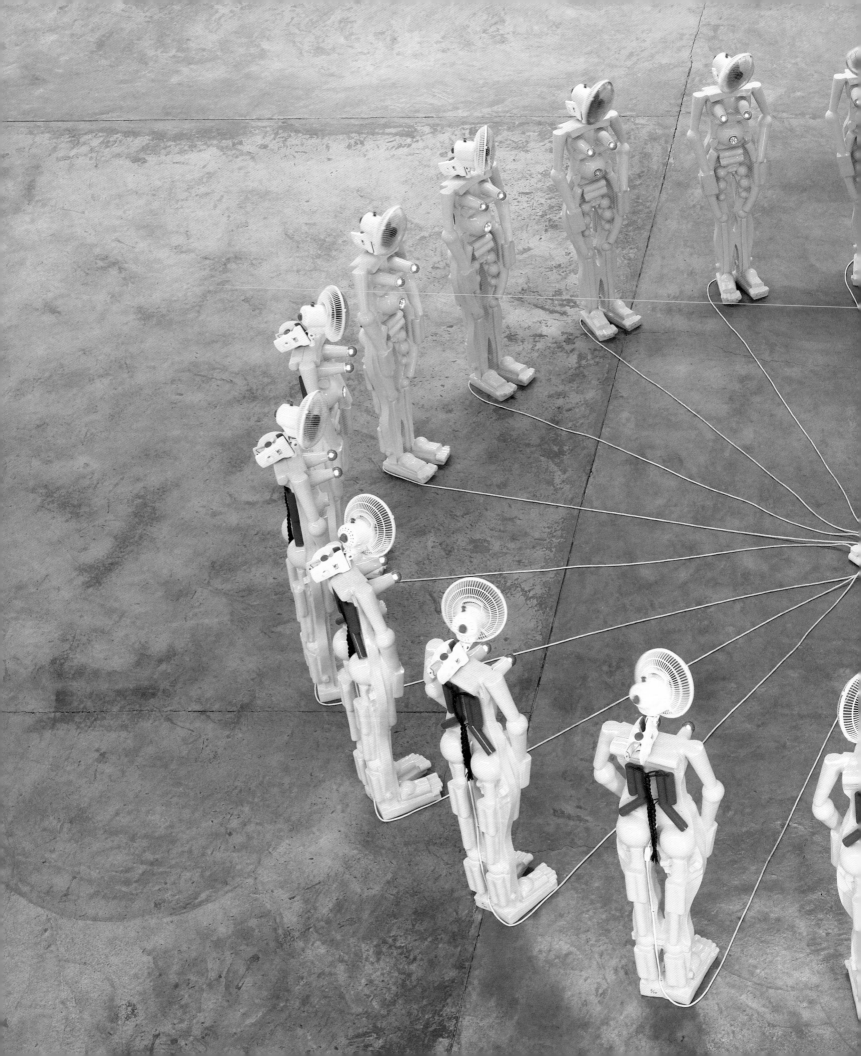

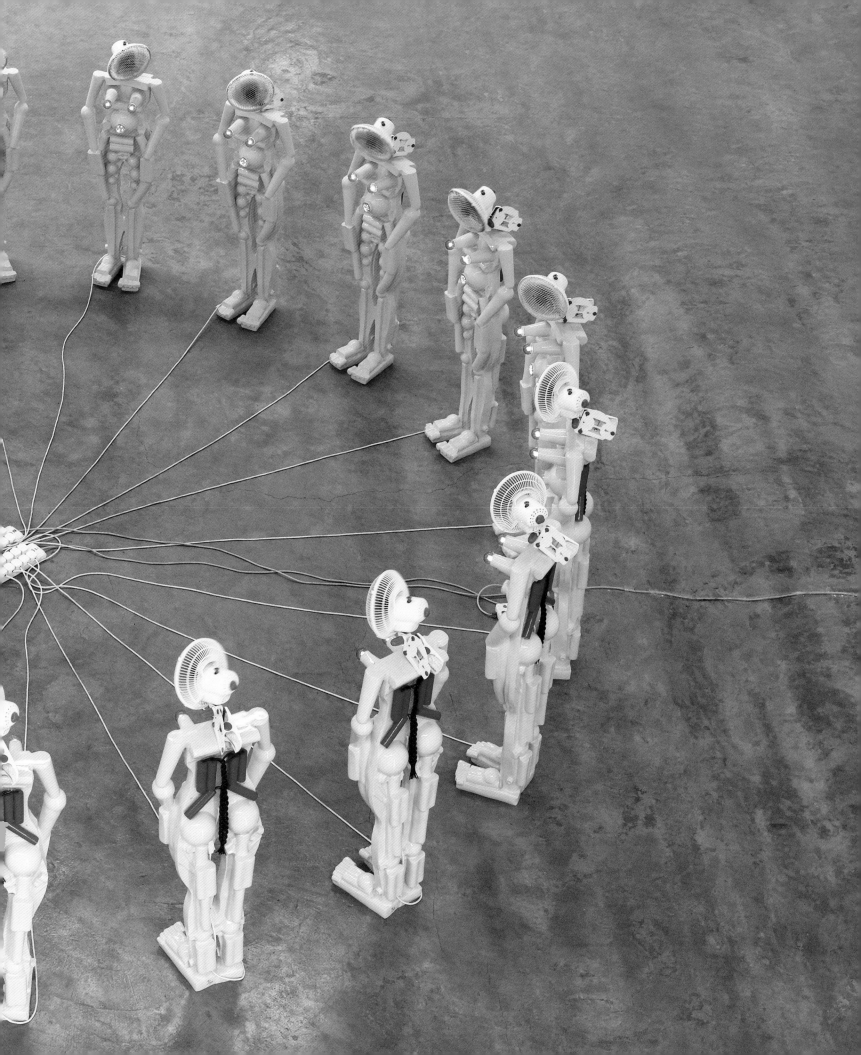

OBJECT
OF DESIRE

From within this work shines a deceptive image of a devilish boar, which traces the cardinal vices of humanity and its most unquenchable and instinctive desires. In the background you can hear Zhou Xuan's popular song from 1930s Shanghai, reiterating the question: "When are you coming again?" Her song was considered decadent and remained forbidden until 1949. It's hard to think that the history of China can go back to its origin after it has travelled such an enormous full circle in time. It seems that everything goes back to the past: "Come, come, come and stay for another drink…"

Object of Desire
2008
Fibreglass, baking paint, light, sound
363 × 355 × 70 cm
Edition of 2

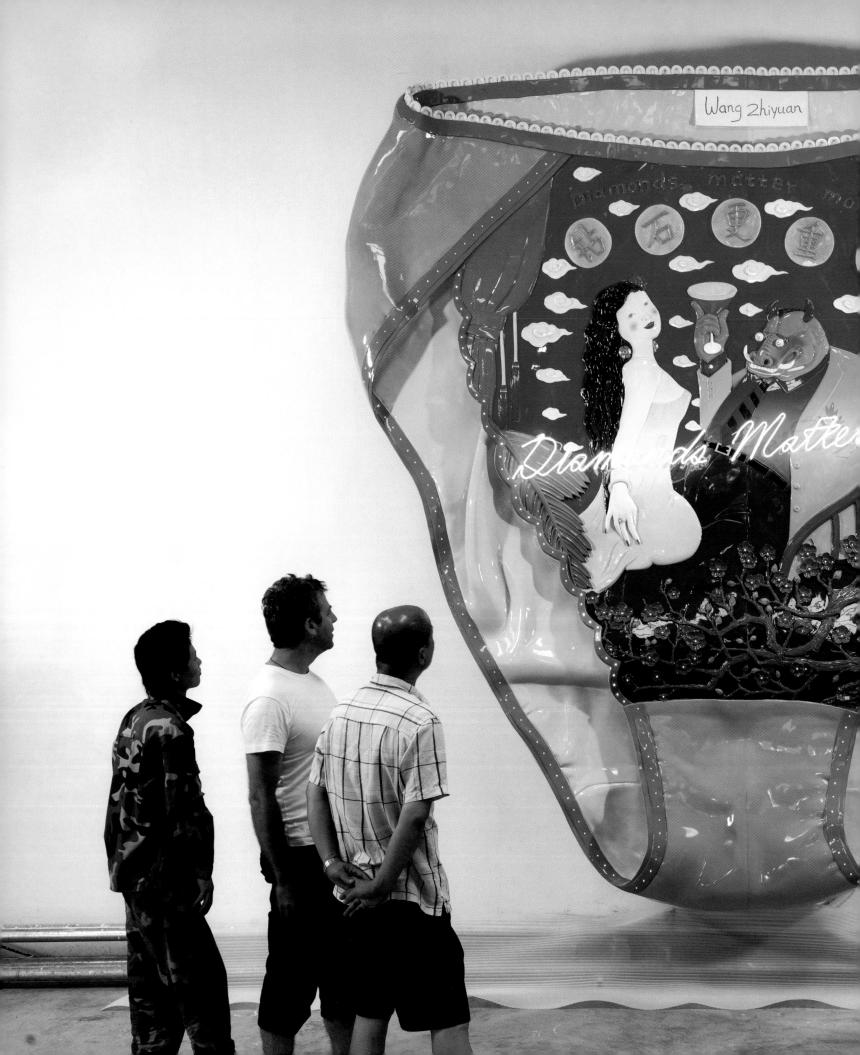

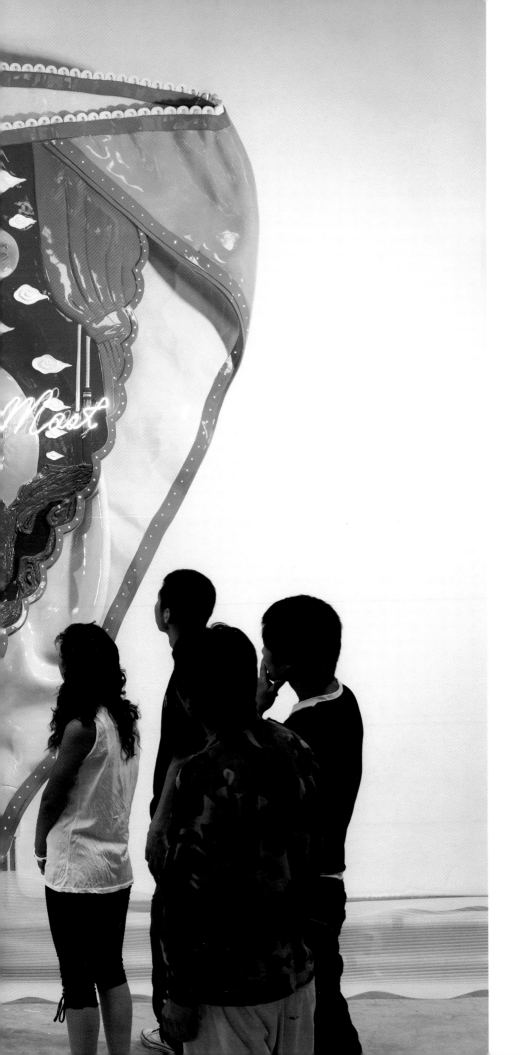

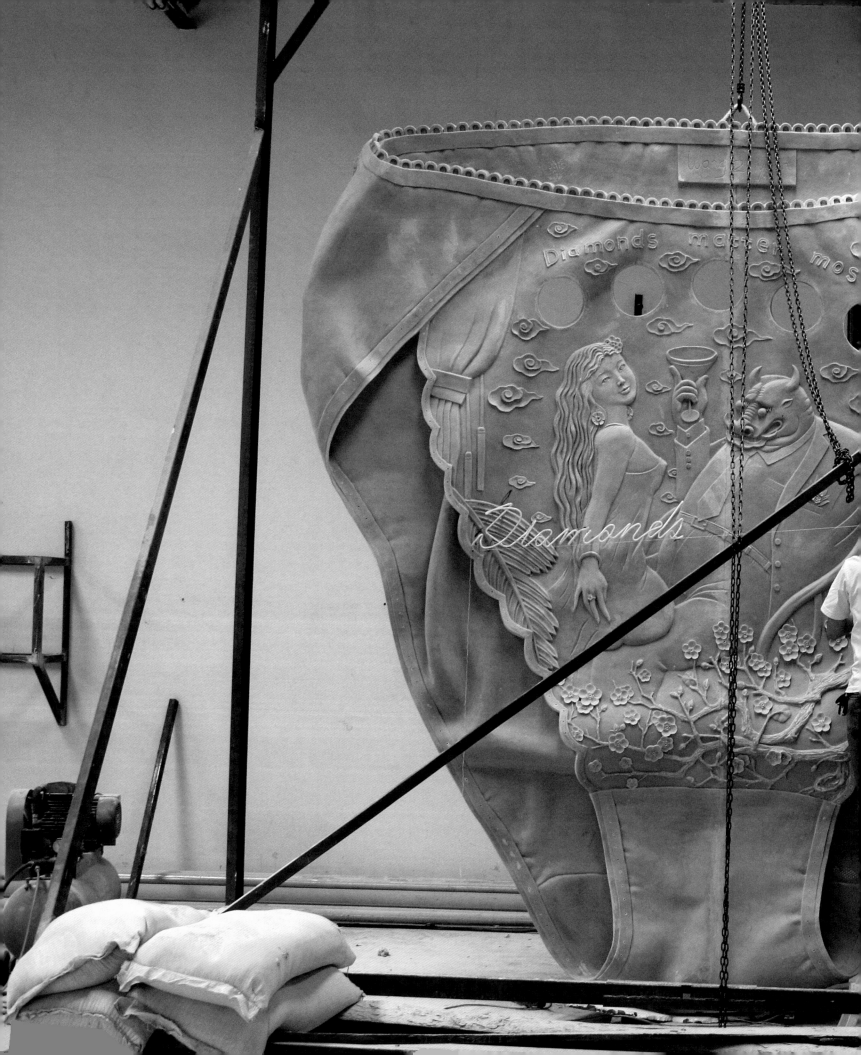

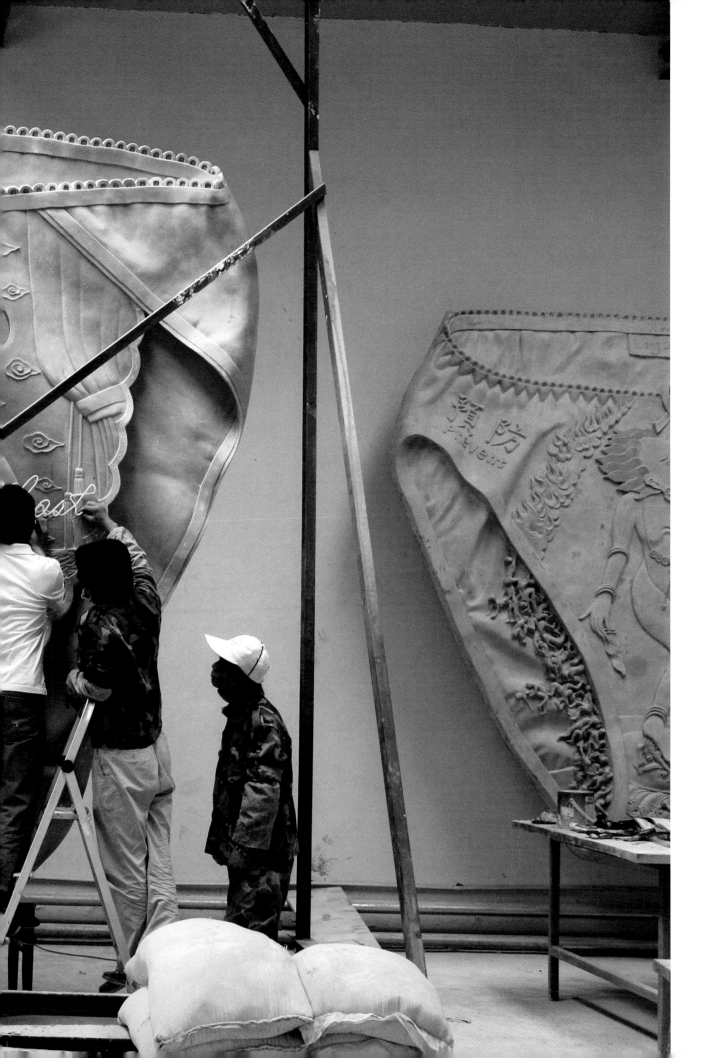

CROSS BEHIND THE UNDERPANTS

This is a multimedia installation, which includes sculpture, video, music, lighting, and pneumatic tools. A pneumatic machine opens the "big panties" as the light switches on and off. The central part forms a white cross, while a video is projected with music. After five minutes the oversized underwear closes and everything is back to its original state. Every three minutes it restarts again and again, since it's all controlled by a computer. By hinting at sex and religion, I hope the work promotes a series of questions related to our thinking and existing beliefs and instincts.

Cross Behind the Underpants
2008
Multimedia
286 × 294 × 75 cm
Edition of 2

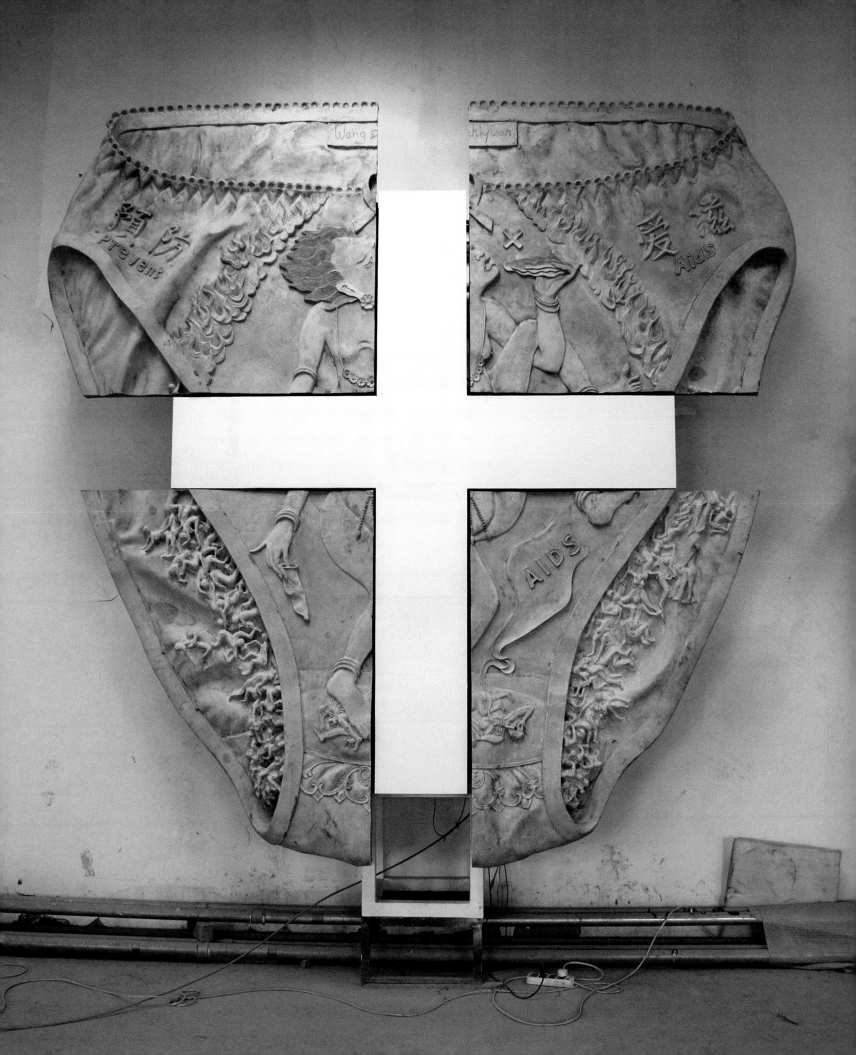

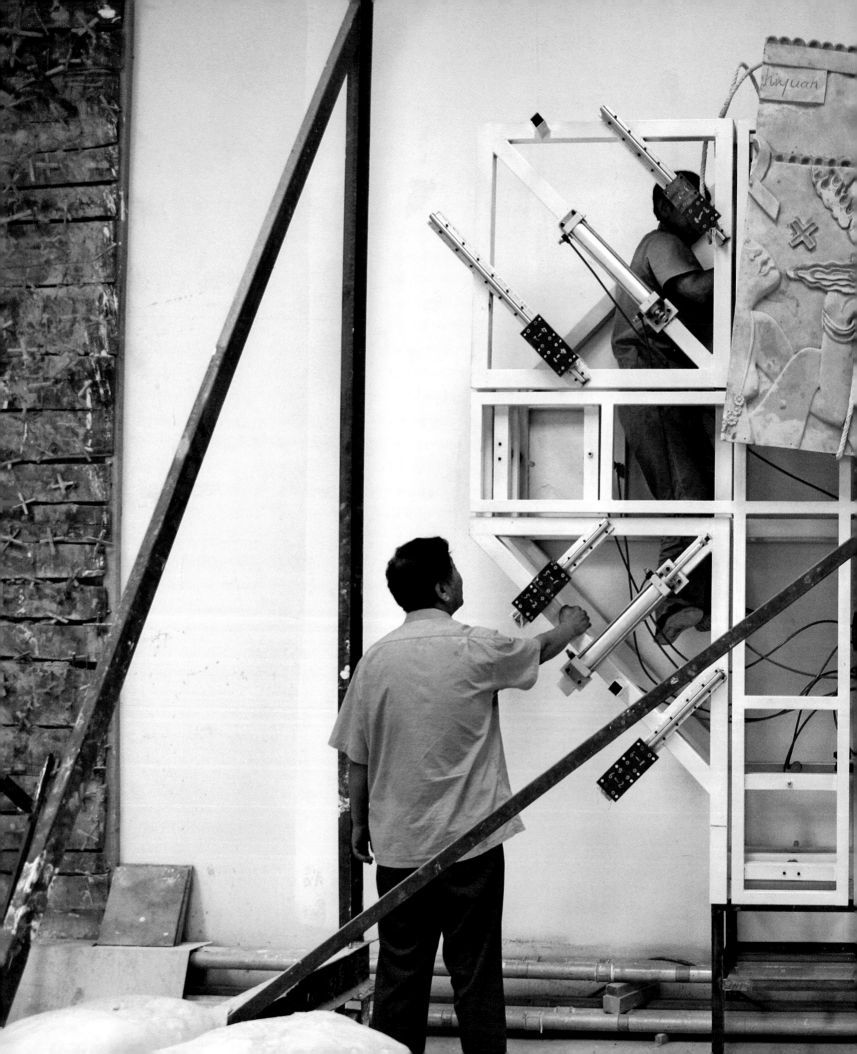

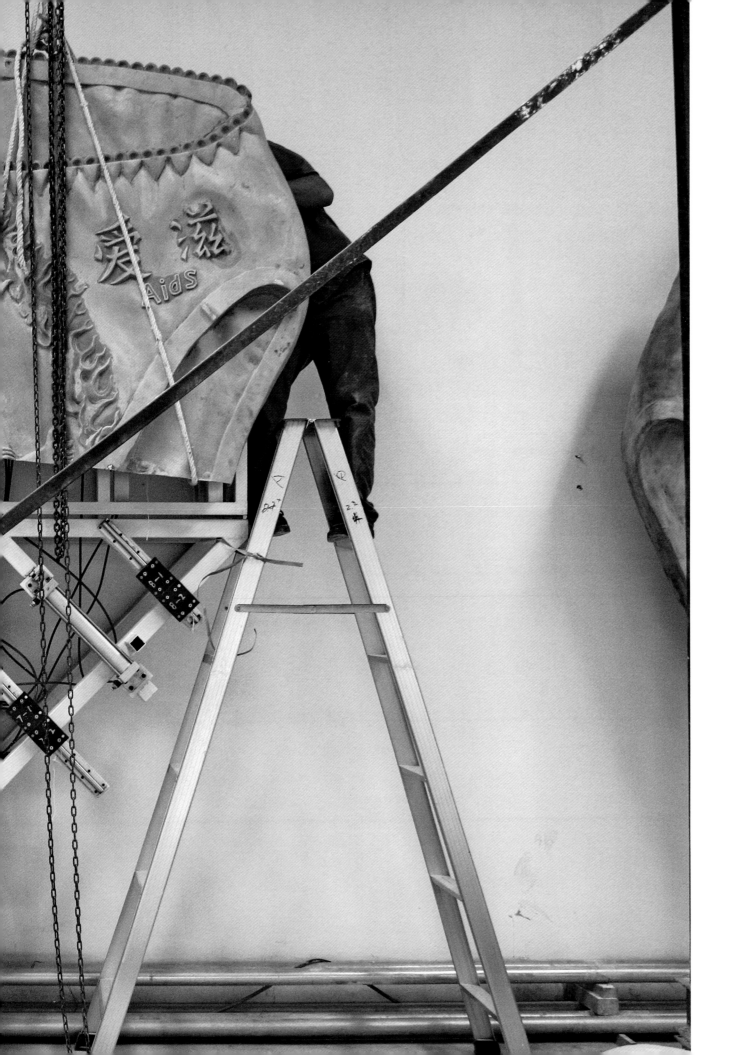

HEART ON THE UNDERPANTS

I juxtaposed the holiest of shapes, the human heart, with unpresentable underwear. And it's not so bad!

Heart on the Underpants
2008
Fibreglass, baking paint, light
165 × 257 × 68 cm

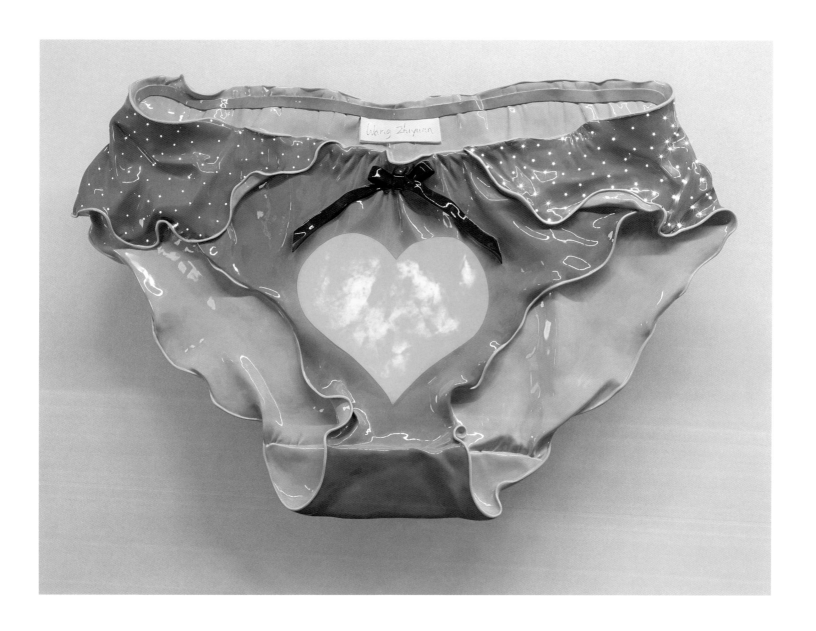

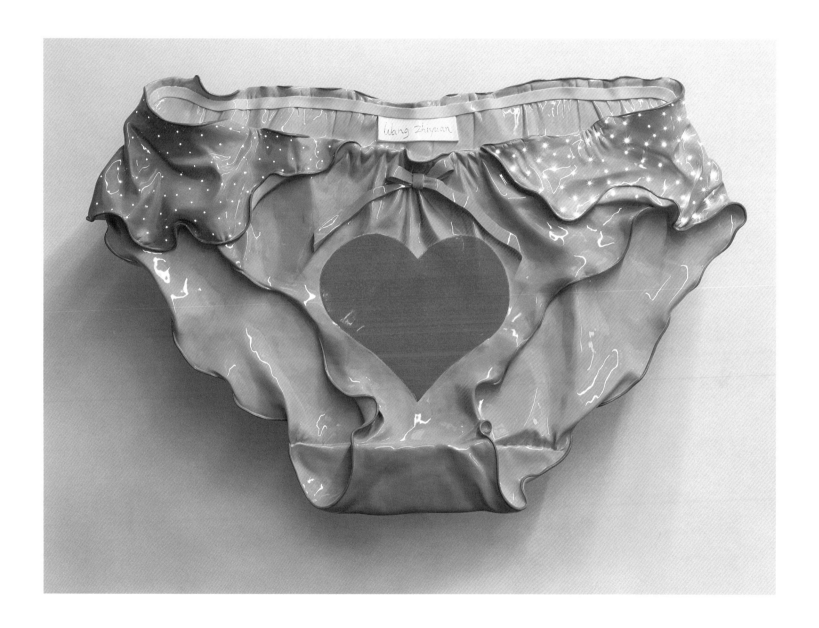

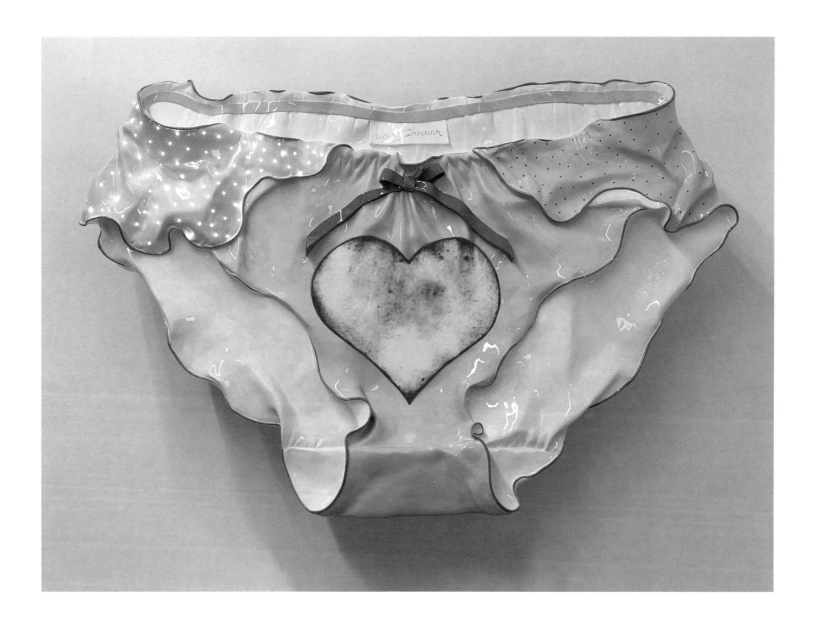

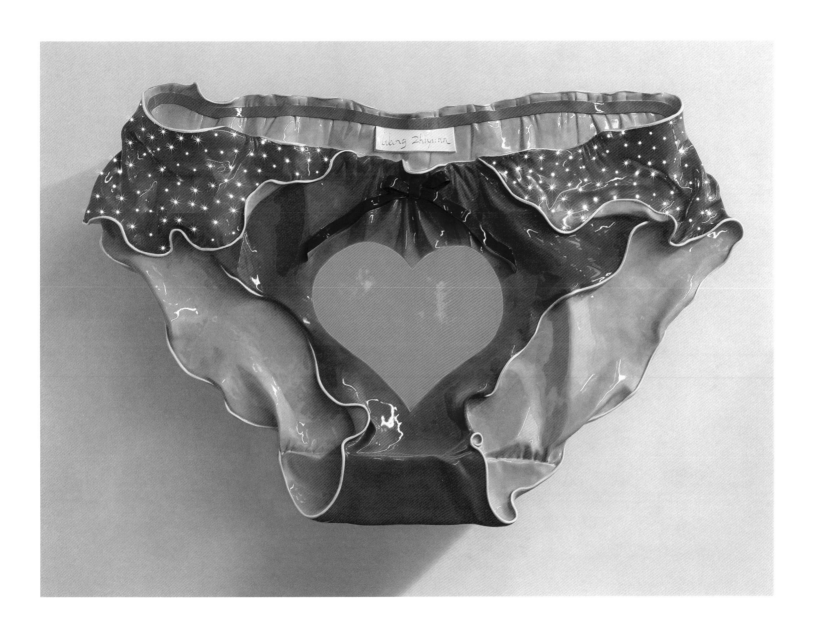

TEACHING
LIES

My inspiration for this series of works came from a street in Beijing. Since the 1990s we have seen lots of advertisements sprayed or pasted on walls everywhere along the road by small private companies. They look like socially directed art and reflect realistic situations and the process of China rebuilding and reconstructing its social life.

I employed two workers to build a long wall with old bricks and black spray paint and to write a large advertisement: "15712966740教撒谎" (my mobile number and three Chinese characters that mean teaching lies).
The style is appropriated, but I changed the content of the advertisement. This kind of street publicity is like a new urban folk art, shaping collective desire.

During the exhibition I received a few phone calls from the public, asking how much I charged per hour. I had to explain that I'm not a real teacher and that I was only joking…

Teaching Lies
2005
Brick, spray paint
1.2 x 8 x 0.3 m

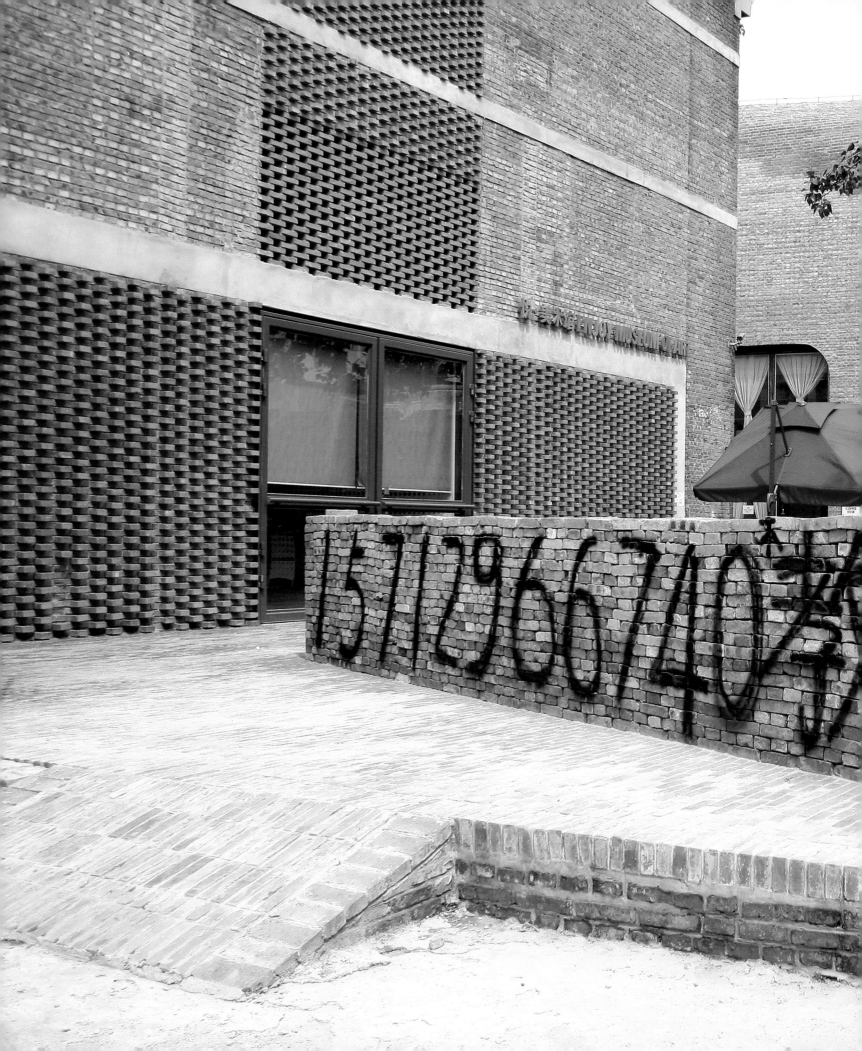

FIRE

Fire represents passion, but it can destroy everything as well. Chinese people have always believed that fire is divine and that it can link us to the underworld. During the annual Qingming Festival (Tomb-Sweeping Day), people will burn paper money for their deceased loved ones. They also burn paper imagery of cars and houses, hoping that through the transformative power of fire these things can still be passed on and shared with family members who have since left this earthly world. It expresses their intense feelings of yearning.

Fire
2004
Installation: MDF, acrylic, multimedia
Variable dimensions

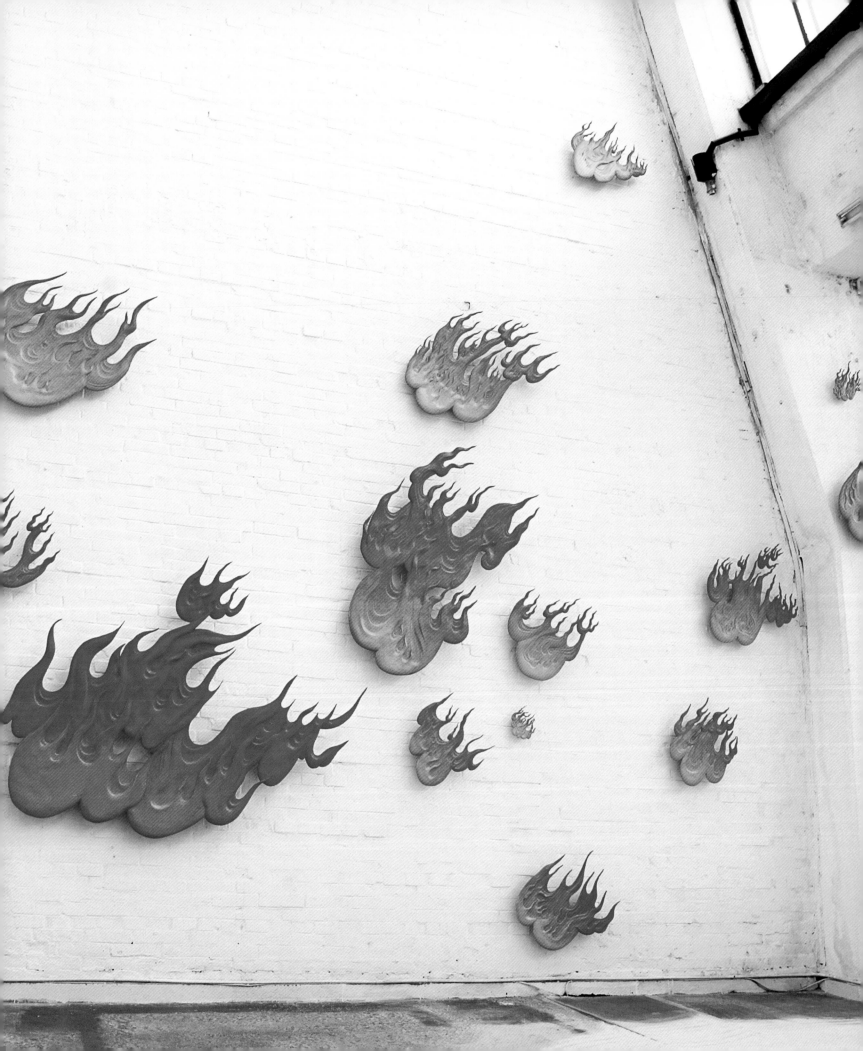

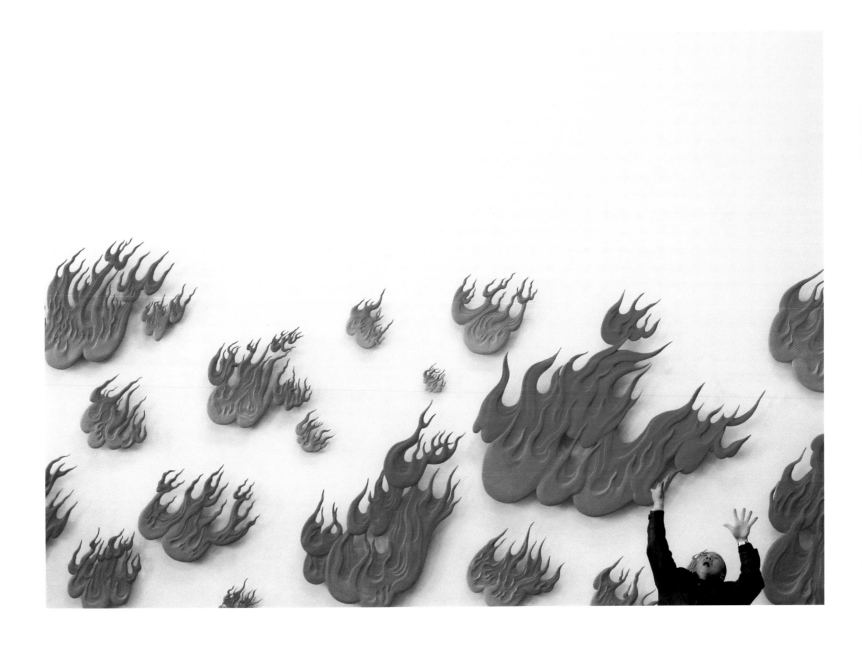

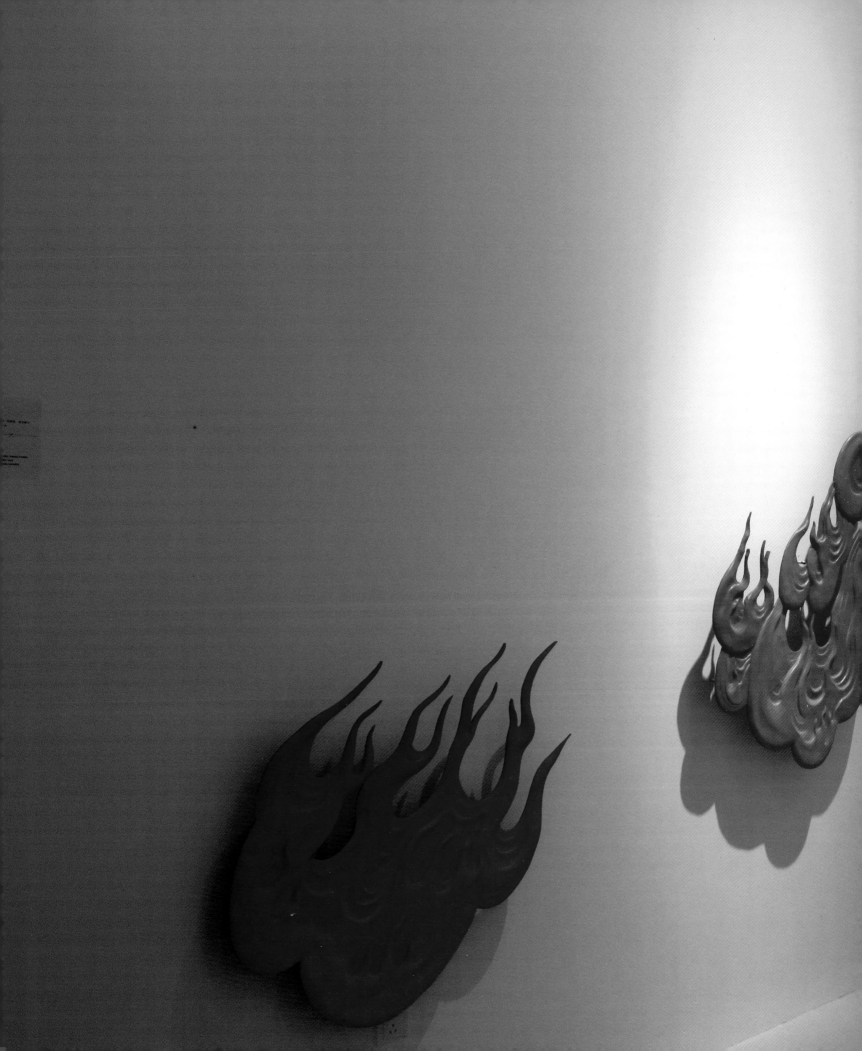

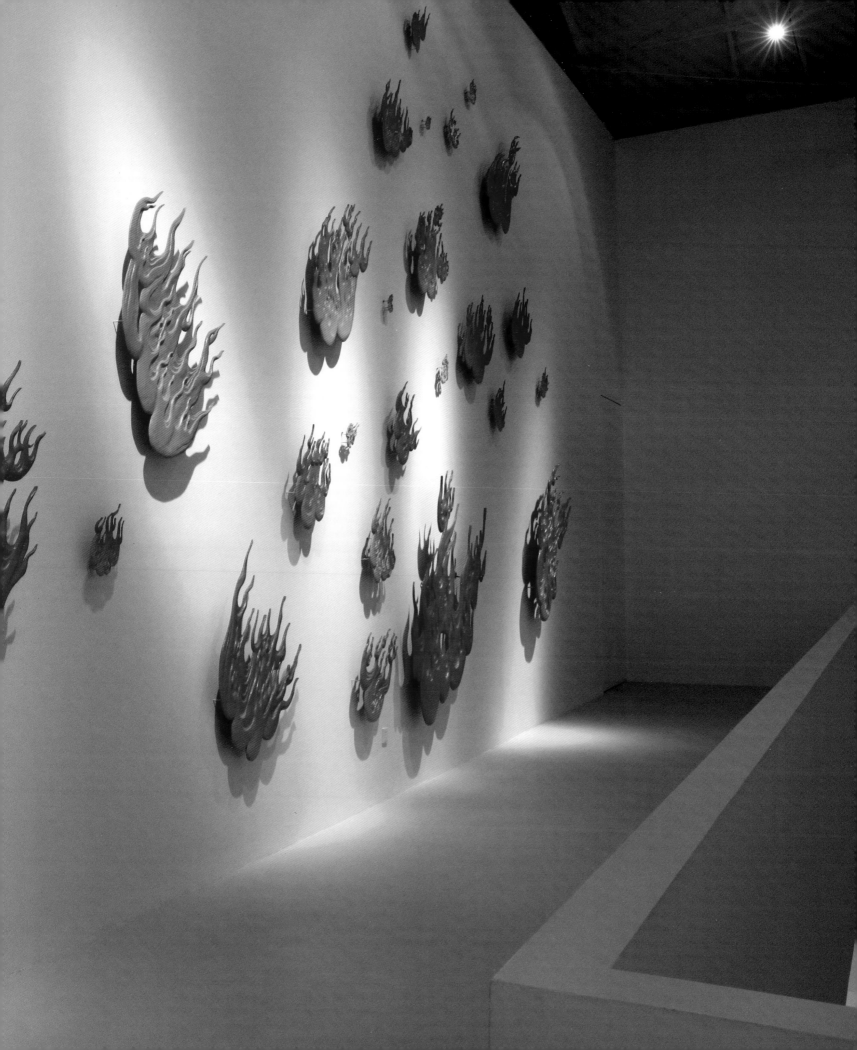

THEY

This installation consists of 200 bronze sculptures and wooden boxes. The gallery provides a large space so it allows me to create the silence and solemnity of a church experience. The audience must look upwards to contemplate these small humanoid replicas. In unison, they inspire a sense of awe but also create a rather oppressive mood. And at the same time the audience becomes the spectacle instead of just the spectators.

They
2004–5
200 bronze pieces
Overall: 5 x 10 m

They
2014
Stainless steel
16 x 14 x 8 cm each

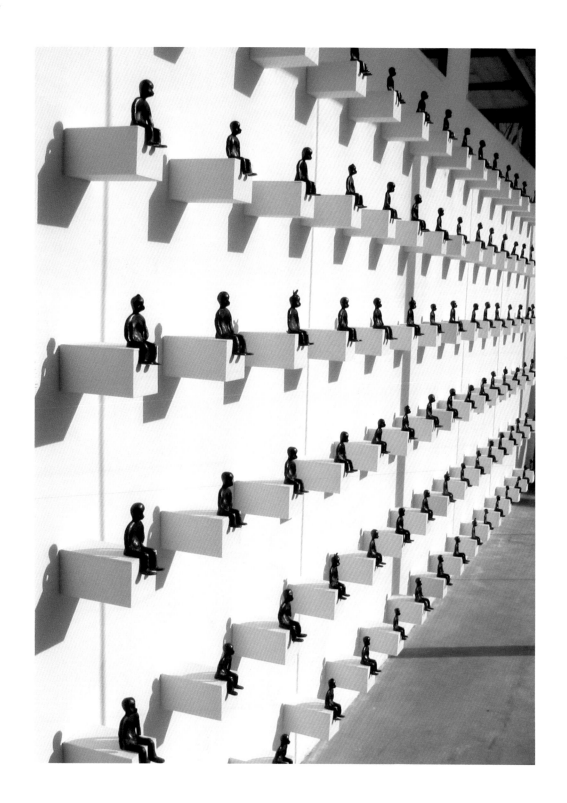

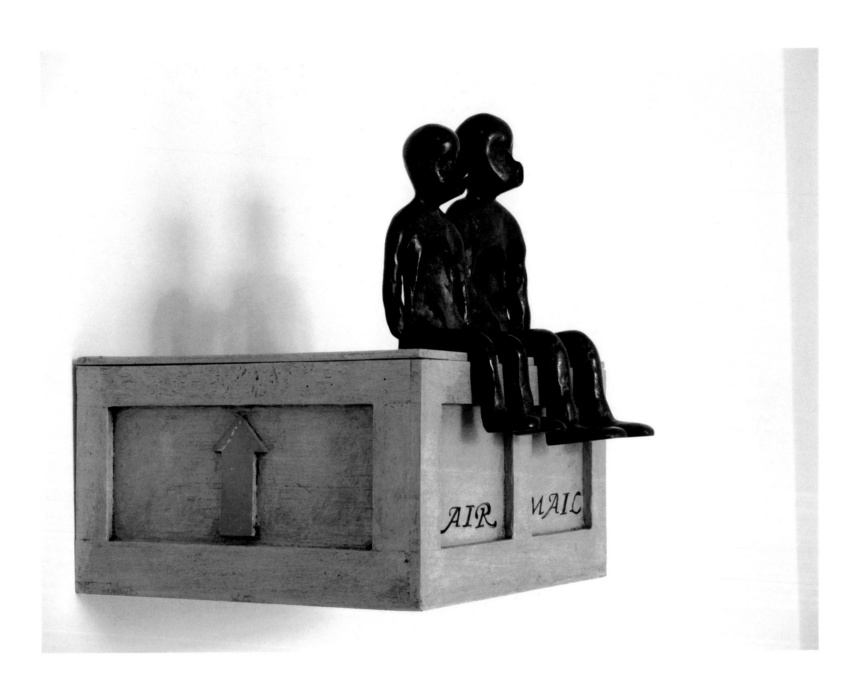

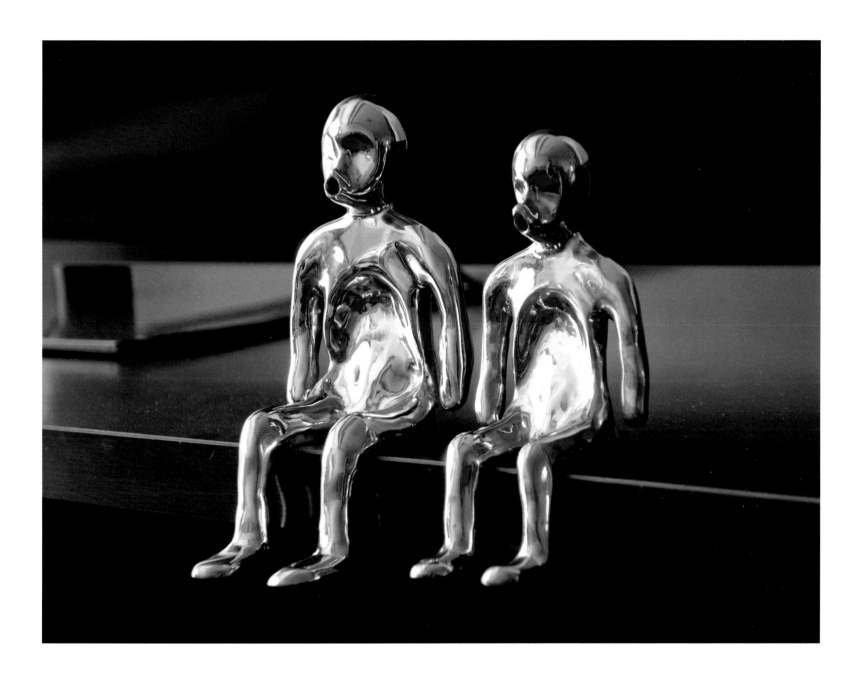

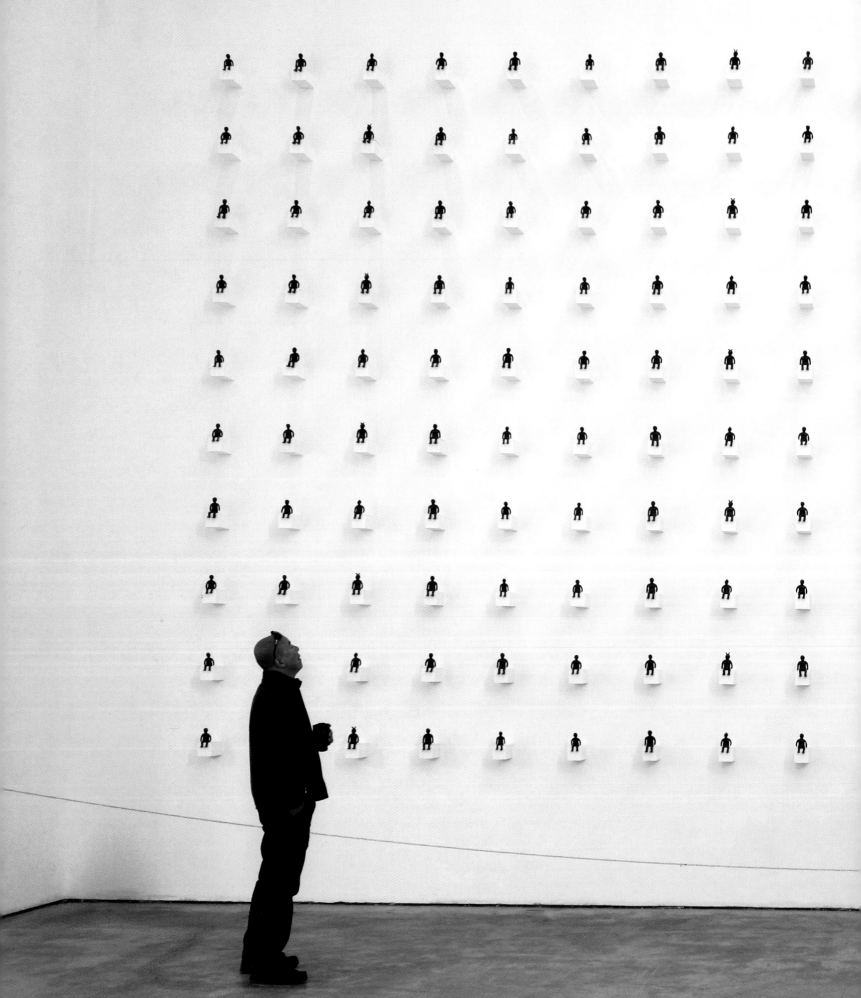

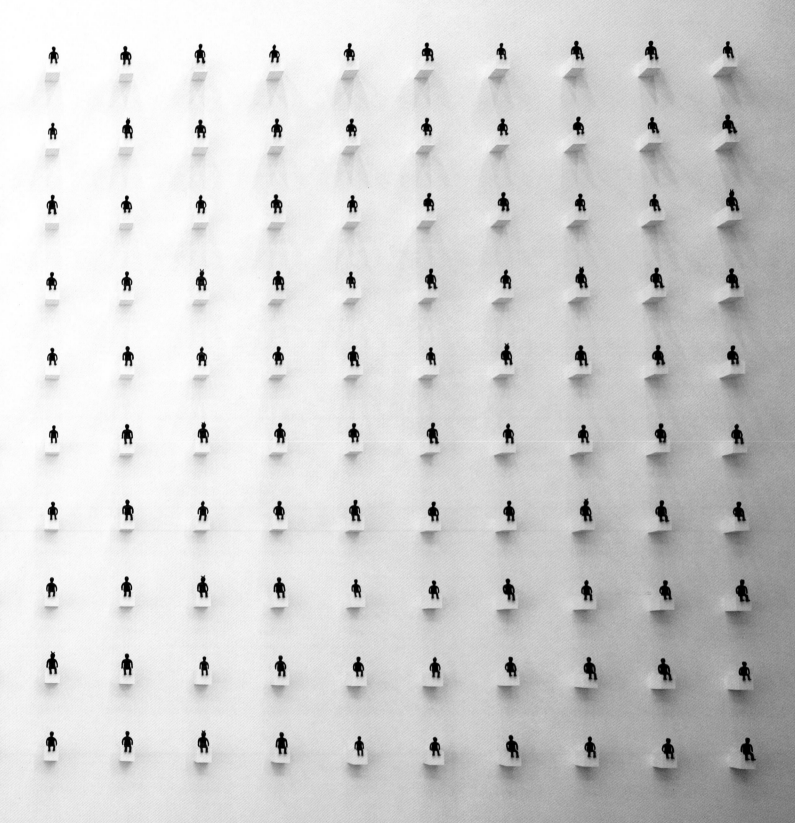

UNDERPANTS II

I use real underpants as models to create a realistic "cameo" relief effect. I have designed them myself and added on new elements compared to my earlier *Underpants 2001* series. The whole process is just like working as an underwear designer!

Underpants II
2003–5
Fibreglass, acrylic, multimedia
Variable dimensions

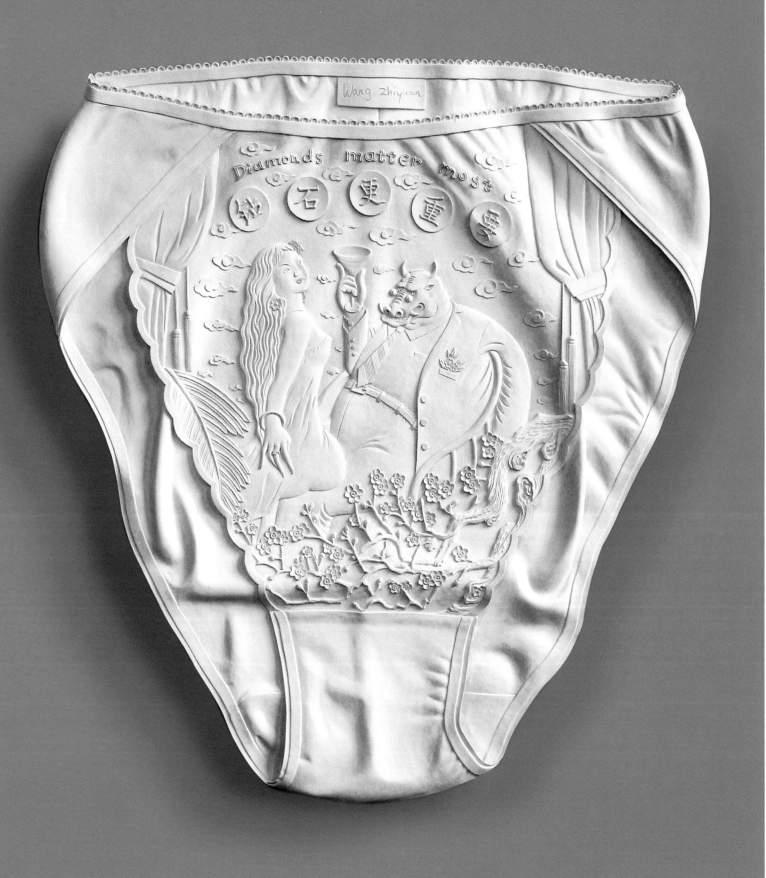

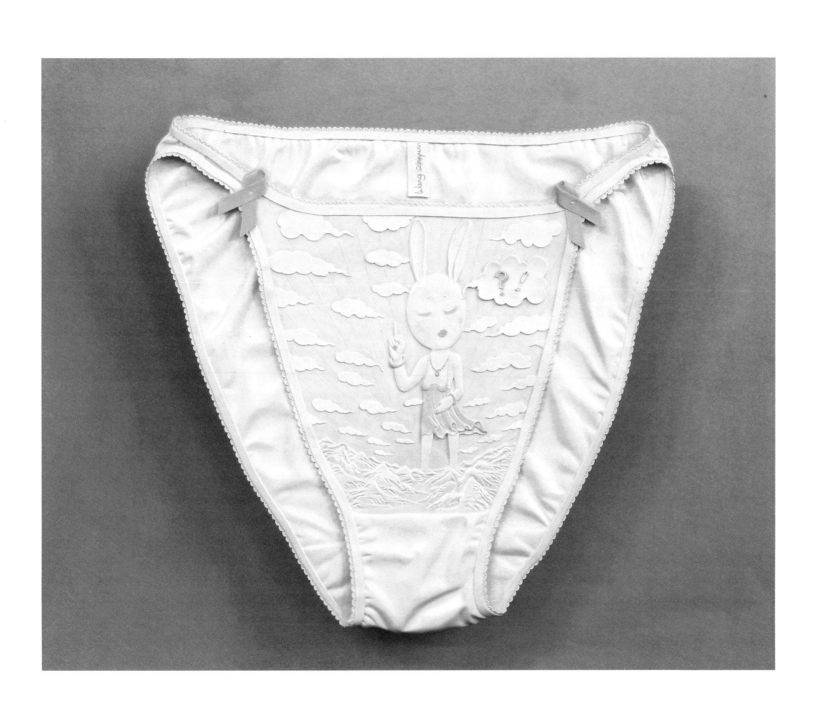

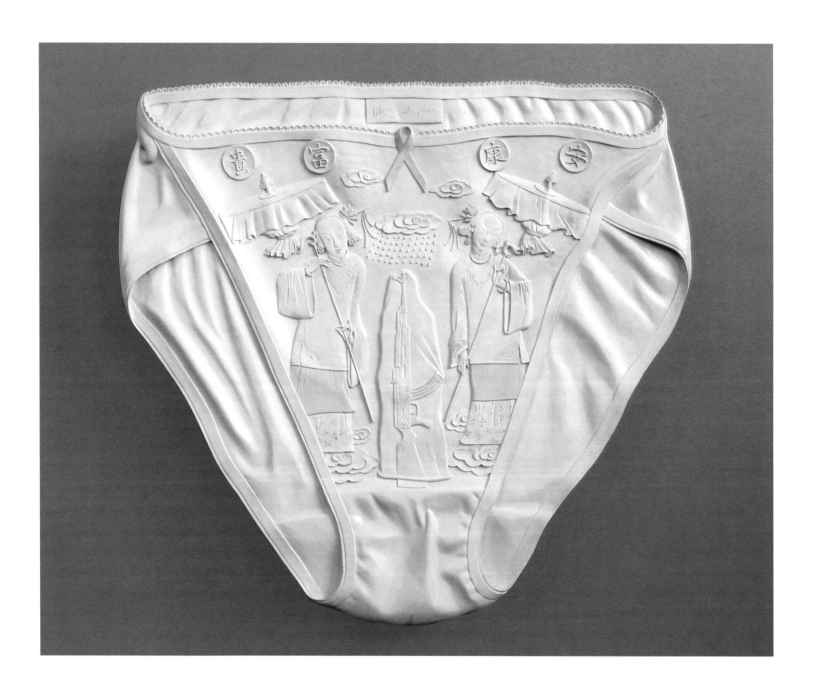

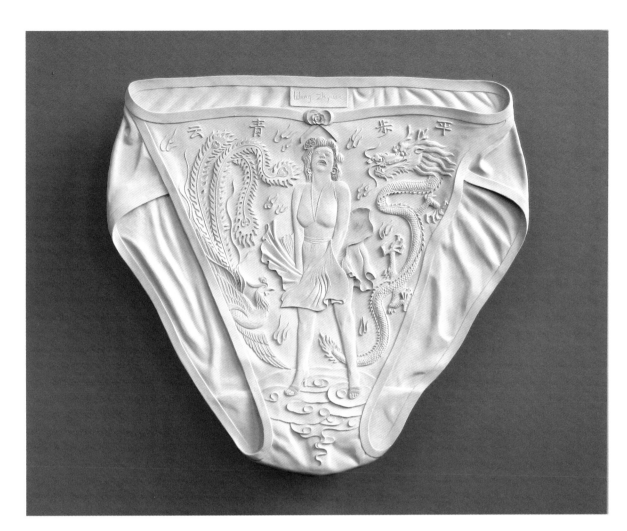

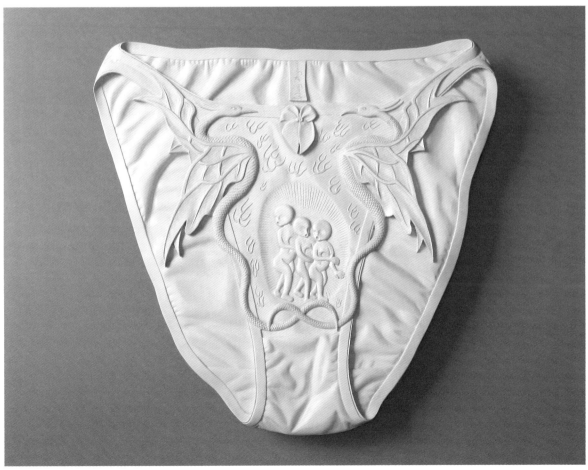

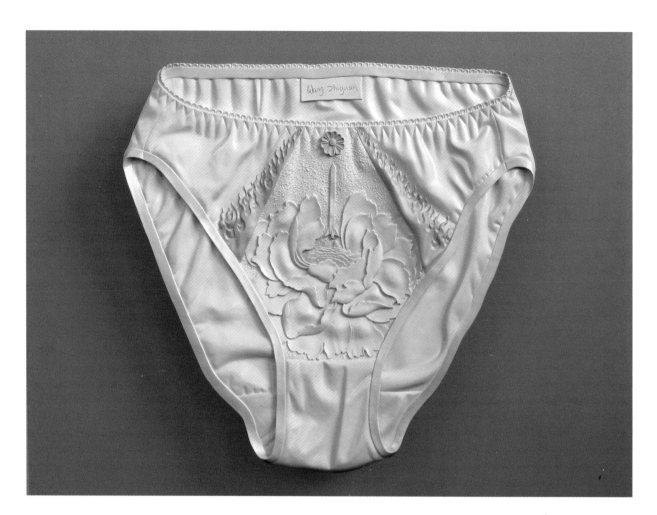

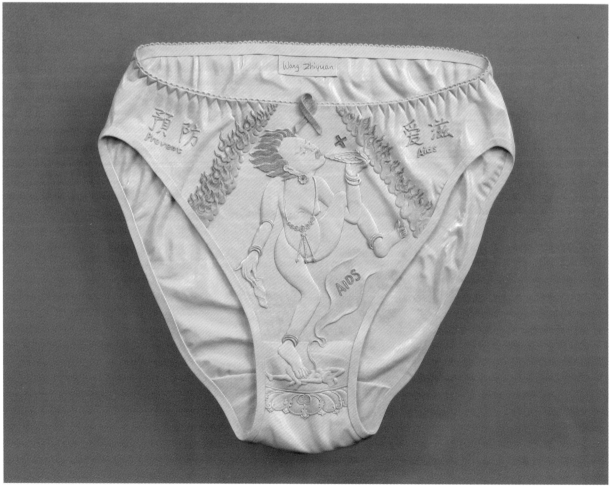

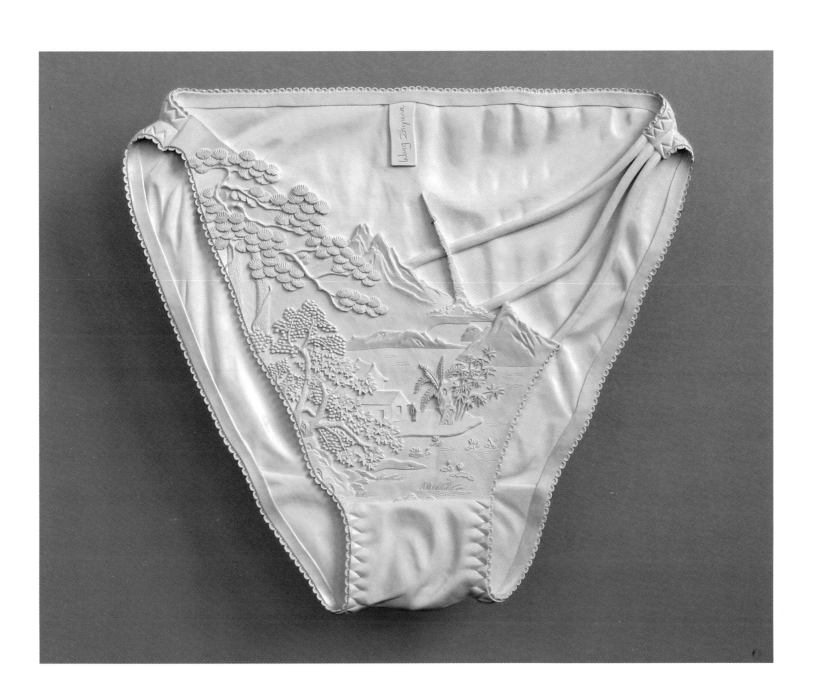

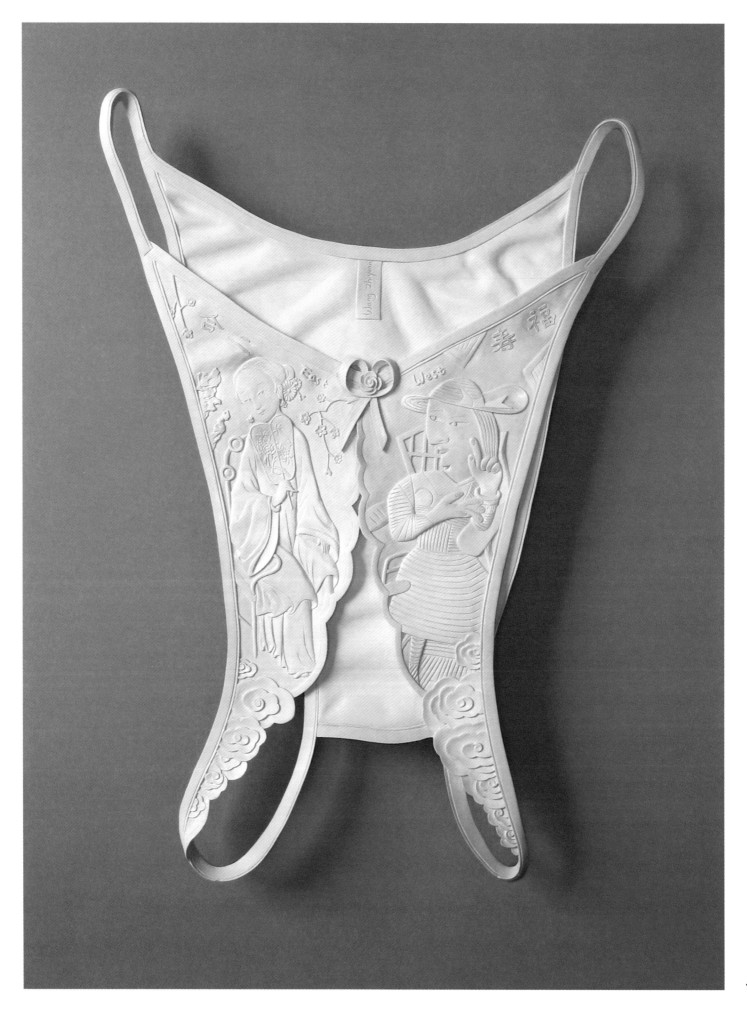

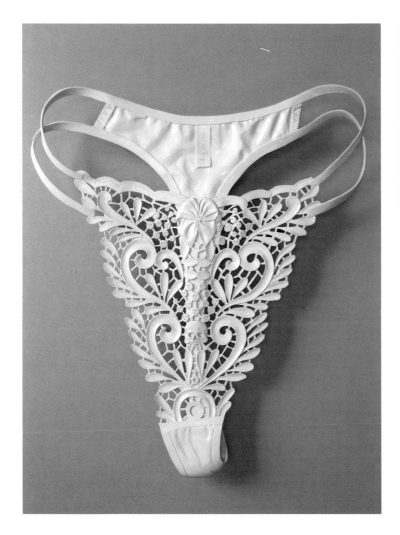

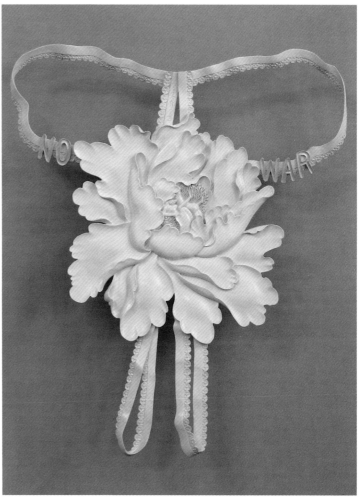

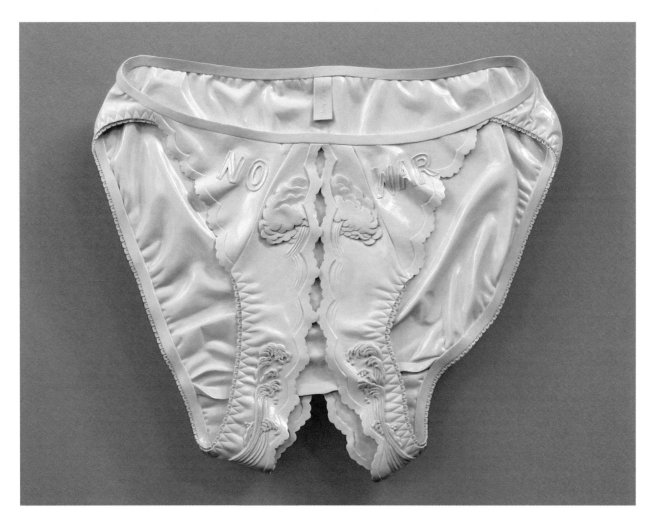

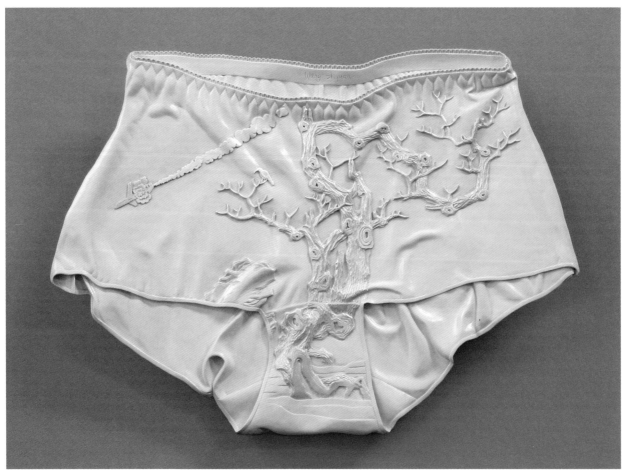

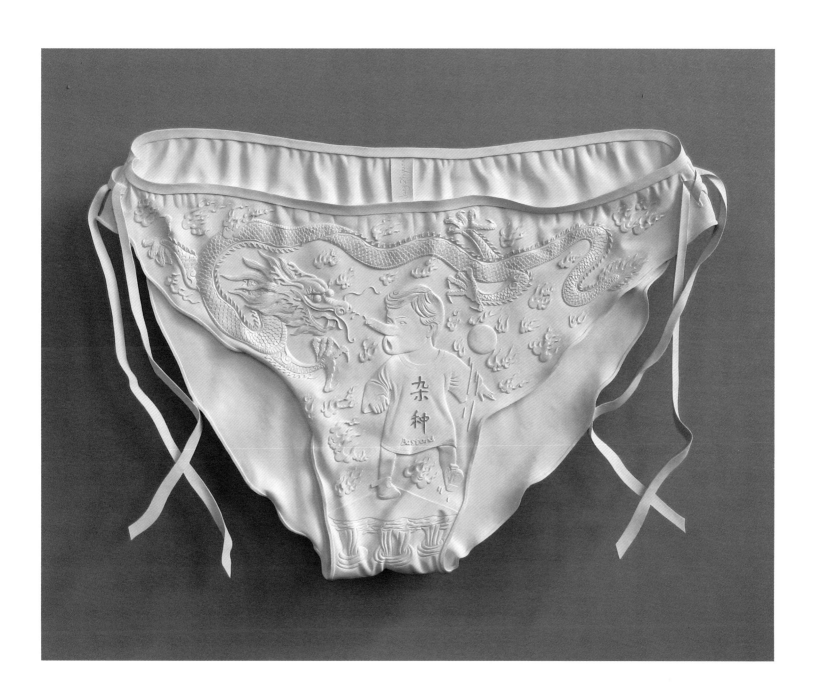

UNTITLED

All these artworks are selected details of traditional Chinese illustrations, made from wood cameo and 100% gold leaf.

Untitled
2002
Wood, gold leaf
Variable dimensions

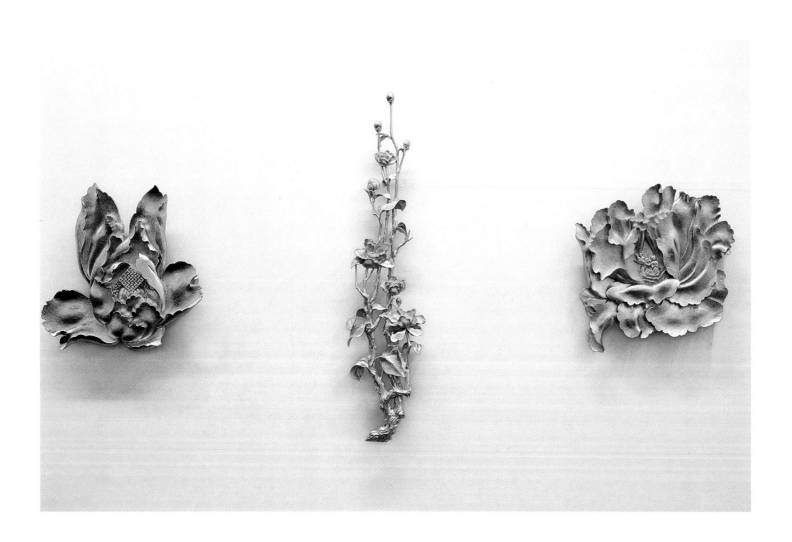

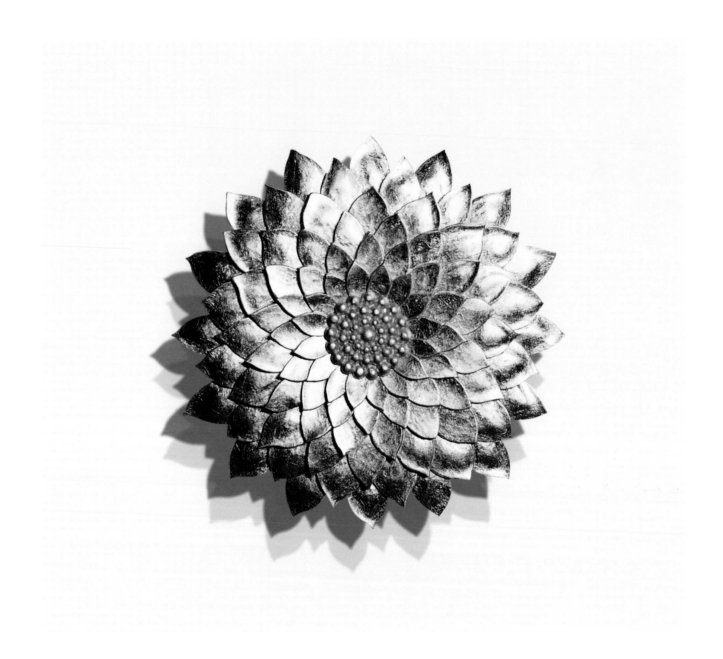

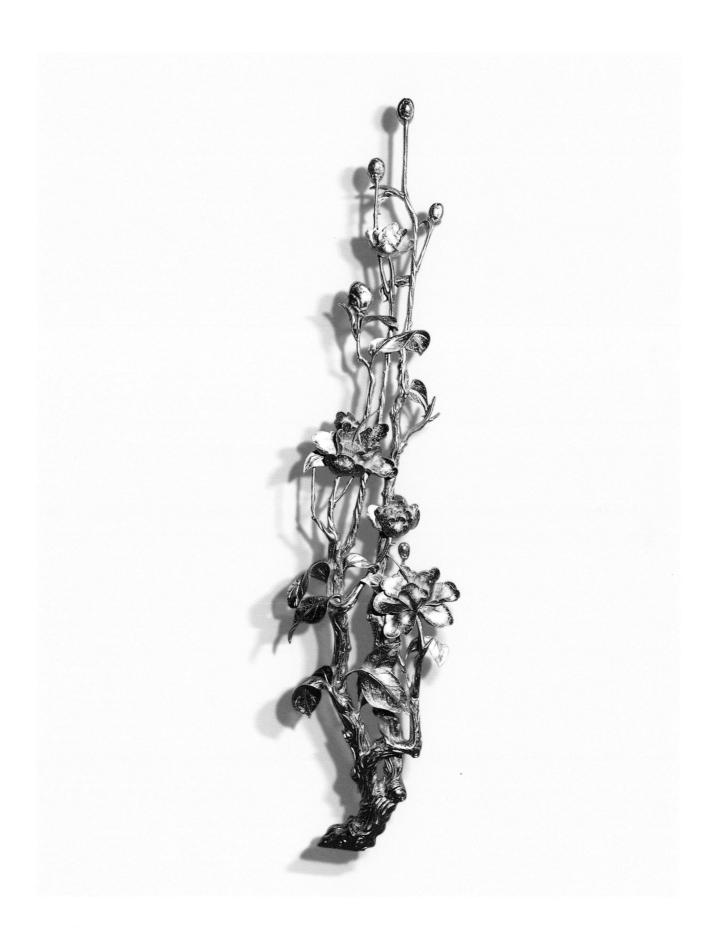

SKETCHES

These two unfinished sketches express my thoughts on the fact that nature bears the brunt of our endless ambitions to possess, colonise, and globalise. Nature's original, unequalled, inimitable, and life-giving riches must bear down while humanity attempts to create its own "wealth".

Sketches
2001–2
Pencil on paper
20 x 29 cm each

"Towards the Globalization"

"迖向全球一体化"

2001

"TANK"

"Think—Tank"

2 m

2 m

水
Water

earth layer 地层结构

"TANK"

"Think-Tank"

2002

MAGICAL
BOX

The packing box placed on the floor is also part of this artwork. After opening the box, twenty artworks emerge like clouds of smoke drifting onto the wall. They are all copies, I just selected and re-created them, continuing to apply the idea of my *Fragments* (2000) series. This time I was parodying the suspicion of originality.

Magical Box
2001
Installation: MDF, acrylic paint
Variable dimensions

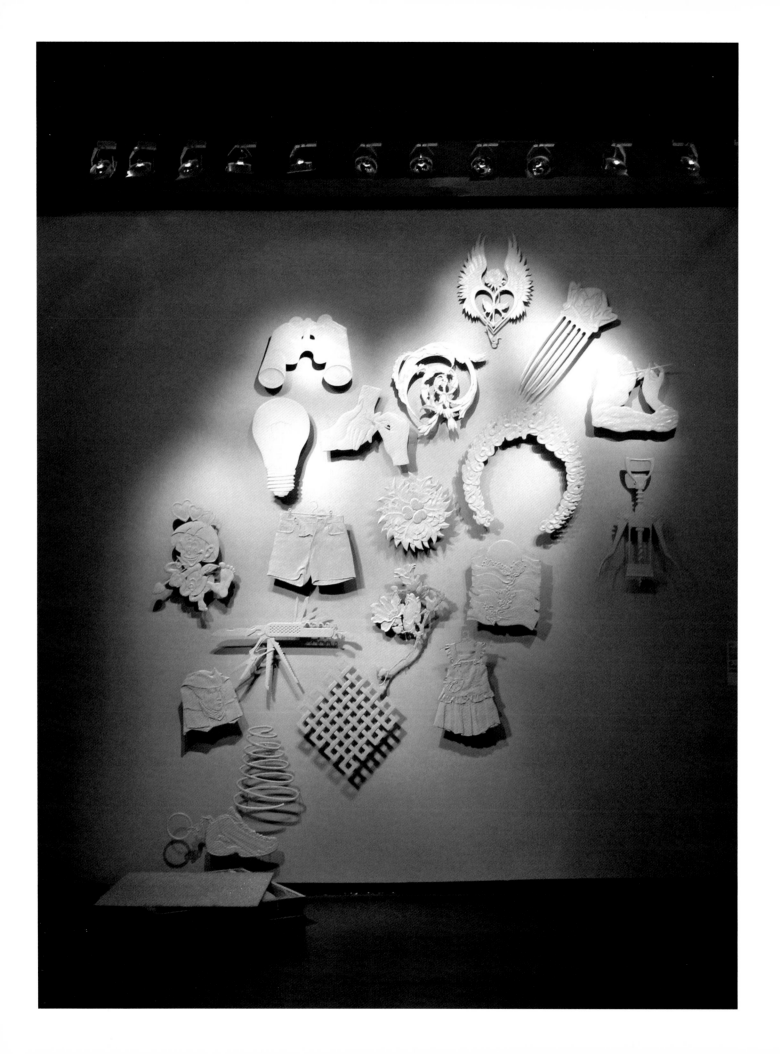

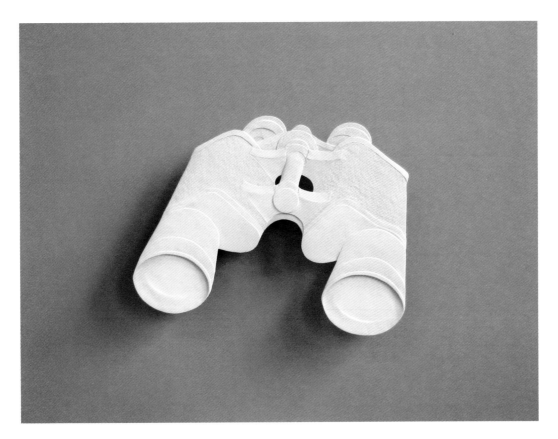

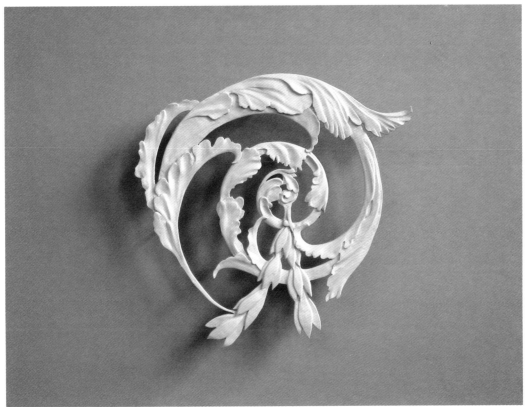

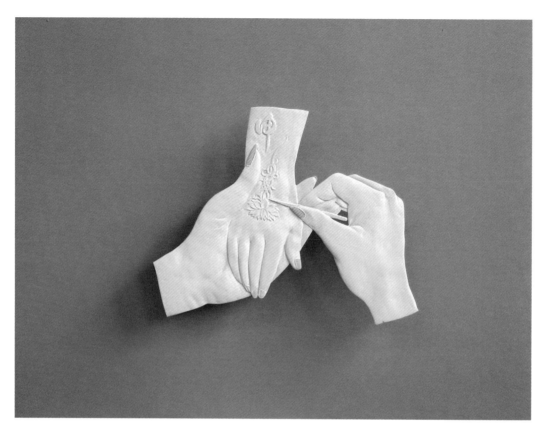

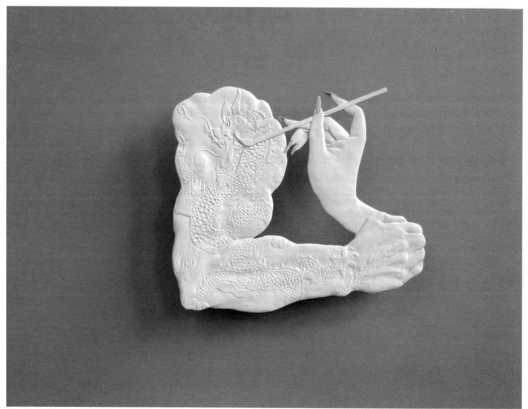

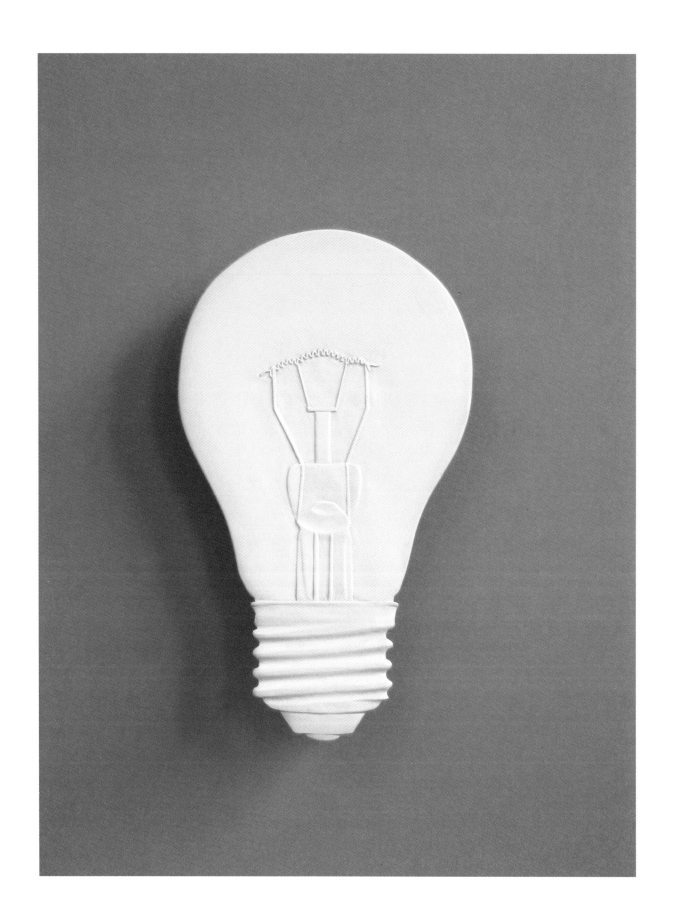

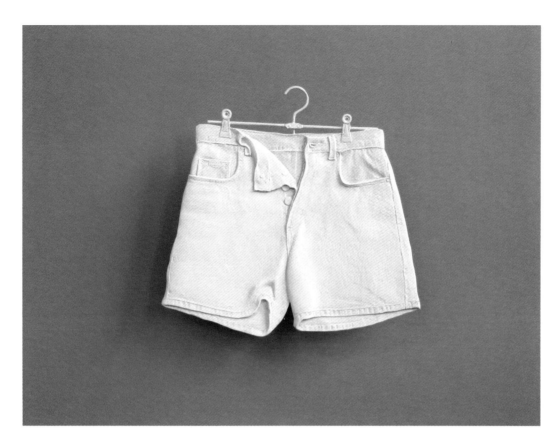

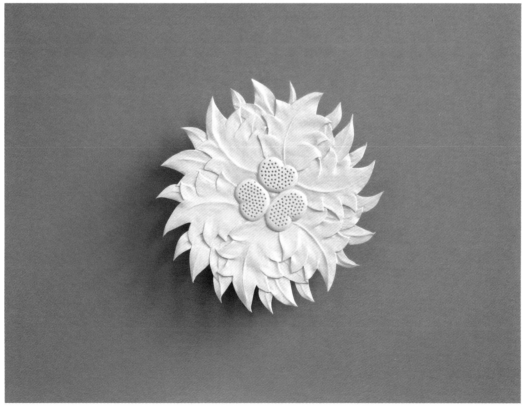

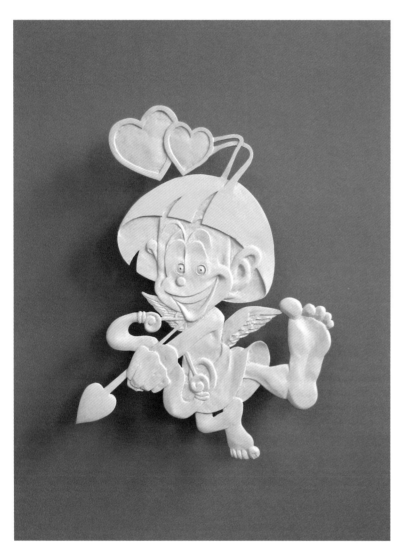

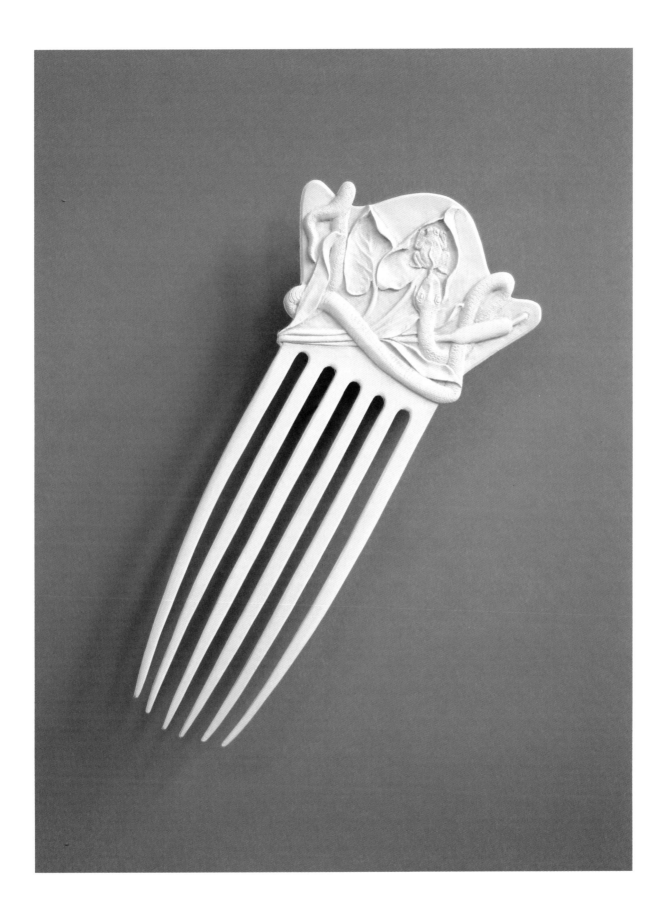

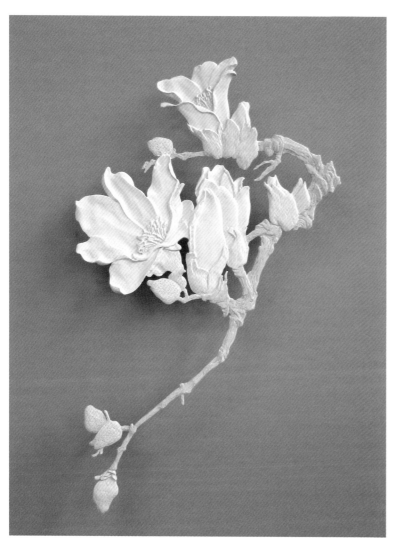
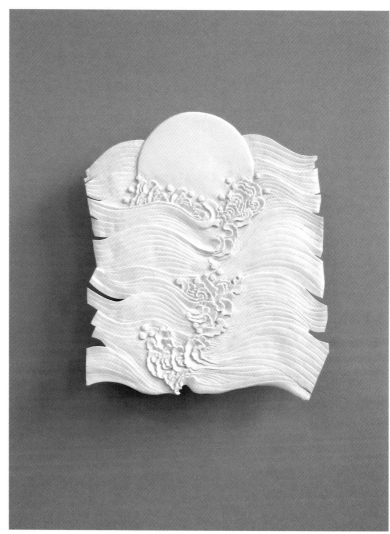

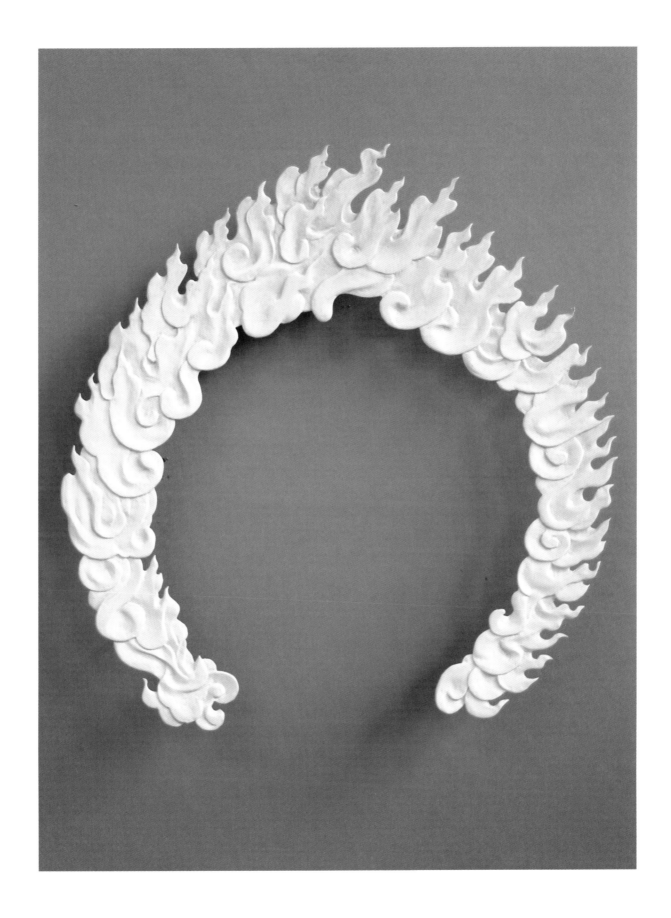

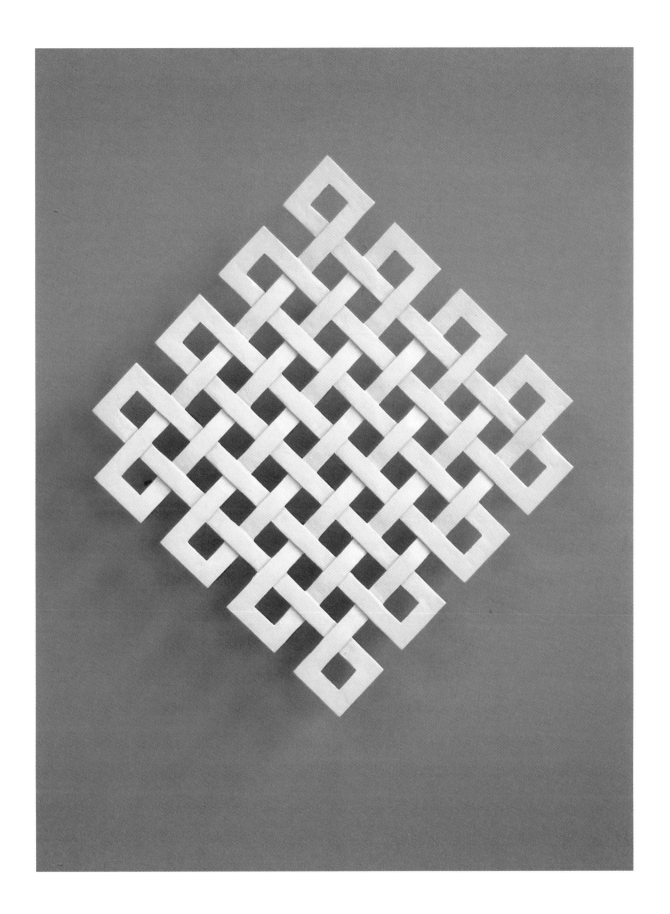

UNDERPANTS I

This work enlarges the previous underwear concept in a very realistic, "relief" manner, in order to highlight their sexy pale colour and intimacy. I wanted to create a feeling of dissonance, since they are on display in places where they don't belong – for instance, exhibition spaces and meeting rooms.

Underpants I
2001
MDF, acrylic paint
Variable dimensions

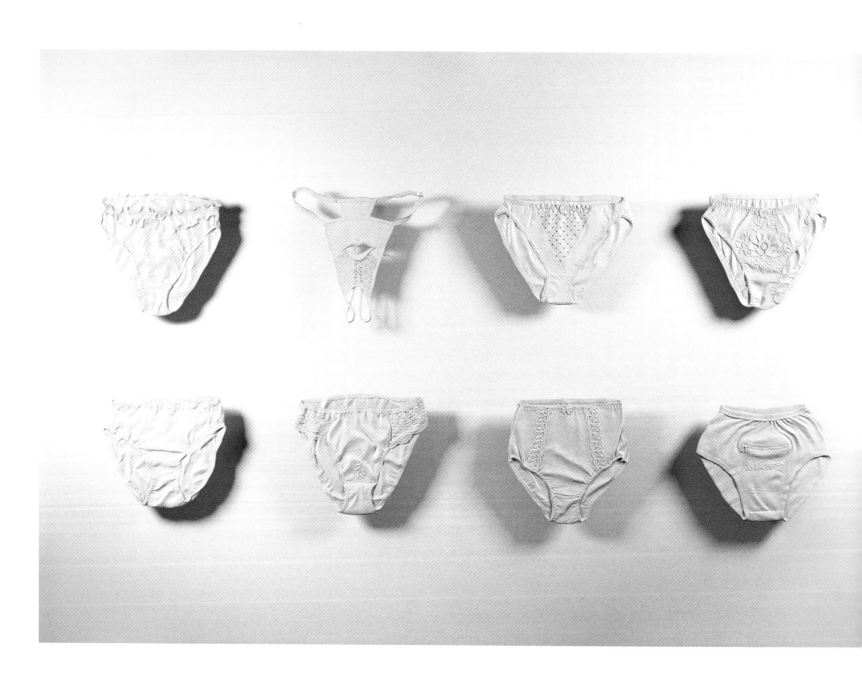

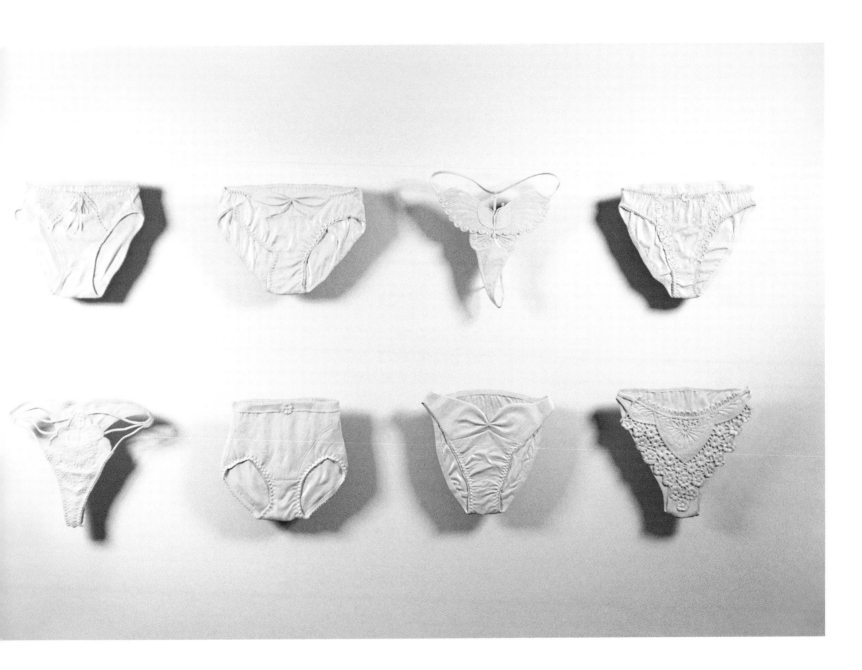

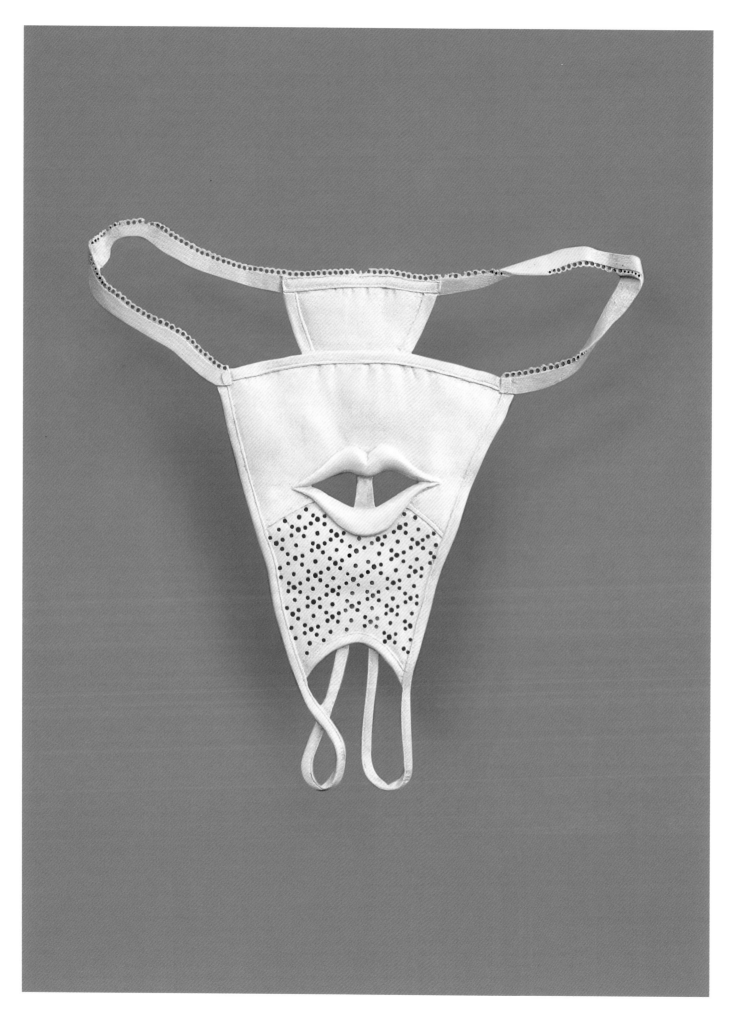

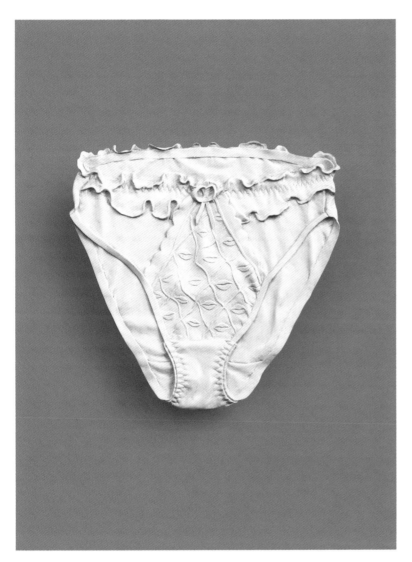

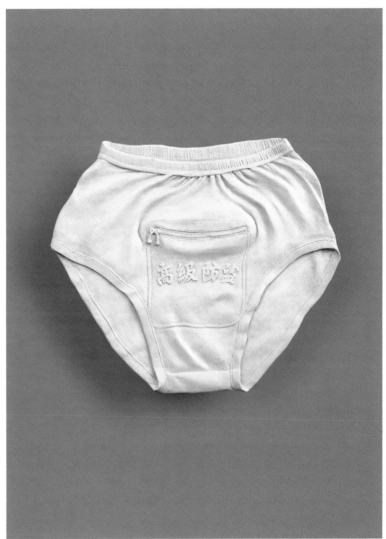

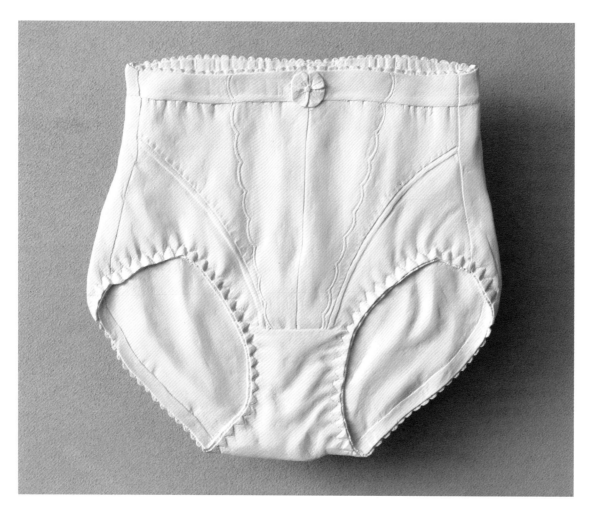

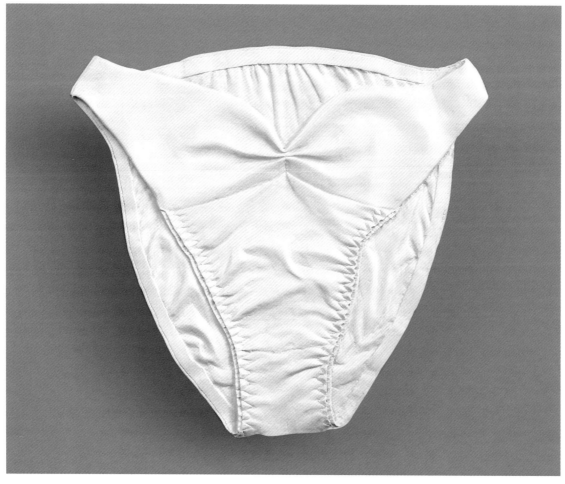

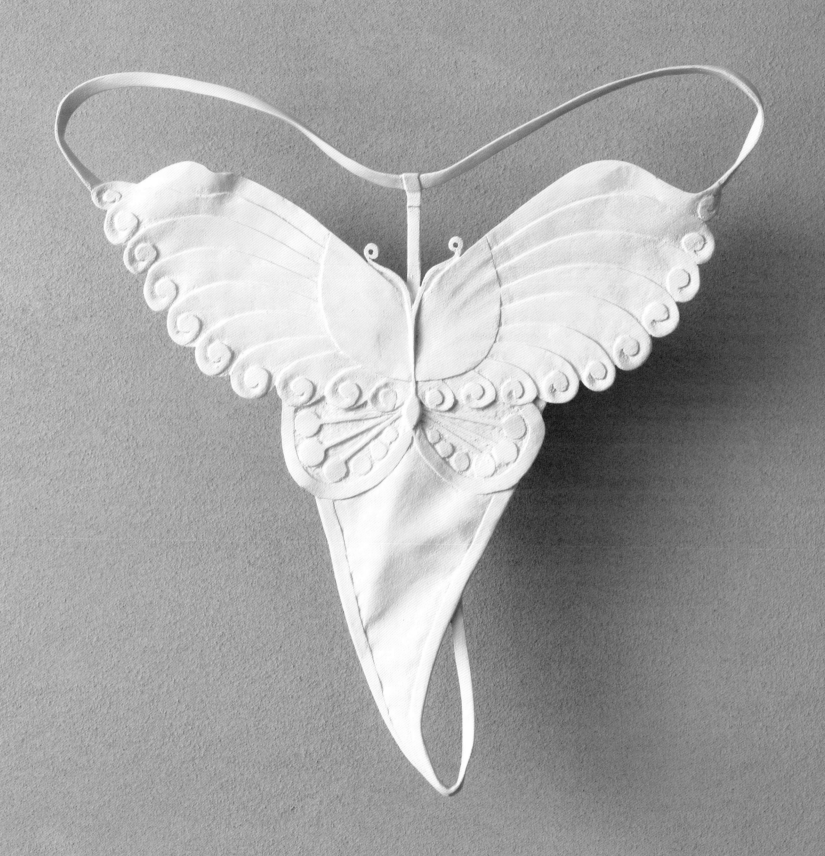

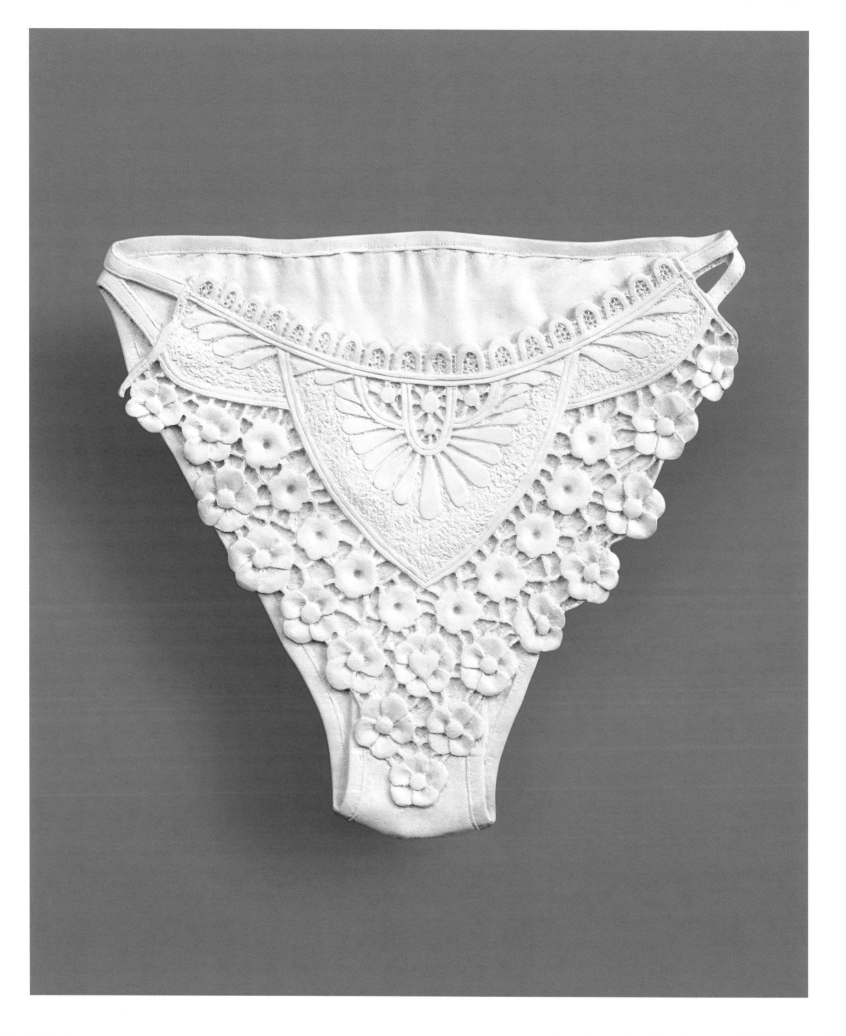

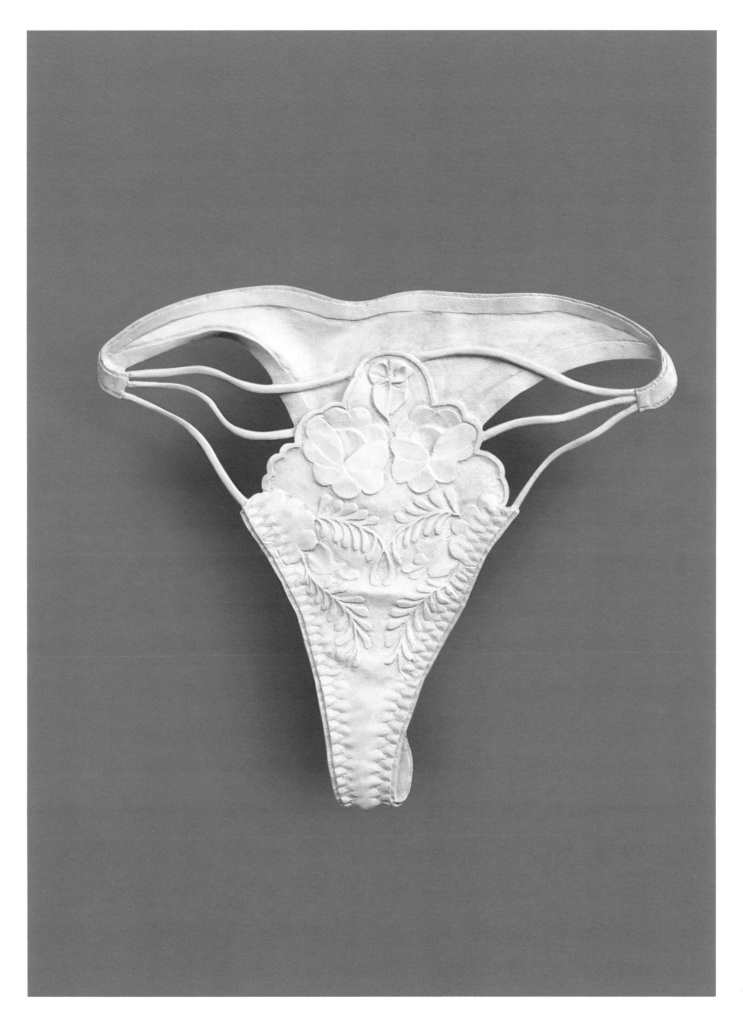

FRAGMENTS

This artwork was created in 2000, when I graduated from the Sydney Academy of Fine Arts. It consists of forty different object shapes, with no fixed or logical connection between them. My idea was to question the notion of originality. So these forms are copied from others or from what I made myself. I simply designed the surface and colour and re-organised them. There is no specific positioning required for any of the pieces on display, and the title has no particular meaning.

Fragments
2000
MDF, acrylic paint
Variable dimensions
Installation view

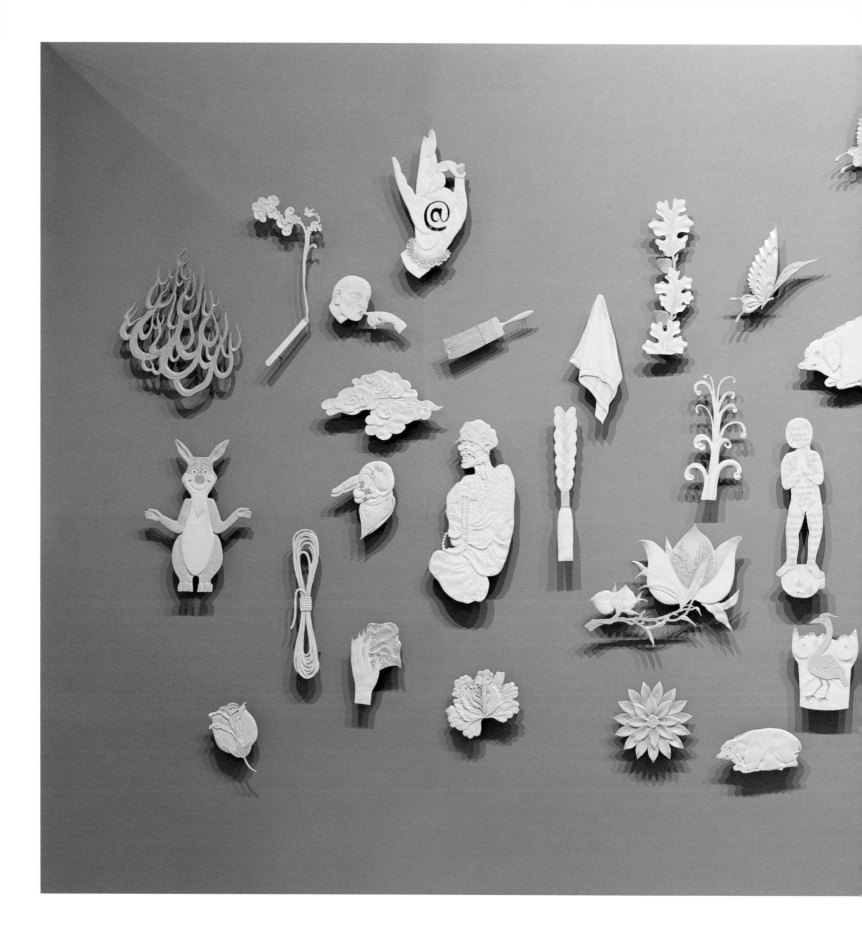

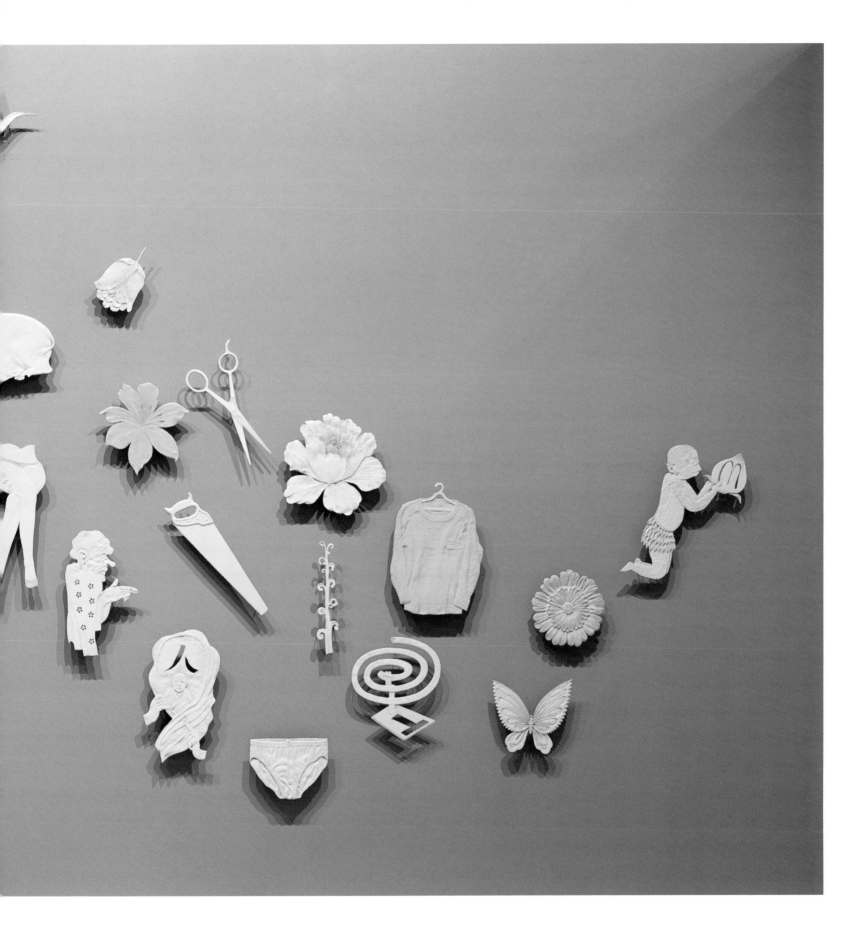

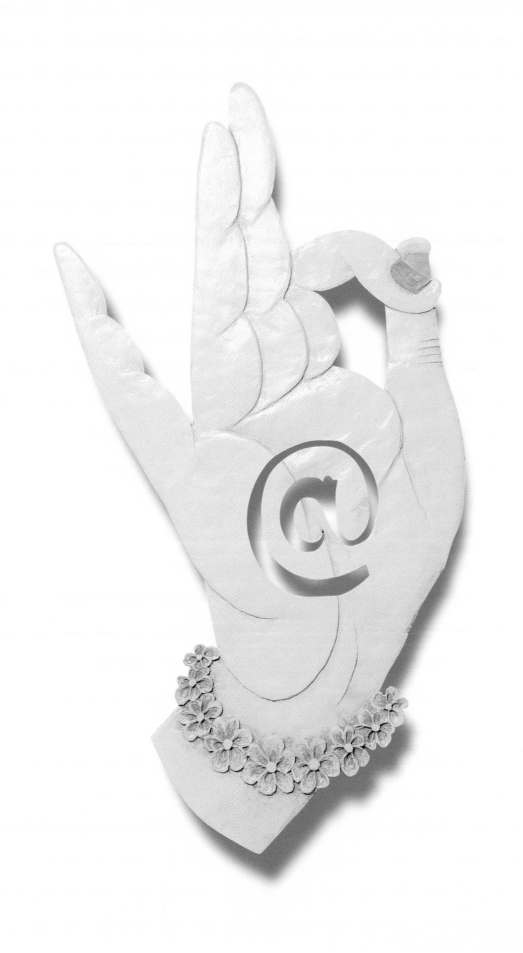

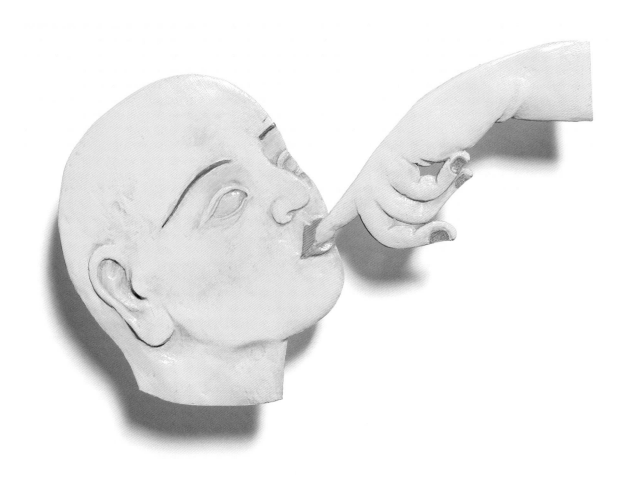

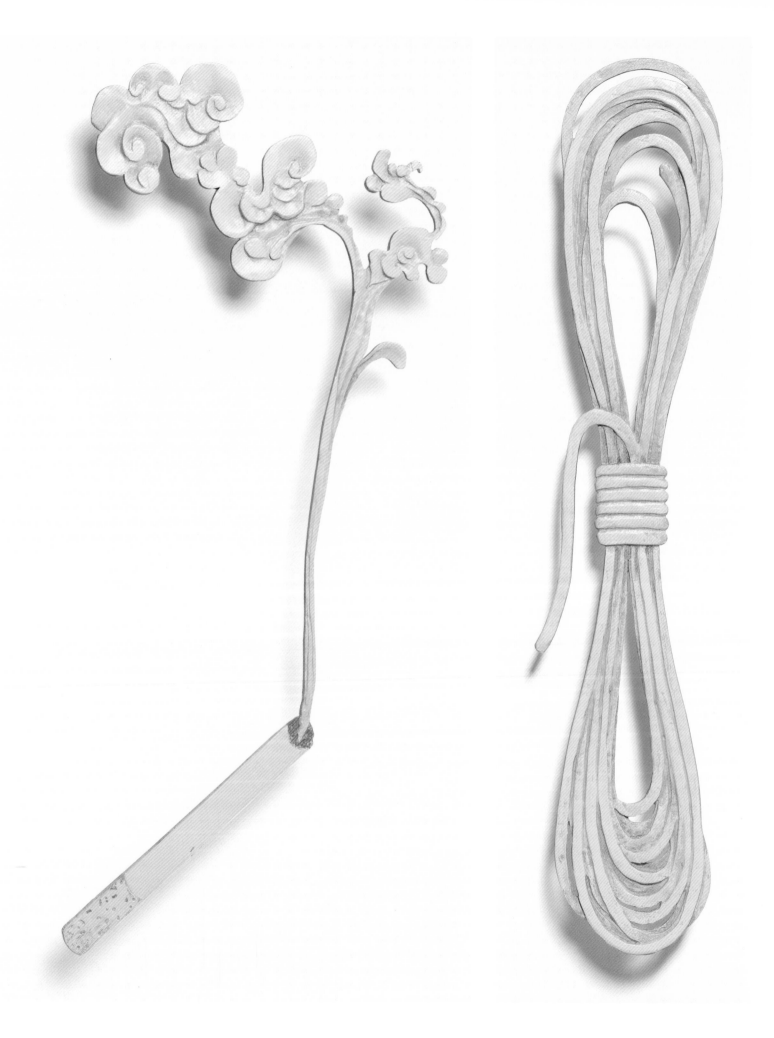

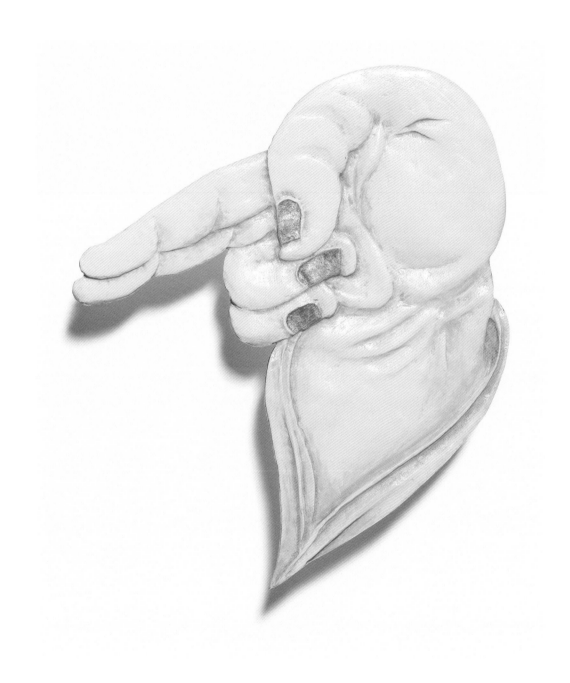

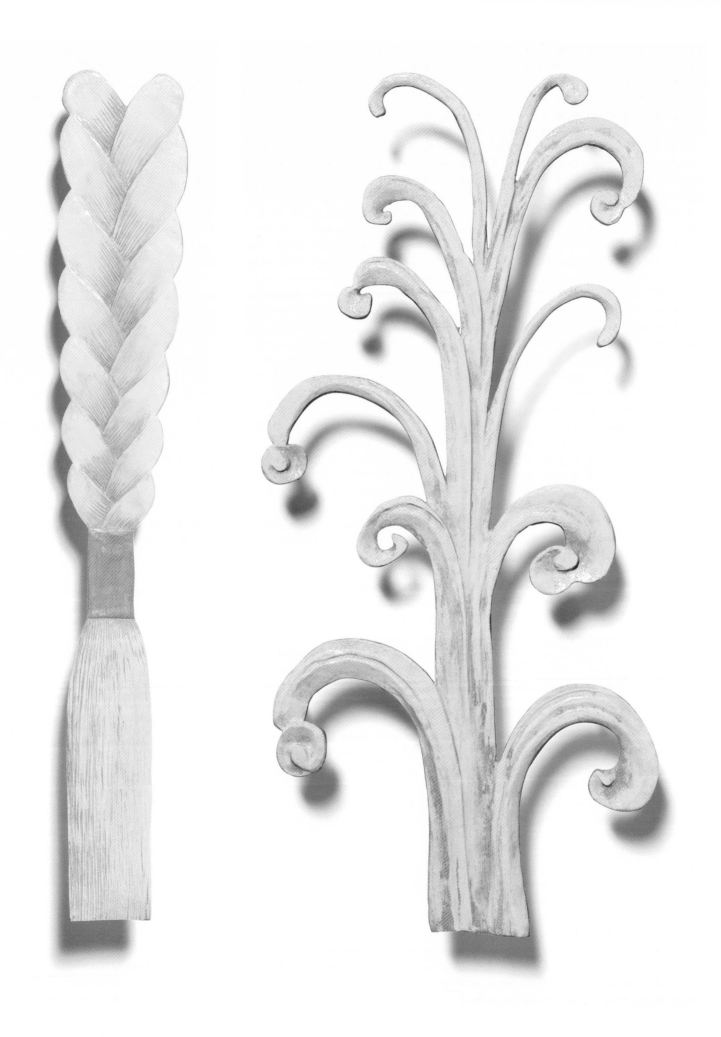

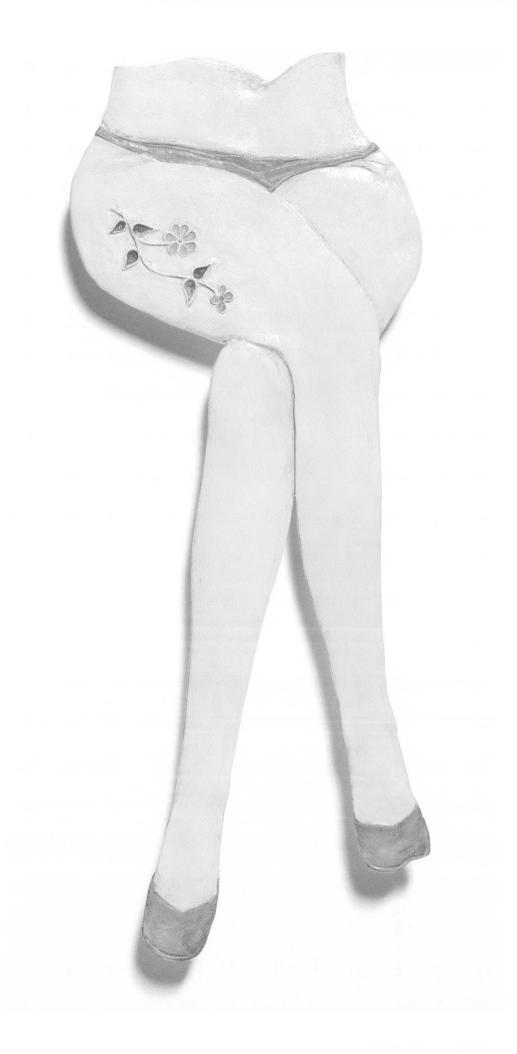

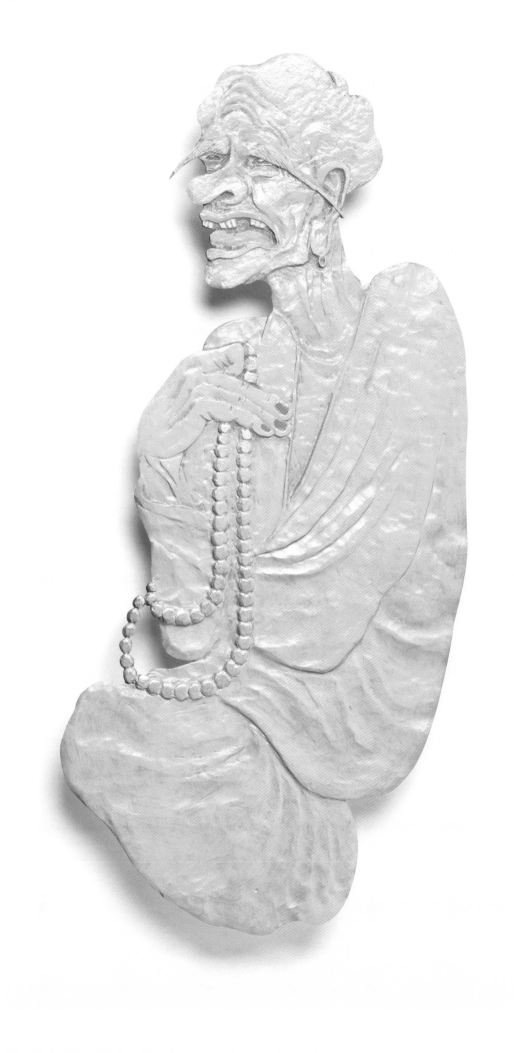

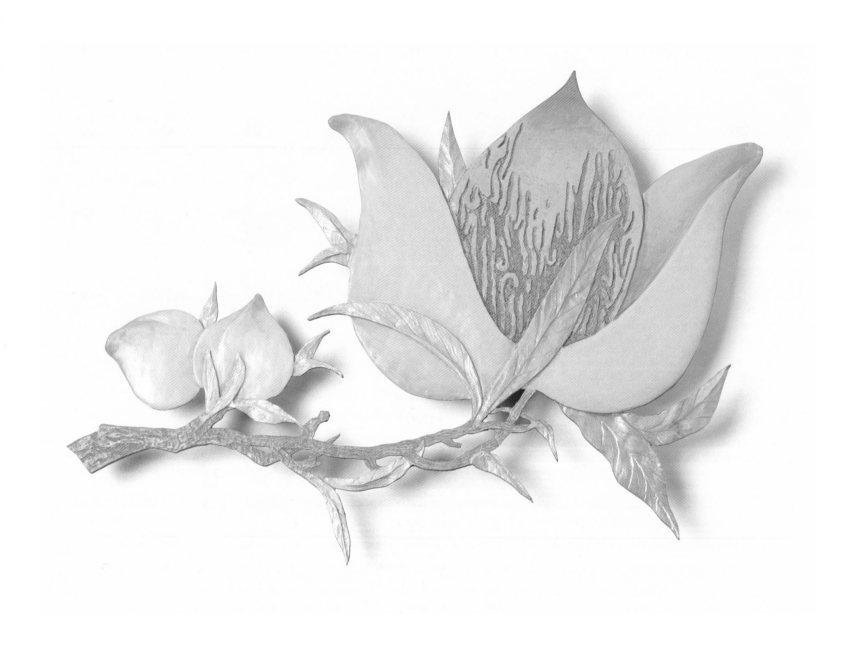

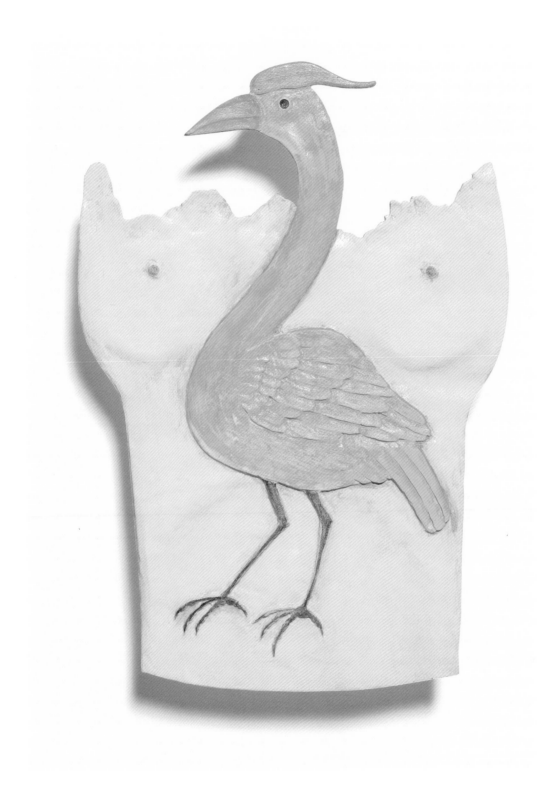

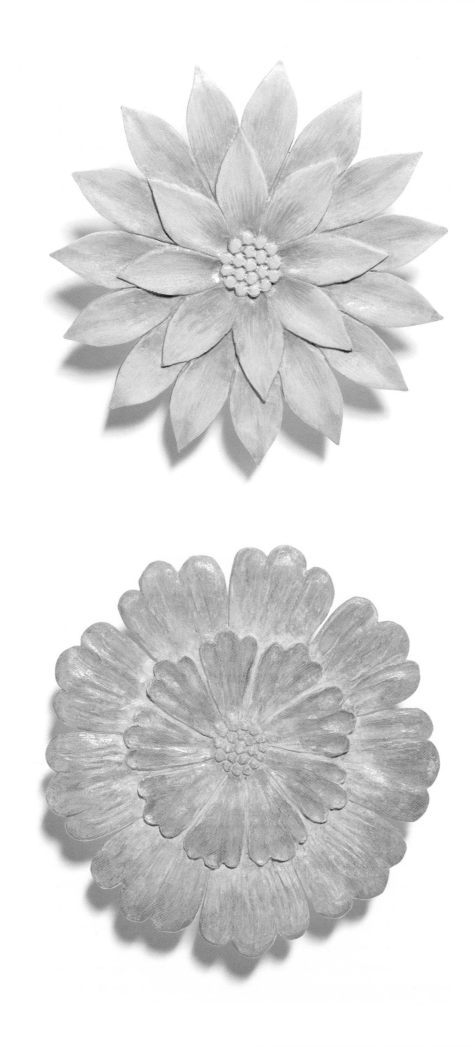

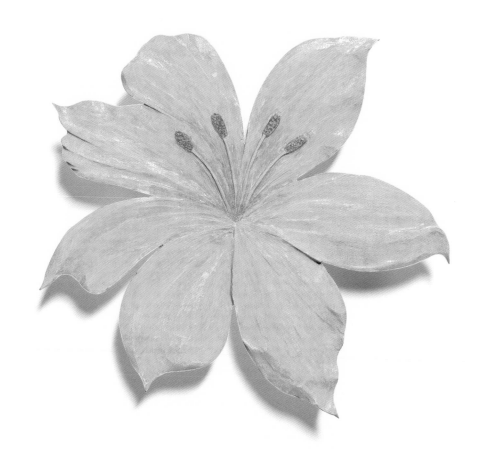

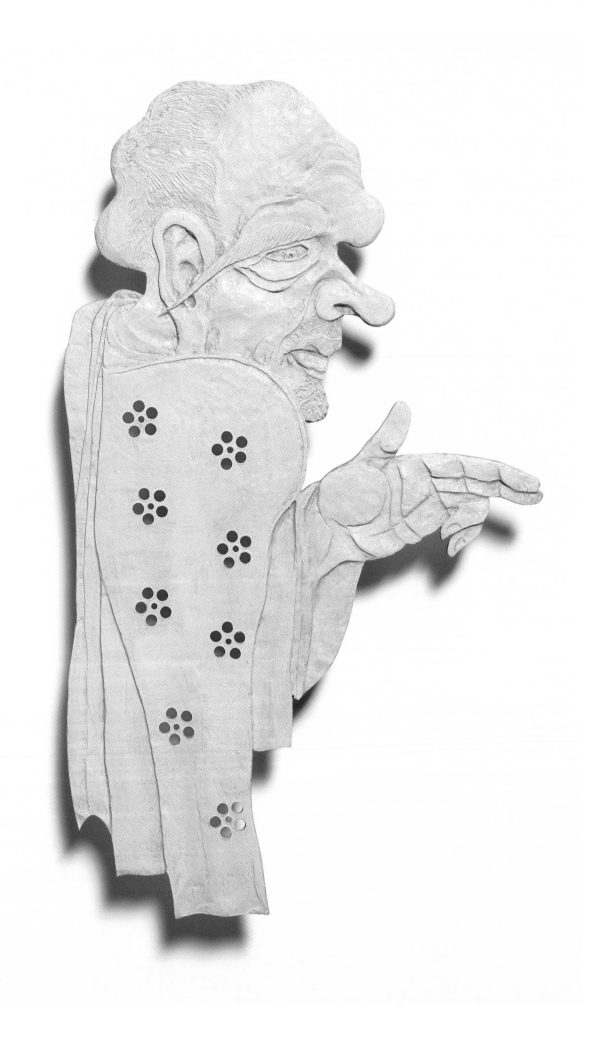

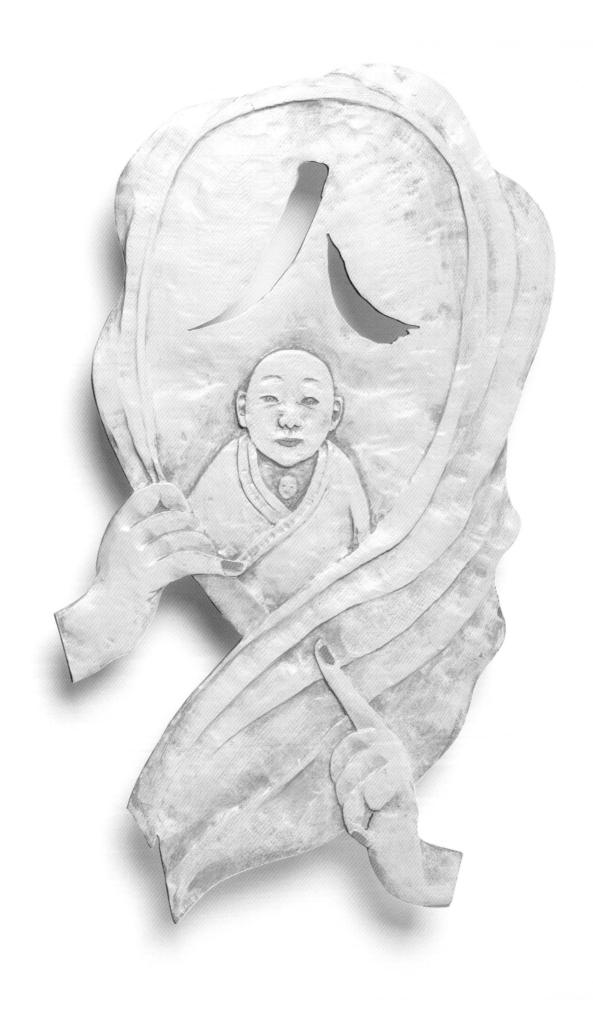

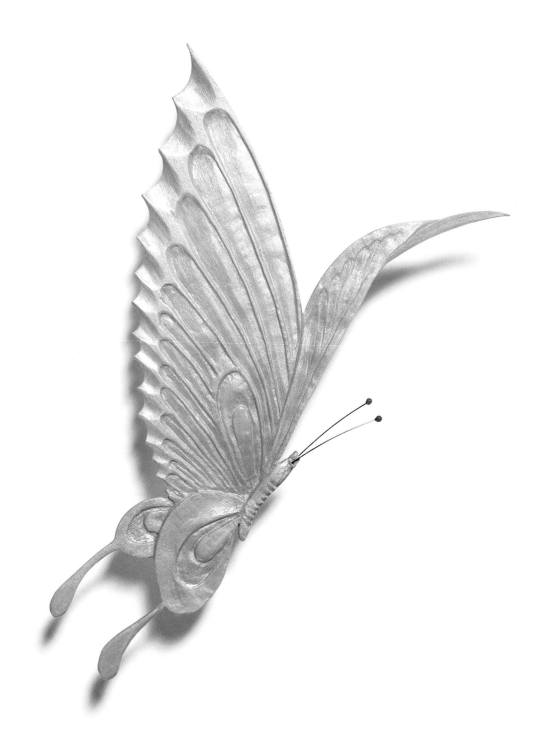

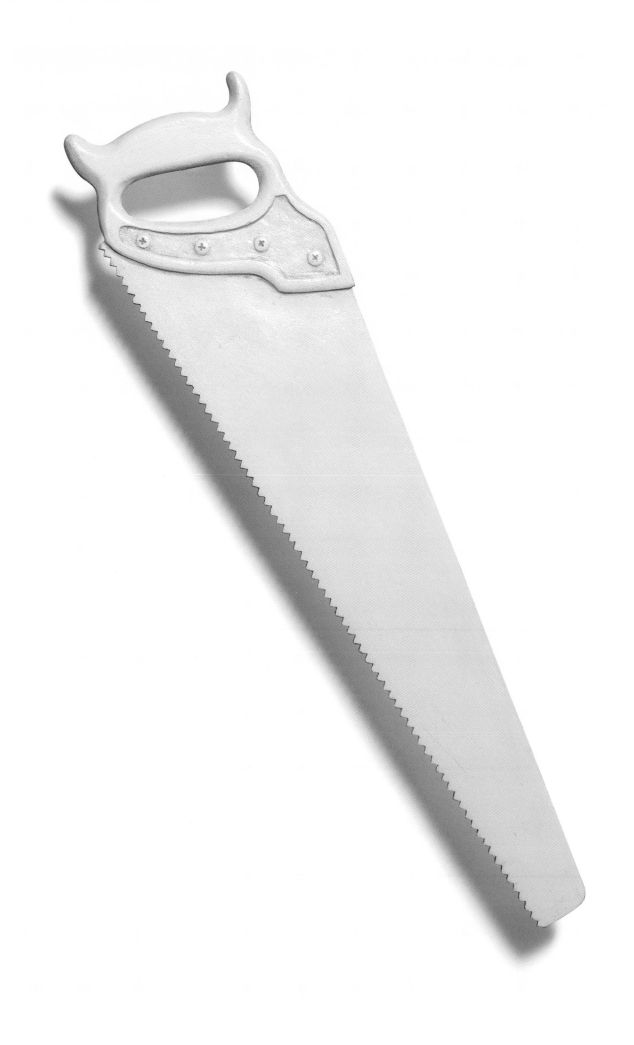

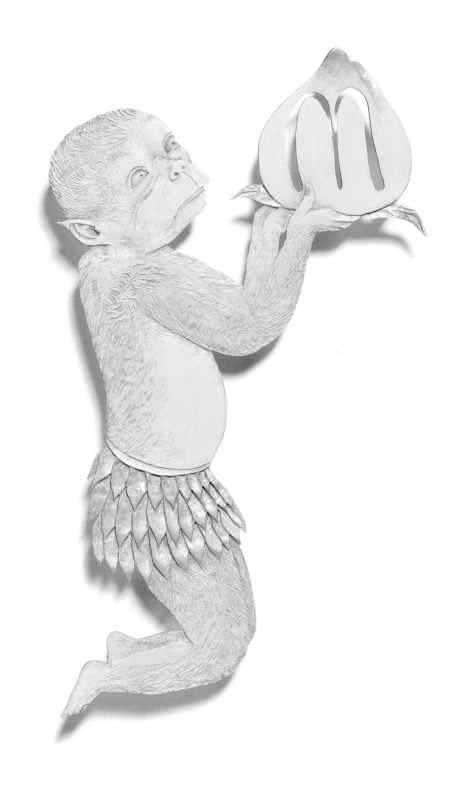

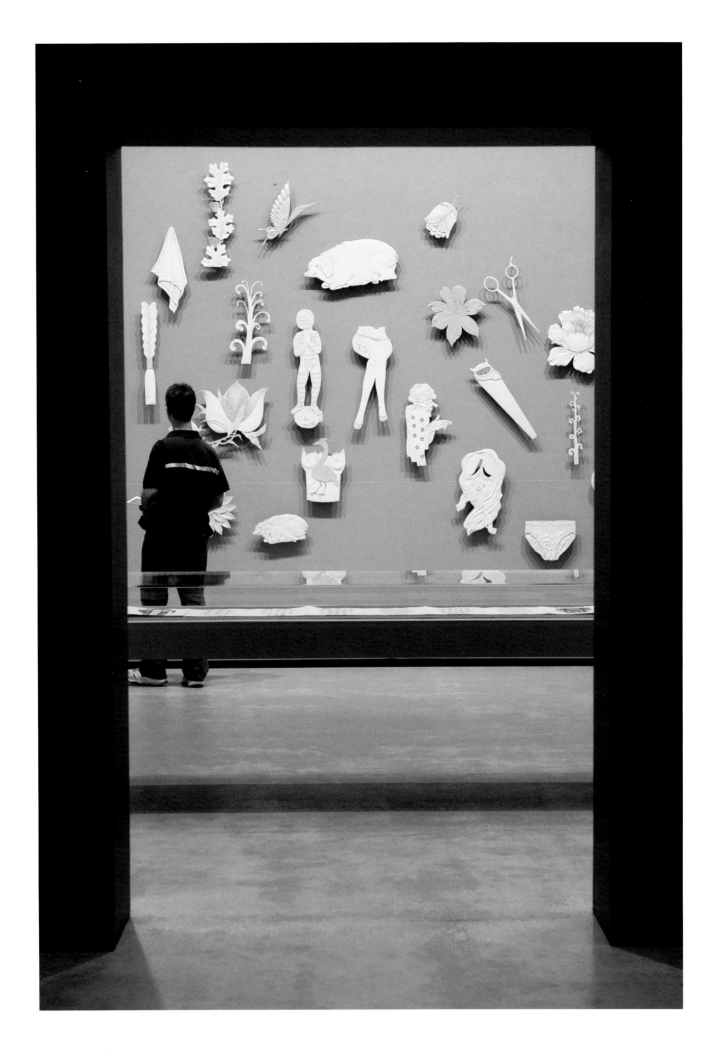

TWO FROM ONE

Lao-Tzu is quoted as having said: "From Tao is born one, from one is born two, from two is born three, and from three are born all living things". I chose these specific details as metaphors: human body parts, animal body parts, plant parts, air, and liquid. The basic concept comes from the primitive approach of ancient Taoism and how it interprets the world within these five fundamental elements, which are constantly subject to change. But I combined this notion with art patterns from contemporary imagery. All these forms are the result of natural growth and development. I deliberately wanted to emphasise their variations in such a way as to make possible what is seemingly impossible. I didn't indicate my attitude or opinion in this series of works, but instead tried to stress the differences by appropriation. The real significance here lies in their composition, where meanings flow and mutate.

Two from One
1998
Metal sheet
Variable dimensions

Two from One
1997
Metal sheet
Variable dimensions

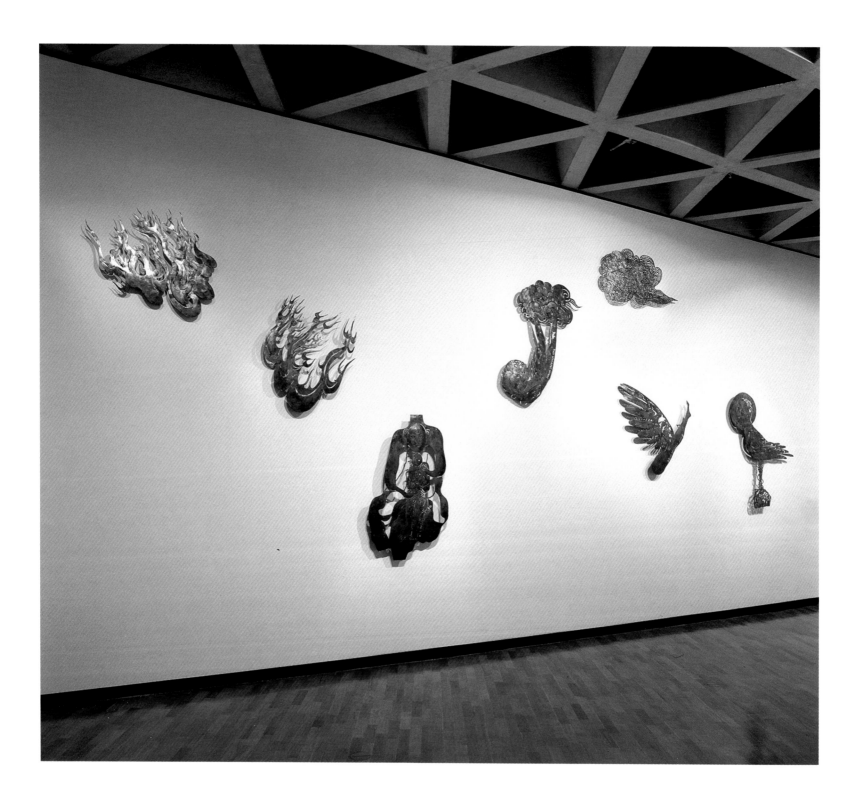

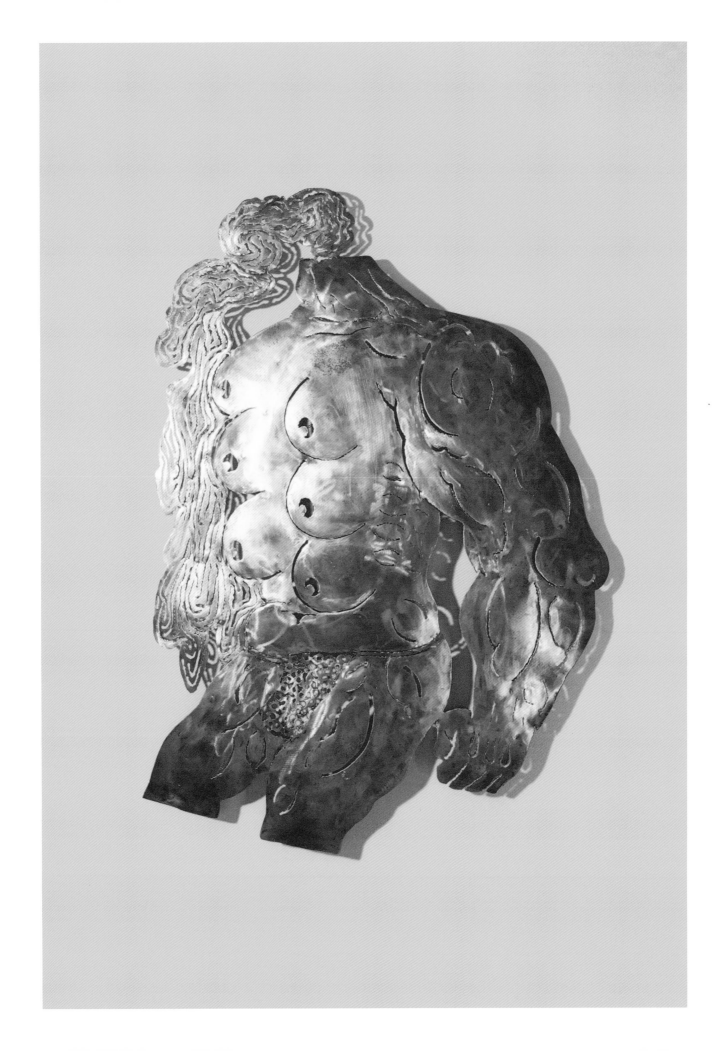

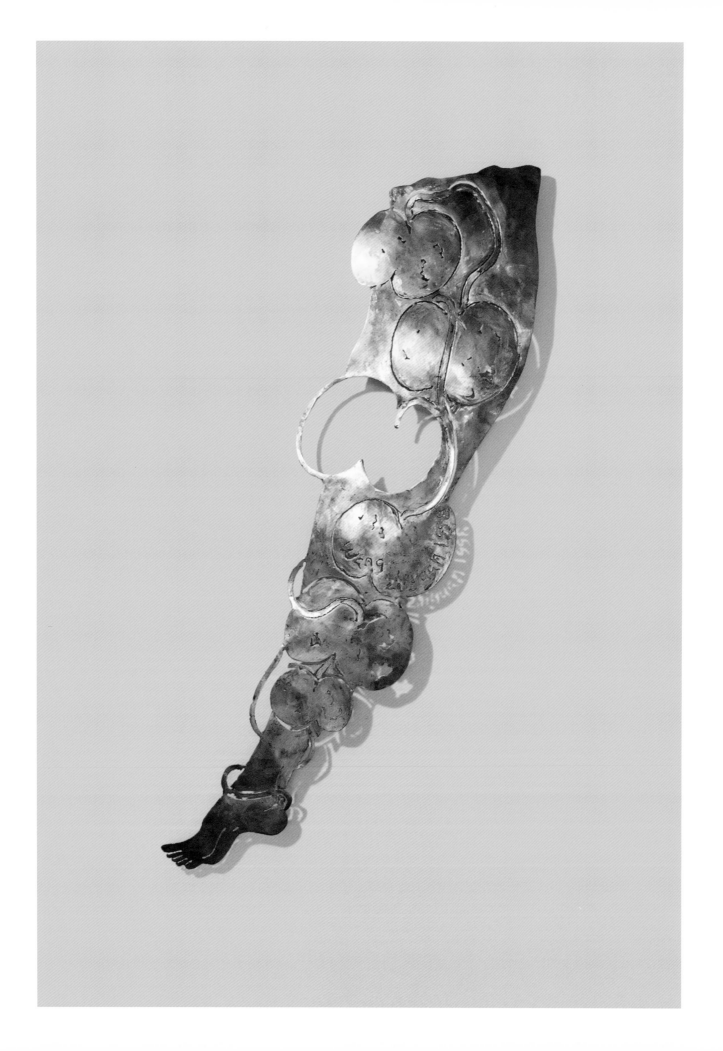

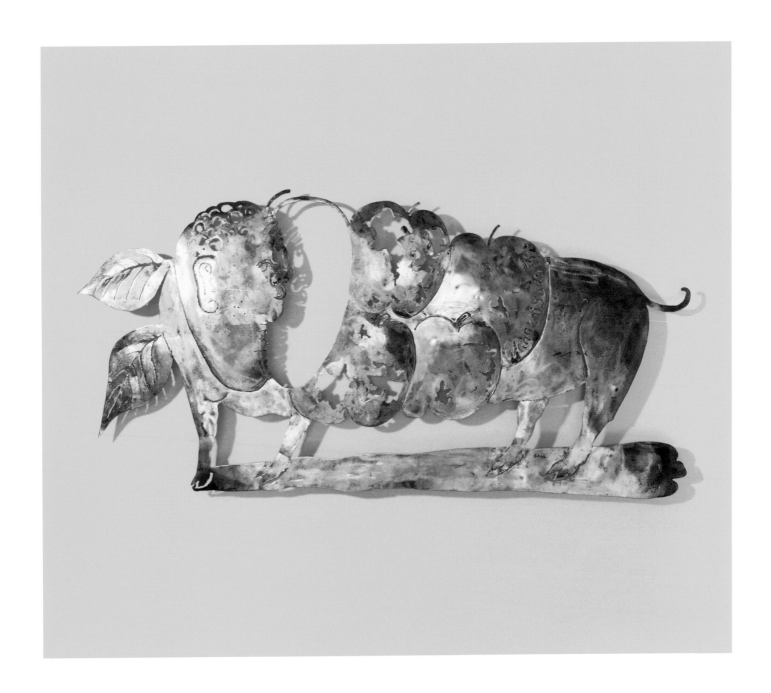

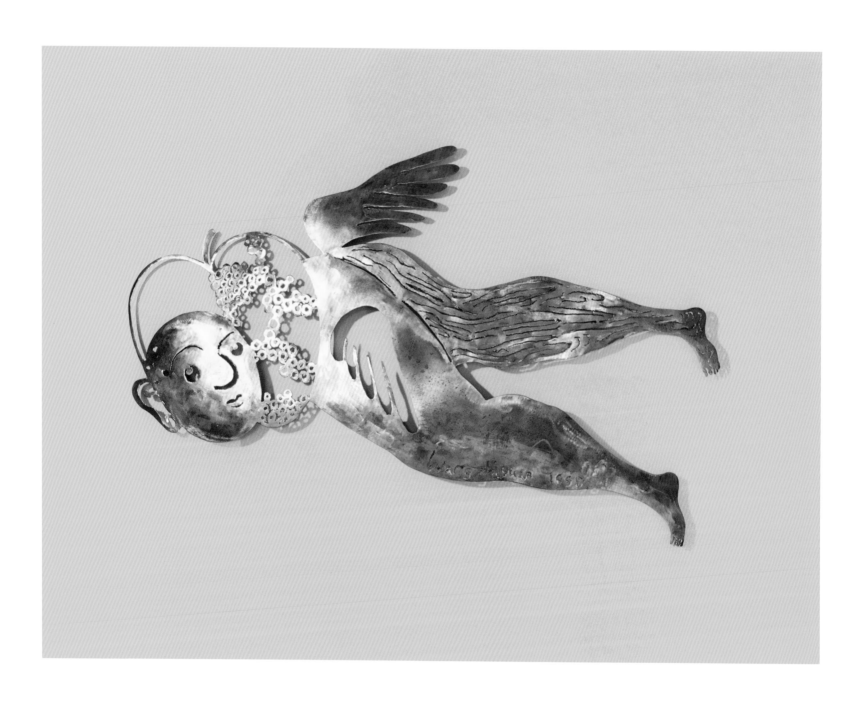

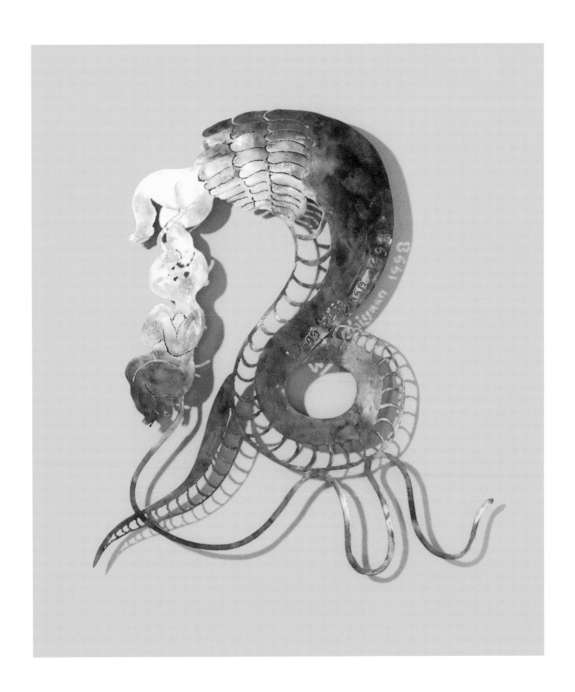

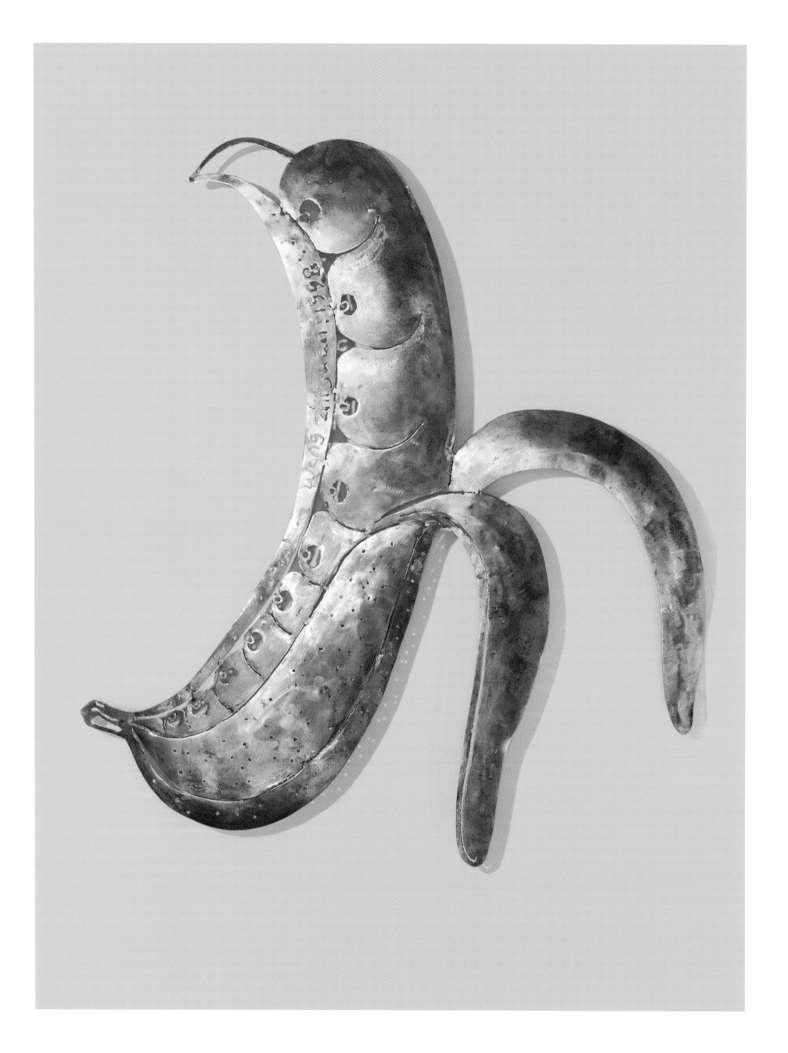

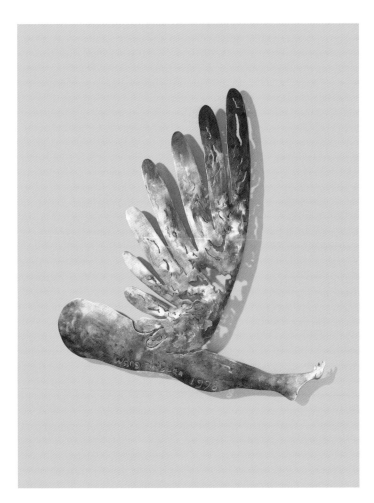

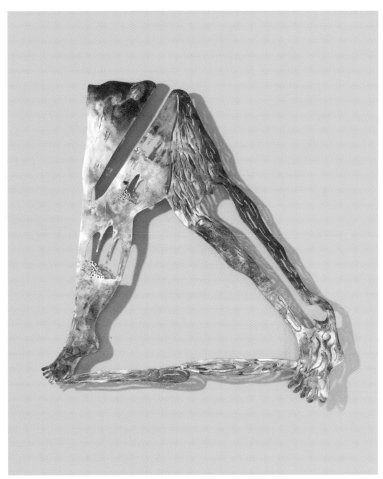

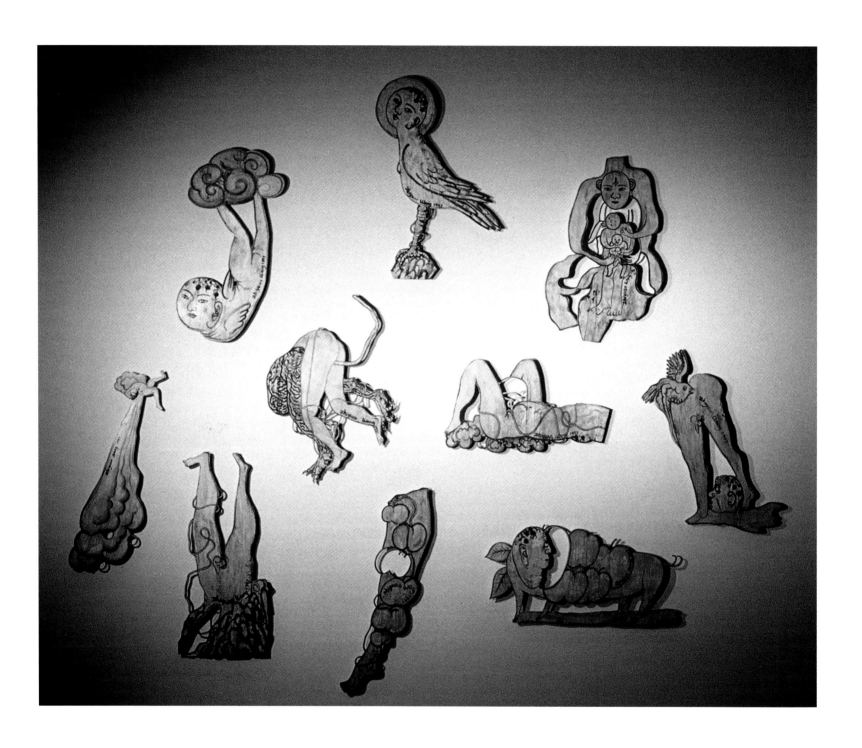

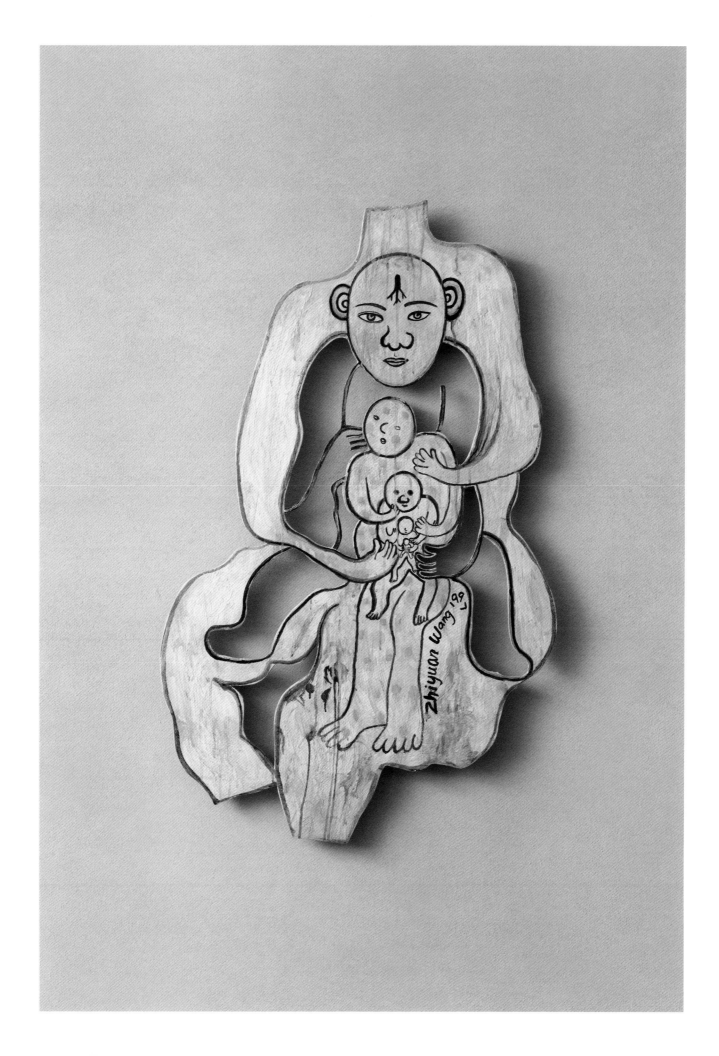

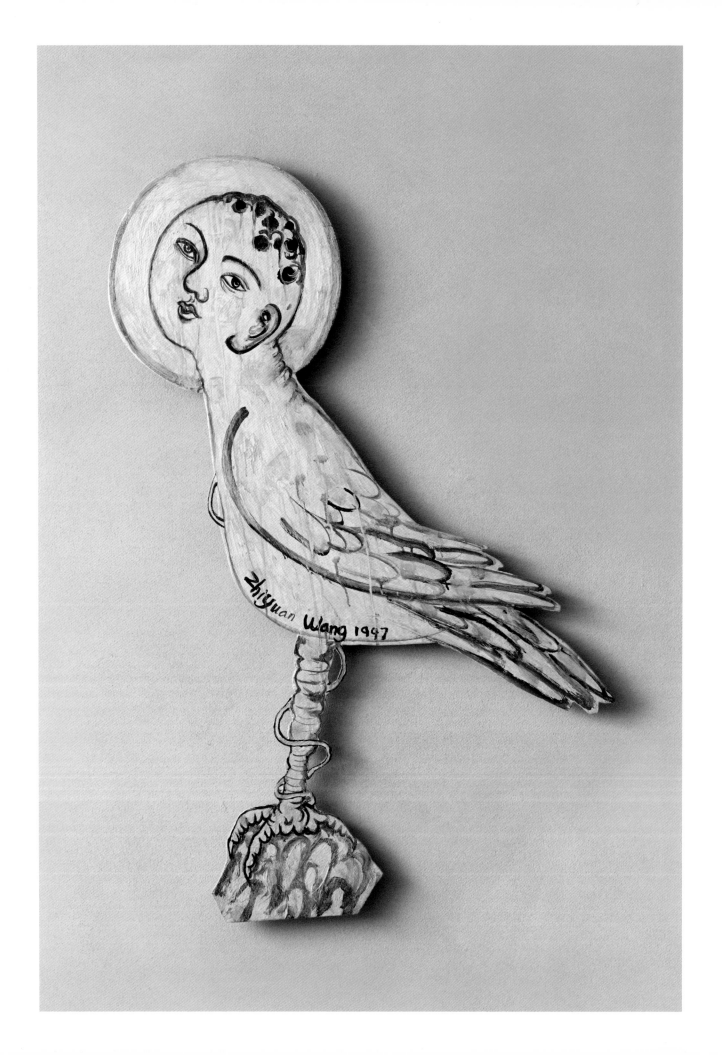

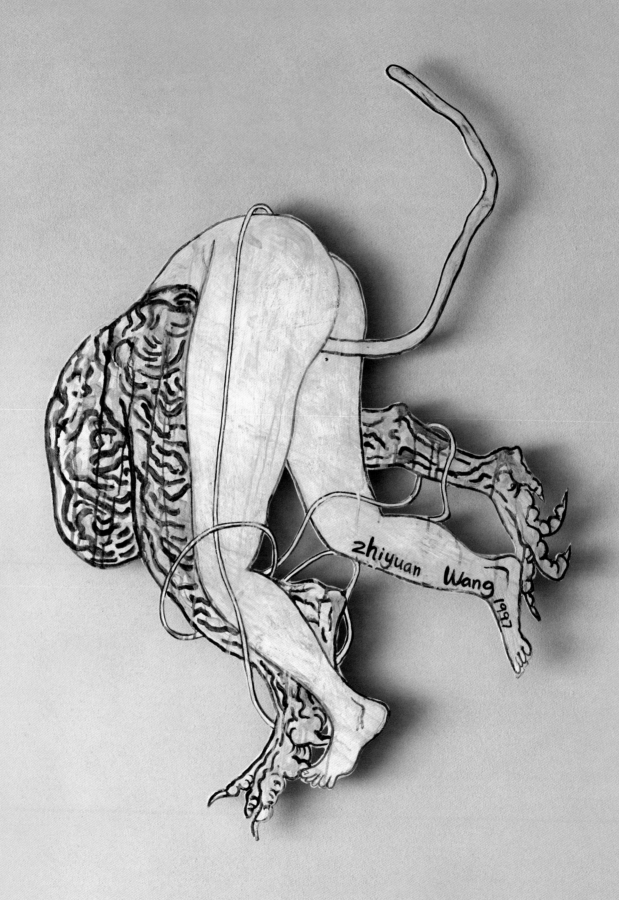

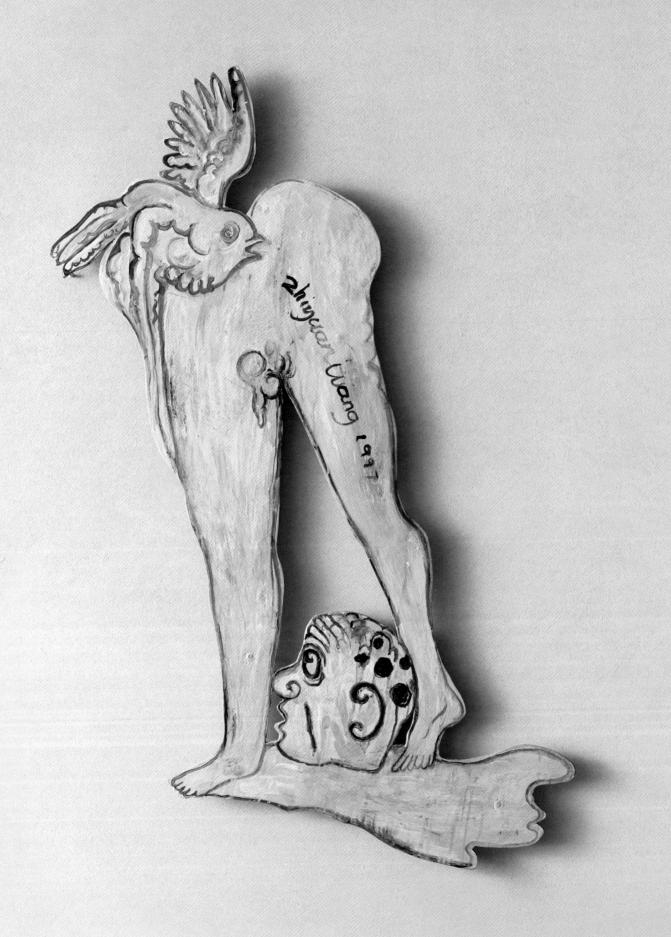

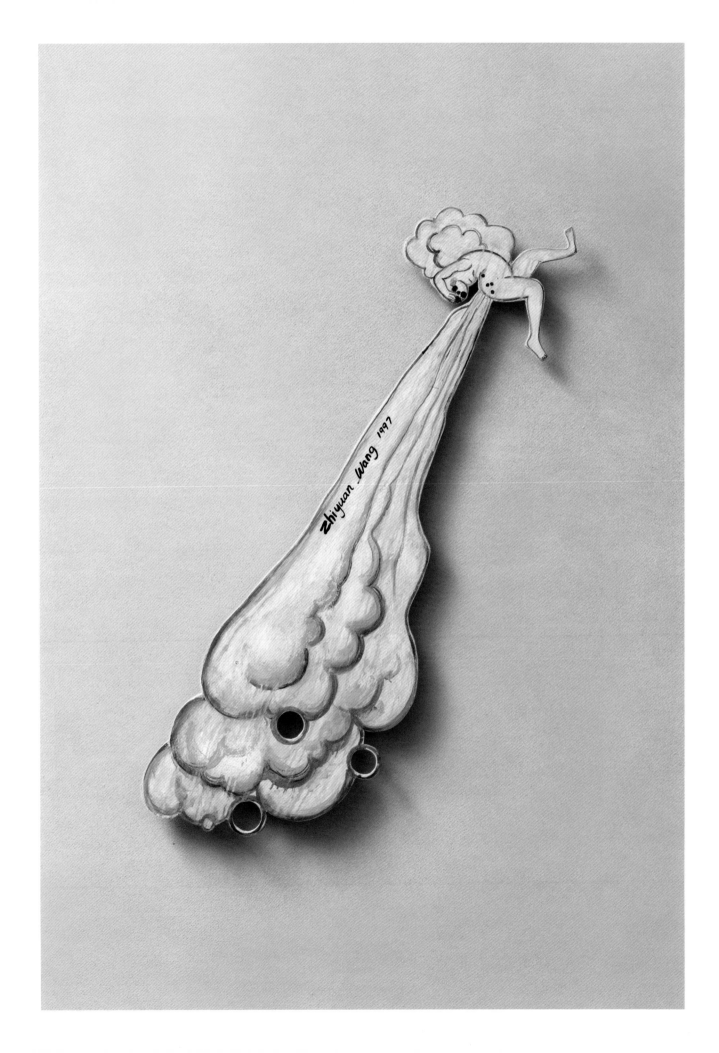

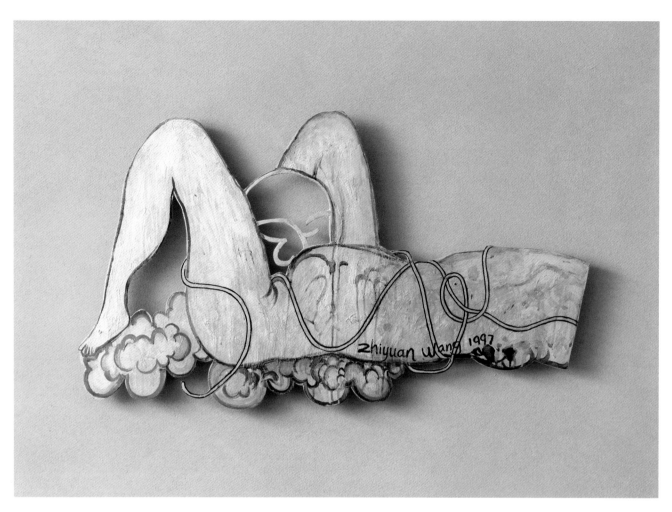

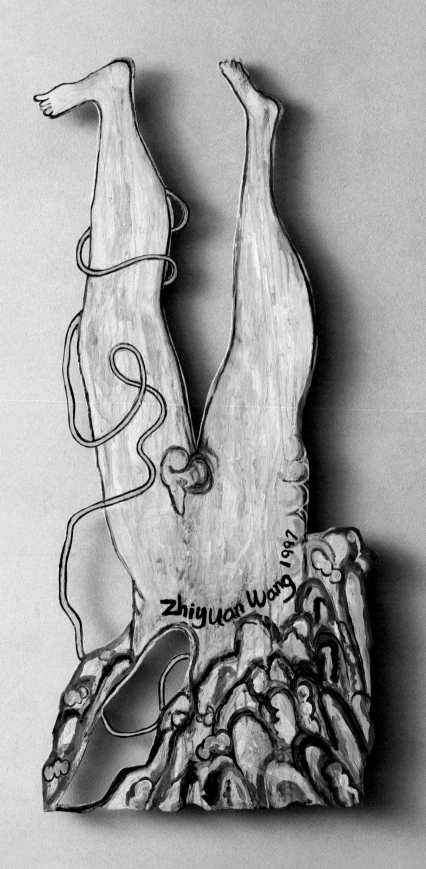

HAPPINESS

Our desire for it is universal. Happiness means so many (different) things to so many (different) people. But when we are happy we all feel the same. The figures in my work are almost always asexual or may even be considered transsexual, implying the inherent interchangeableness of meanings, roles, cultures, and ideas in the "present" moment.

Happiness
1996
Acrylic on canvas
1.7 × 8 m

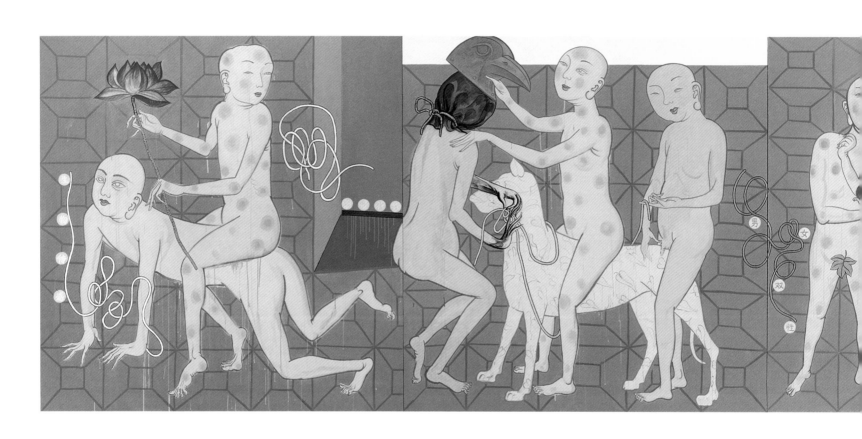

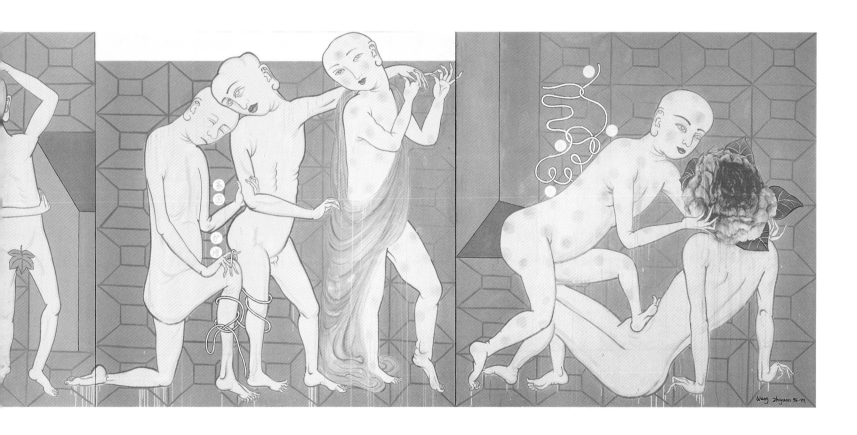

BEAUTIES CAPTURED IN TIME

The subject matter in this work is based on selective appropriations of the tradition of Chinese erotic painting from the eighteenth and nineteenth centuries. In form and colour, they are a hybrid of the light and perspective emerging from Chinese folk art and classical western oil painting. My intention here was to capture and revive a Chinese tradition to recreate something that was distinctly oriental and that didn't already exist in contemporary art. Whatever the result, I tried to adhere to some basic principles for this work: auspiciousness, happiness, and frivolity. I portrayed eight Chinese maidens in different poses and dress, appearing more like prostitutes than girls from "respectable families".

Beauties Captured in Time
1994
Oil on canvas
220 × 368 cm

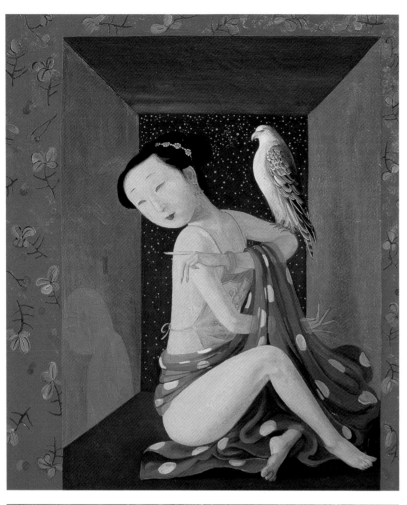
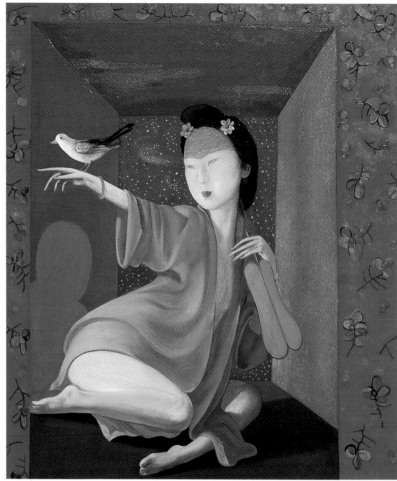
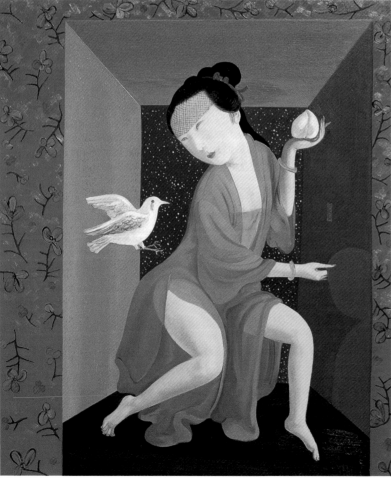
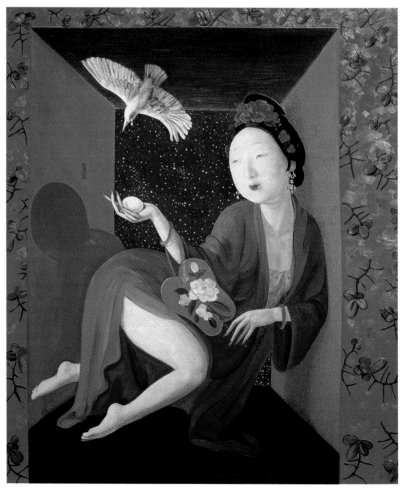

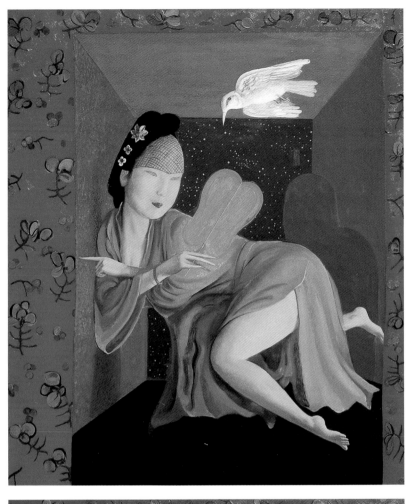
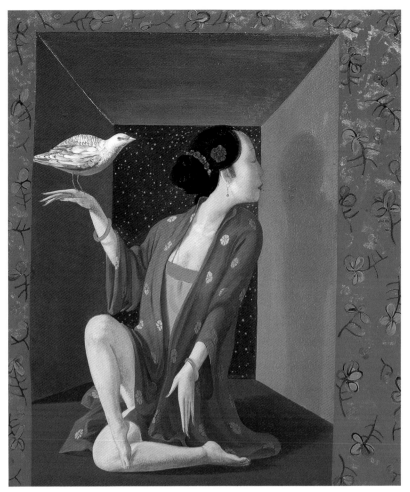
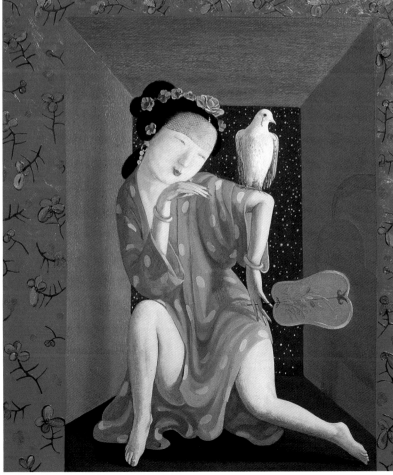
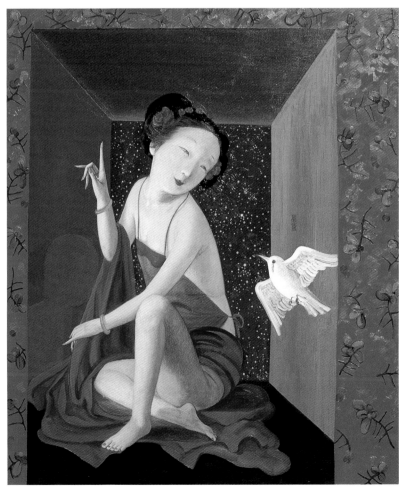

WILD
FLOWER

The prototype for this work evolved from the many sketches I did at the time. In 1982 I went to a village in Xinxiang County, in northern Henan Province, to paint en plein air. The simplicity and poverty of the farmers there shocked me. When Chairman Mao visited these same villages in 1958, he fully affirmed the system of the People's Communes, where everything was shared and organised in production brigades and teams with governmental, political, and economic functions. This system soon spread across the whole of rural China. It later resulted in widespread poverty and became totally unsustainable. Eventually, in 1983, the system was abolished.

Wild Flower
1982
Ink on rice paper
30 x 30 cm

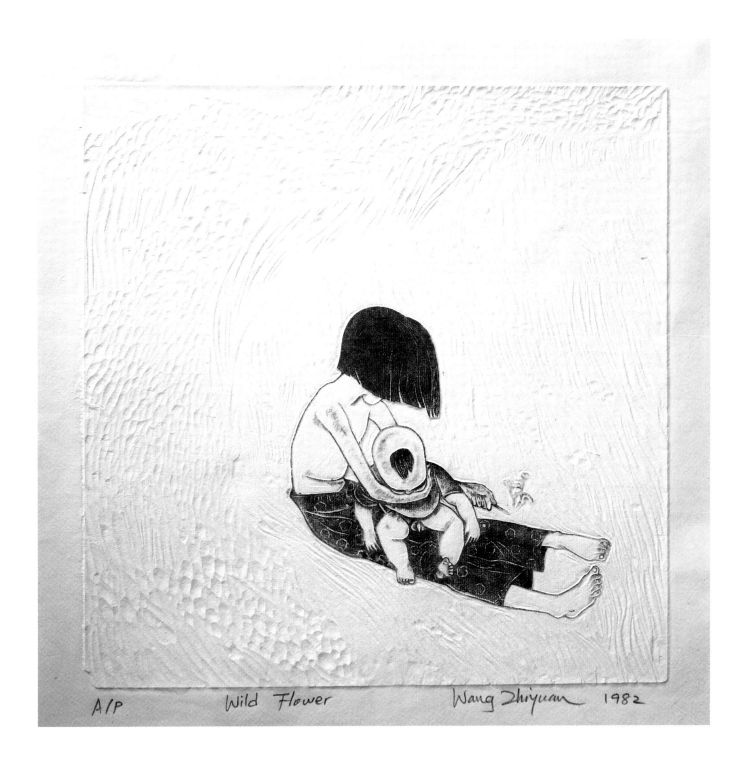

A/P Wild Flower Wang Zhiyuan 1982

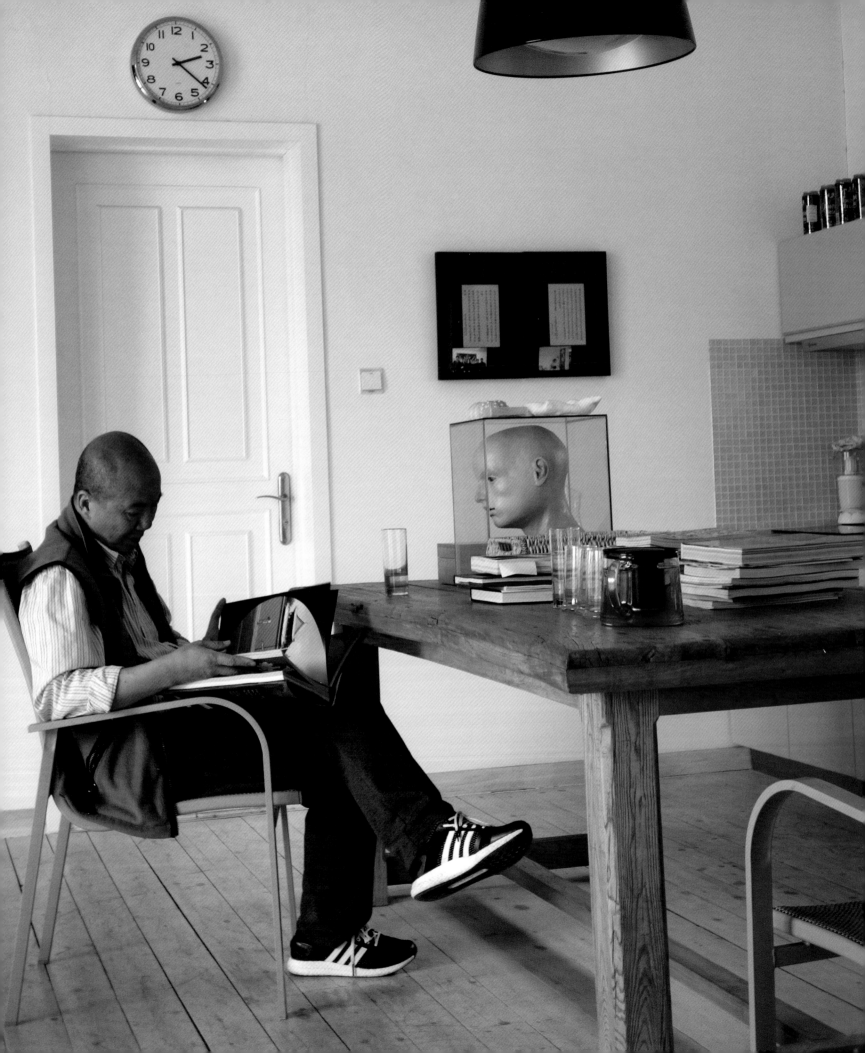

Biography

Wang Zhiyuan
Born in 1958 in Tianjin, China.
Currently lives and works in Beijing.

Education
1999–2000
• Enrolled in a two-year master's course at Sydney College of the Arts (Sydney University), Sydney.
1980–84
• B.A. Fine Arts (print media) at Central Academy of Fine Arts, Beijing.

Work
2016
• Organised a group exhibition, *This Future of Ours*, at Red Brick Art Museum, Beijing.
2006–12
• Collection consultant for White Rabbit Chinese Contemporary Art Collection, Sydney.
1984–89
• Lecturer at Attached Middle School of Central Academy of Fine Art, Beijing.

Selected solo exhibitions
2013
• *Wang Zhiyuan's Solo*, Xindong Chen Space for Contemporary Art, 798 Art District, Beijing.
• *Close to the Warm*, Force Gallery, 798 Art District, Beijing.
2011
• *Displacement: Wang Zhiyuan's Solo Show*, Enjoy Art Museum, 798 Art District, Beijing.

Selected group exhibitions
2014–15
• *Chinese Contemporary Art Research Exhibition*, Union Art Museum, Wuhan.
2014
• *Peach Blossom Spring / Cacotopia*, Kui Yuan Gallery, Guangzhou.
• *Erosion*, Room C, Shone-Show Gallery, 798 Art District, Beijing.
2010
• *Negotiations: The Second Today's Documents*, Today Art Museum, Beijing.
2009–10
• *Beijing Time*, Madrid and Santiago de Compostela.
• *Chinese Contemporary Art*, White Rabbit Chinese Contemporary Art Gallery, Sydney.

• *Coming Home*, 798 Linda Gallery, Beijing.
• *Individual*, JoyArt 798, Beijing.
2008
• *West to the East. The Aesthetic Context of Intellectuals*, SZ Art Center at 798, Beijing.
• *Best of Discovery – 08 Shanghai Art Fair International Contemporary Art Exhibition*, Shanghai Exhibition Centre, Shanghai.
2007
• *Curious 2007. New Object and Sculpture*, Galerie Deschler, Berlin.
2006
• *The Damn of Meaning*, Beijing Tokyo Art Projects, Beijing.
• *Living Furniture*, Busan Biennale, Busan, South Korea.
• *Brush Hour 2*, Space ieum, Beijing and Sun Contemporary Gallery, Seoul.
• *Art 37 Basel*, Gallery Hyundai, Basel.
• *Fiction Love*, Museum of Contemporary Art Shanghai, Shanghai.
2005
• *Grounding Reality. New Chinese Contemporary Art*, Seoul Art Center, Seoul.
• *Austral-Asia Zero Five*, Sherman Galleries, Sydney.
• *Shanghai Cool. Creative Reproduction*, Shanghai Duolun Museum of Modern Art, Shanghai.
• *Asian Traffic*, Today Art Museum, Beijing and Zhengda Art Museum, Shanghai.
• *Paradiso d'Amore. Neo-Aesthetics of Animamic Age*, Art Museum of the China Millennium Monument, Beijing.
• *Inter-tivity*, Today Art Museum, Beijing.
2004
• *Artificial Happiness*, RMIT Gallery, Melbourne.
2003
• *Lost and Found*, Queensland Art Gallery, Brisbane.
• *Group Show*, Beijing Seasons Art Gallery, Beijing.
• *50x50*, Temple Bar Gallery & Studios, Dublin.
2001–4
• *Glacier*, RMIT Gallery, Benalla Regional Art Gallery, Newcastle Regional Art Gallery, Australia.
• Gallery, QUT Art Museum, Bond University Art Gallery, Gold Coast, Australia.

2000–1
• Seven-piece sheet metal wall-sculpture on display in the *Australian Art* section of the National Gallery of Australia, Canberra.
2000
• *Group Exhibition*, National Gallery of Australia, Canberra.
1998
• *Culture Graft*, 4A Gallery, Sydney.
1997–2000
• *IN and OUT, Contemporary Chinese Art from China and Australia*, touring to Melbourne, Sydney, Tasmania, Queensland, Perth, Canberra in Australia, as well as to Shenzhen, Beijing in China, and Singapore.
1994
• *Sulman Prize Exhibition*, Art Gallery of New South Wales, Sydney.

Grants and residencies
2007
• Project grant, Australia Council for the Arts, Sydney.
2003–4
• Artist in residence, Irish Museum of Modern Art, Dublin.
2001
• Artist in residence, Sydney College of the Arts, Sydney.
2000, 1996 and 1995
• Project grant, Australia Council for the Arts, Sydney.

Collections
• British Museum, London.
• RMIT, Melbourne.
• National Gallery of Australia, Canberra.
• Queensland Art Gallery, Brisbane.
• Platinum Asset Management and White Rabbit Chinese Contemporary Art Collection, Sydney.
• Various private collections in Japan, Korea, USA, Canada, Germany, Switzerland, Ireland, Australia, and Taiwan.

www.wangzhiyuanart.com

FAMILY AND LIFE

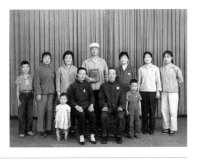

1. My mother in 1967, on her fiftieth birthday, during the Great Proletarian Cultural Revolution. I was nine years old at the time, and I still remember her dressing up in front of a mirror to have this photo taken.

2. In 1960 I was two years old. The girl sitting next to me was my neighbour, everyone called her Xiao Hua.

3. My eldest sister with me in 1961.

4. All our family members in a "happy" pose. This photo was taken in 1969 when my brother was leaving home to join the "Down to the Countryside Movement". I was eleven years old (second row, far left).

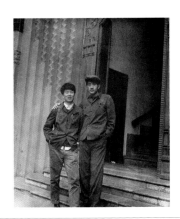

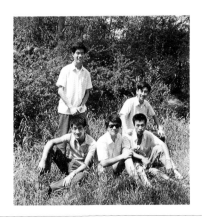

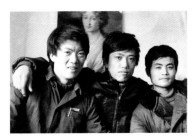

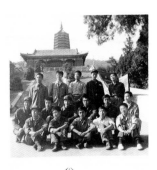

5. Classmates from the Interior Design Department, the School of Art and Craft of Tianjin (1975–78). There were eighteen boys in our class. This is Fragrant Hill Park, Beijing. Our programme required us to complete a forty-day course of landscape painting. We lived in a classroom in Shi Jingshan Middle School located at Western Mountains, Beijing. This was our summer vacation in 1976 (I'm in the last row, second from left).

6. Here I am with Wang Jie, a good friend and classmate at the Specialty Middle School, in front of the Youth Palace of Tianjin in 1979. I worked as an art editor in "The One-hundred Flowers Art Publishing House" from 1978 to 1980. During this time, I read hundreds of books collected by the publisher.

7. In 1980, I passed the entrance exam and enrolled into the Central Academy of Fine Arts. Before leaving Tianjin for Beijing, my good friends at the Specialty Middle School saw me off (Wang Xiaojie, Wang Jie, Sun Zhenwu, and Li Enxiang).

8. Just after I entered the Central Academy of Fine Arts in 1980 (I am on the left). Mr. Chen Danqing (centre) just completed his famous eight work series of Tibetan paintings.

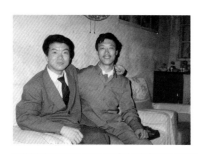

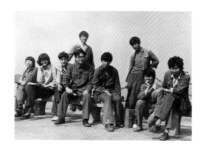

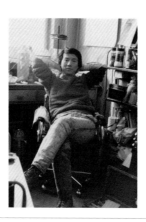

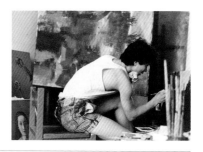

9. Here I am with my eldest brother in Tianjin in 1981. I was a college student – with a light heart and heavy body – back home from Beijing for the Chinese Spring Festival. I didn't realise my brother's situation at that time. He had been living in northeast China for ten years (1969–79) as an "Intellectual Youth". He went back to Tianjin with nothing (no job, nowhere to live, no wife), only two large boxes containing wood.

10. Eight classmates and our teacher, Zhao Ruichun, from the Print Media Department in 1982 at Taishan Mountain. We were all poorly dressed and had long hair.

11. In the dormitory. From 1985 to 1989, I was a teacher at the High School of Fine Art attached to the Central Academy of Fine Arts. I shared a room with Wang Shuibo. By the look in my eyes, you can tell that I wasn't so quiet.

12. In 1987 working in the studio at the High School attached to the Central Academy of Fine Arts in Beijing. At that time, I thought I was producing hopeless artworks. Now, when I think of them, maybe I would have been better off enjoying life with good food and drink!

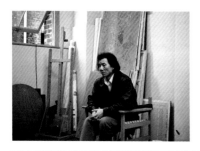

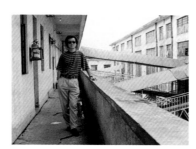

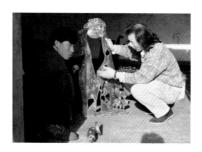

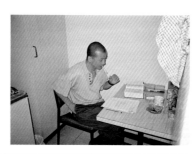

17. Sitting in a studio space in Sydney in 1995. I had some production materials and a few unsold works. Time had stopped… I felt helpless, lonely, and feared that there was no way out of my situation.

18. Seven years after leaving China I returned home. This is the workers' sleeping quarters in a factory in Dong Guang, Guang Dong Province, where my eldest brother worked. I visited him here and got the impression that everything was like a "mad meat grinder". Three months later, after returning to Australia, I got a call from home that my brother had died of a heart attack.

19. In 1998, I returned to Tianjin. Our house was located next to a steel finishing factory, where I created a series of 37 sheet-metal works. Sometime later, the National Gallery of Australia purchased seven of these for its collection. I didn't know this when I was making them, but what I did know was that the conditions for the factory people were very basic and the weather was extremely cold.

20. My "blue sky year" was 2000, when for an entire year I sat in a small kitchen in the middle of a small continent to finish my master's thesis *From Painting to Wall Sculpture*. At the same time my *Fragments* series was acquired by the Queensland Museum of Art.

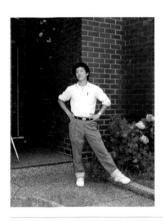

13. In November 1989 I went to Australia. You can see I still had big dreams! My Taiwanese classmates were surprised – I looked like a young guy from mainland China, dressed very fashionably.

14. Soon after I arrived in Sydney in 1990. I am on the far right, sitting next to me are Lao Deng, Wang Xu, Huang He, and others. We all made a living by doing street portrait painting. We ate, chatted and looked at each other – there was a tacit understanding that there was no future in what we were doing.

15. By 1993 I was really thin! I organised a group exhibition with my friends in Sydney. My work was text-based in Chinese and English and read: "When the air comes from the mouth, it's classical art. When the air comes from the arsehole, it's modern art. When the arsehole air passes out through the mouth, it's post-modern… post, post-modern. The next stage occurs when the air from above and below comes out together".

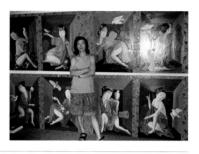

16. In 1994, it took me one year to complete my painting titled *Beauties Captured in Time*. Based on that work, I received a grant from the Australia Council for the Arts, which was a much-needed boost in terms of my standard of living and my art career.

21. With Richard Dunn, my supervisor, who oversaw my post-graduate studies at the Sydney College of Arts (1999–2000).

22. It was the first of December 2000, when I passed my oral evaluation, and the most relaxing time for me in ten years since my arrival in Australia.

23. The White Rabbit Chinese Contemporary Art Collection began in 2006. I was invited to be an art consultant on the project. Here I'm with Judith and Kerr Neilson at 798 Art District, Beijing.

24. My studio in the 798 Art District, Beijing.